W9-BYX-966

Pierre Cabanne,
art historian and critic, has contributed
to many of the principal art journals. A professor at the Ecole
Nationale Supérieure des Arts Décoratifs, he has written some
thirty books and essays including *Degas* (1958), *Interviews with
Marcel Duchamp* (1967), *Picasso* (1968), *The Psychology of Erotic
Art* (1971) and *The Art of the Twentieth Century* (1982). He is at
present preparing an encyclopaedia of art deco and a
book on eighteenth-century art.

WORLD OF ART

This famous series
provides the widest available
range of illustrated books on art in all its aspects.
If you would like to receive a complete list
of titles in print please write to:
THAMES AND HUDSON
30 Bloomsbury Street, London WC1B 3QP
In the United States please write to:
THAMES AND HUDSON
500 Fifth Avenue, New York, New York 10110

VAN GOGH

PIERRE CABANNE

with 149 illustrations, 67 in color

THAMES AND HUDSON

TRANSLATED FROM THE FRENCH BY
DAPHNE WOODWARD

Any copy of this book issued by the publisher as a
paperback is sold subject to the condition that it shall
not by way of trade or otherwise be lent, resold, hired
out or otherwise circulated without the publisher's
prior consent in any form of binding or cover other
than that in which it is published and without a similar
condition including these words being imposed on a
subsequent purchaser.

First published in Great Britain in 1963
by Thames and Hudson Ltd, London
First paperback edition (revised) 1969
Published in the USA in 1986 by Thames and Hudson Inc.,
500 Fifth Avenue, New York, New York 10110

Library of Congress Catalog Card Number 85-51232

This edition © 1963 Thames and Hudson Ltd,
London
© 1961 Editions Aimery Somogy S.A., Paris

All Rights Reserved. No part of this publication may
be reproduced or transmitted in any form or by any
means, electronic or mechanical, including
photocopy, recording or any other information
storage and retrieval system, without prior
permission in writing from the publisher.

Printed and bound in Spain by
Printer Industria Gráfica sa. Provenza, 388 Barcelona
D.L.B.: 25449-1985

CONTENTS

ZUNDERT
30th March 1853—30th July 1869

One of the most tragic lives in the history of painting began on 30th March 1853 at Groot-Zundert, in Dutch Brabant, near the Belgian frontier—a little town of three thousand inhabitants, set in a melancholy landscape of heath and peat-bogs interspersed with copses, under a low sky. It was here that Vincent van Gogh was born.

Vincent's father, Theodorus, was a pastor and the son of a pastor; his forbears for generations had been clergymen (a van Gogh was once Bishop of Utrecht), goldsmiths or tradesmen; three of his uncles were picture dealers. His mother, Anna Cornelia Carbentus, three years older than her husband, was the daughter of a Court bookbinder at The Hague. Their married life was happy and uneventful.

Yet the marriage had begun with misfortune; their first child, Vincent-Wilhelm, died at the age of six weeks. Fortunately, a year to the very day after, the pastor's wife bore a second son, who was given the same names as the first-born.

Another son, Theo, Vincent's favourite brother, his support and guide, was born on 1st May 1857. Then came four more children—another boy, Cornelius, and three girls, Anna, Elisabeth-Huberta and Willemien.

Vincent lived in his native village till he was twelve years old. He was a quiet boy, liable to sudden bursts of impatience or high spirits which alternated with long periods of depression. Obstinate and rather secretive, he did not mix with other children. His sister Elisabeth wrote of him later that 'Not only were his little brothers and sisters like strangers to him, but he was a stranger to himself as well.' [1] But Vincent was not antisocial; he shared in the family life and showed great affection for his home circle. He found in it a warmth to which he was by no means insensitive; to the end of his days he used to recall the quiet days at the parsonage with his father—dutiful, affectionate and kindly

but weak—whose death in 1885 plunged him into deep grief in spite of all that had divided them, the domestic virtues of his mother, who, like himself, alternated between moods of excitement and withdrawal, and the love of the other children. Nor did he ever forget the countryside of his long, solitary walks.

'. . . What is sure to remain is something of the stern poetry of the real heath,' he wrote later to his friend the painter van Rappart[2]; and after his fit of madness at Arles he recalled with melancholy '. . . every room in the house at Zundert, every path, every plant in the garden, the view of the fields outside, the neighbours, the graveyard, the church, our kitchen garden at the back—down to the magpie's nest in a tall acacia in the graveyard.'

His childhood was outwardly dull and he was a lonely boy, but stubborn and determined. His time was spent in the rather confined family circle, but he was always conscious of the distant horizon bounded by the low sky, where the light was subdued even in summer.

His home set Vincent an example of 'fruitful life' for which he formed an enduring respect. It was the only kind of life that he felt had meaning, though he himself never attained to it. And to the very end he loved his native land, with its austere, melancholy beauty—even while he fled from it towards the light, in his effort to know and fulfil himself more completely.

The lessons he learnt from the soil and the simple, rough people who worked it marked him strongly. He wrote to his mother from Saint-Rémy[3]: '. . . I have always remained very much like a Zundert peasant, Toon or Piet Prins for example. It seems to me at times that I feel and think like a peasant.'

Vincent's character is indicated by his physical appearance. His sister Elisabeth describes him[4] as 'broad rather than slender, his back slightly bent from the bad habit of hanging his head, his red hair cropped short beneath a straw hat that shaded a strange face—not the face of a young man. His forehead was already a little wrinkled, brows drawn together in a frown of concentration, eyes small and deep-set, sometimes blue and sometimes greenish, people's impressions varied. Despite this unprepossessing exterior, the unmistakable suggestion of inviolate depths gave a kind of strangeness to his whole person.'

In spite of the gulf between them, his family lavished affection on him and tried hard to find excuses for his moods of violence or depression; they longed to understand him, or to love him in a different way. Vincent, for his part, tried to draw closer to them and be more sociable, though he did not always succeed, and his failure would bring on a period of dejection.

'There may be a great fire in our soul,' he wrote [5], 'yet no-one ever comes to warm himself at it, and the passers-by see only a wisp of smoke coming through the chimney, and go along their way.'

One of the keys to van Gogh's nature is no doubt to be found in the mixture of mysticism und realism, fervour and restraint, passion and stolidity, inherited from his paternal forbears, among whom pastors alternated with adventurous merchants and seafarers—the one firmly-rooted, the other rebellious. To this heritage was added, from his mother's side, some further idiosyncrasies, derived from the Carbentus family, who tended to be either dour or hotheaded, and among whom were several epileptics (a maternal aunt died of epilepsy). But neither Vincent's father nor his grandfather ever revealed any serious physical flaw.

Van Gogh was made up of bewildering contrasts, and though it may sometimes seem possible to 'account for him', in the last resort he escapes explanations. Throughout his life he bore the stamp of his violent, secretive childhood; the seeds of his work lay there, in the seething excitement and the moments of dread, the depression, the solitude, the ungovernable passion, the repressed tenderness and the vague sense of guilt.

On 1st October 1864, when he was eleven years old, Vincent left Zundert to go to the Jean Provily school at Zevenbergen. This town was some miles from his native village—between Rosendaal and Dordrecht—but just as bleak and gloomy. His parents thought their son would be 'civilized' by associating with boys of his own age, but the results were disappointing. He became slightly less unsociable and highly-strung, perhaps, but he often went off by himself to read books on philosophy or theology which were too advanced for his age, or simply to dream. He did not do well at lessons.

A few months later Vincent made a drawing of a farm-house and a

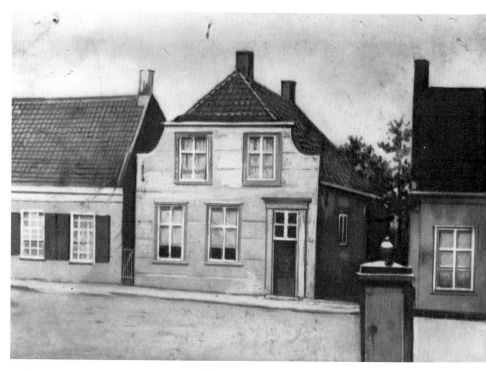

Van Gogh's Birthplace in Zundert

barn as a present for his father, whose birthday was on 8th February. He may have inherited his love of drawing from his mother—we have some agreeable water-colours from before her marriage—and he had already given evidence of it in various sketches and studies. We have, for example, his drawing of a bridge, signed and dated 11th January 1862, with some profiles verging on caricature on the back of the page; a milk jug, dated 5th September of the same year; a barking dog, of 28th December; a Corinthian capital of 22nd August 1863; some flower-studies; some water-colour landscapes including *Surroundings of the Château de Croy, near Aarle* (1863); and a goatherd and his flock, dated 9th October 1862. All of these are drawn with meticulous care, the work of an industrious schoolboy, interesting only as the earliest evidence of Vincent's taste for drawing.

10

In September 1866 Vincent went from the Jean Provily school to a similar one at Tilburg, where he boarded with the Hannick family, 47 rue du Cerfeuil.

His parents were growing anxious about his future, for his disposition showed little improvement and his school work was still unsatisfactory. He stayed at Tilburg for two years, until 14th March 1868, when he returned to Zundert. He was then fifteen years old.

He stayed at home for fourteen months, reading, going for walks, finding little to say to his family. No doubt he was drawing or painting water-colours as well, but nothing has survived from this period of marking time.

Zundert Church

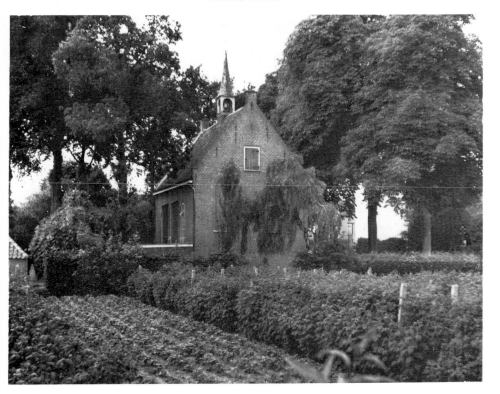

THE HAGUE
30th July 1869—13th June 1873

On 30th July 1869, on the recommendation of his Uncle Cent, Vincent was engaged as an assistant by a Mr Tersteeg, the manager of the Dutch branch of the Paris art dealers Goupil & Co., which was at The Hague (Plaats No. 10). He was to stay in this job for four years. They were peaceful, hard-working years and they introduced him to a long succession of pictures of the kind then in favour with the public: genre paintings, military studies, nudes, sunsets and sentimental anecdotes. Mr Tersteeg was pleased with him and the van Gogh family forgot their uneasiness about his future.

On 29th January 1871, Pastor van Gogh with his wife and children left Zundert for Helvoirt, to which he had been appointed by the Protestant Consistory, and Vincent never saw his native village again. At the age of nineteen he passed abruptly from boyhood to manhood. In August 1872 he and his brother Theo—then at boarding-school at Oisterwijk—began their life-long correspondence. 'A work such as this,' wrote Marcel Arland [6], 'might stand as evidence of man's wretchedness and his greatness; it would be enough to redeem mankind on the Day of Judgment.'

Of all Vincent's brothers and sisters, Theo was the one who came closest to him; yet they were very unlike, Theo being as gentle and trusting as his elder brother was irritable, imperious and distraught. Still, the younger boy understood, or rather 'accepted' the difficult personality of the future painter.

For Vincent, Theo was a refuge, a haven, a prop; he was to become a confidant and later a witness. At first the younger boy was rather alarmed and troubled that his elder brother should expect so much from him, and uneasy for fear of disappointing him; but gradually his voice grew firmer and his hand steadier. Whatever happened, he would never try to escape the trust. In the end Vincent's passion became his own.

On 13th June 1873 Vincent was transferred to the London branch of Goupil's, and took lodgings in a boarding-house kept by a Mrs Loyer, the widow of a Protestant clergyman. On the day of his arrival

he wrote to Theo, who by now was also working for Goupil, at Brussels: 'So far the boarding-house where I am staying pleases me. There are also three German boarders who are very fond of music and play the piano and sing, so we spend very pleasant evenings together.'

LONDON
13th June 1873—15th May 1875

'How I should like to talk with you about art, instead we must write about it often. *Admire* as much as you can, most people *do not admire enough*', Vincent wrote in January 1874.

For Vincent, art was so far more or less confined to the pictures at Goupil's; he liked Millet's *Angelus,* Meissonier, and Ary Scheffer's *Marguerite at the Fountain.* 'Is there a purer being than that girl "who loved so much"?' he wrote to Theo.[7] But he also admired the English painters, who came to him as a delightful surprise—Constable, Turner, Gainsborough, Reynolds—and had begun to collect prints.

He was still a voracious reader; Dickens appealed to him particularly. He advised Theo to 'read as much about art as you can, especially the *Gazette des Beaux-Arts,* etc. By all means try to get a good knowledge of pictures.'[8] On 31st July 1874 he wrote: 'I am glad you have read Michelet and that you understand him so well. Such a book teaches us that there is much more in love than people generally suppose.'[9]

Vincent spoke from the heart, for he was strongly drawn towards Ursula, his landlady's daughter. Mrs Loyer looked kindly upon this turn of events, but she cannot have fully understood the situation. Van Gogh was transfigured. The object of his devotion worked in a crèche and thus brought him into contact with what he revered most in the world, 'fruitful life'. He called her 'the angel surrounded by babies', and his letters to his family reflect his joy and his hope of setting up a home. He was so innocently happy that he never suspected that Ursula might be making fun of his exalted frame of mind and blindness; he lacked the courage to declare his love, it was enough for him to gaze at her, speak to her, be in the same house with her. To read the Bible in her company raised him to the seventh heaven.

Finally, feverish with emotion, he confessed his feelings and asked

her to marry him. She feigned astonishment and then burst into laughter. She was engaged already to a previous lodger, she told him. Vincent, terribly distressed, implored her to break off the engagement, but she would not hear of it. She admitted she had led him on, making fun of him; and as he persisted, continued to plead with her, she burst again into laughter, cutting him to the heart. Wounded and despairing, he left London and joined his parents at Helvoirt. They found him utterly distracted, gloomier and more quarrelsome than before, his usual refuge being an obstinate silence. Happiness had been within his grasp, but fate had put an end to his foolish hopes; the dream had vanished and he was left alone in darkness and grief.

From October to December 1874 he worked at Goupil's in Paris, but just before the year's end he was sent back to the London branch. He took the opportunity to see Ursula again and tried desperately to persuade her to change her mind; but again she refused him. Vincent tried to find forgetfulness in reading, in assiduous church-going, and in long, solitary walks about London. At home he spent the time drawing, smoking or reading the Bible. He felt that Ursula's rejection of him had put an end to everything and that his life was ruined. He could not see why good fortune should have deserted him, after his long weeks of happiness in Ursula's company and his wonderful dreams for the future. Had he been undeserving of God's goodness?

In the following months his mystic fervour intensified. He believed his suffering was a sign that he must set himself to redeem, by acts of charity, the offences for which God was punishing him. In the solitude he refused to depart from, he deliberately exaggerated the importance of his failure with Ursula, feeling an obsession that now conditioned his whole outlook.

On 15th May 1875 Vincent was again transferred to Paris.

PARIS
15th May 1875—31st March 1876

'I have taken a little room in Montmartre that you would like very much,' Vincent wrote to Theo on 6th July. 'It is very small, but it looks on to a small garden, all overgrown with ivy and virginia creeper.'

On 22nd October his father left Helvoirt for Etten, where he had been appointed pastor. Vincent went on reading, meditating, going to church and feeling unhappy. He visited the Louvre, the Luxembourg, the Salon and the Corot exhibition. His long, lonely evenings were usually given over to Victor Hugo, Heine, Keats, Longfellow or George Eliot, though he sometimes read and discussed the Bible with an eighteen-year-old English boy, Harry Gladwell, 'a very unlicked cub', who also worked at Goupil's and lived in the same house as himself in Montmartre.

On 12th September 1875, he wrote to Theo:

'Wings, wings over life!

'Wings over grave and death!

'That is what we want, and I am beginning to understand that we can get them. Don't you think Father has them? And you know how he got them, by prayer and the fruits thereof—patience and faith—and from the Bible that was a light unto his path and a lamp unto his feet.'

His religious feelings continued to increase in intensity. To his sister Anna, then in England, he sent *The Imitation of Christ,* and to Theo,[9] '. . . some fragments from the Bible, in the same edition as the Psalms I sent you.' Continuing his evangelizing, he suggested edifying reading to his brother.

He was now repelled by the agnostics Michelet and Renan and ceased to read them, advising Theo to do likewise. 'I think that will bring you peace of mind,' he assured him, and recommended Erckmann-Chatrian's novels as a substitute. On 14th October 1875: 'Look for light and freedom, and *do not ponder too deeply over the evils of life.*'

Vincent was so wrapped up in his reading and reflection that he was neglecting his work. Goupil's had been taken over by Messrs Boussod and Valadon, who looked less kindly on their odd-looking assistant. Their customers felt ill at ease with him; furthermore, Vincent did not like the pictures they sold, and said so. Finally, after several disputes, he informed his employers that picture-dealing was a form of 'organized fraud', whereupon they dismissed him. He left Paris on 1st April 1876.

This was a fresh setback for Vincent. Uncle Cent, who had got him his job in the first place and had had great hopes of him, now said he

would never help him again, and Vincent's parents' fears were revived. He too was brooding anxiously over his destiny; the love that had been denied him, his failure at the gallery and the hypocrisy of which he believed himself to be a victim, were all, in his eyes, signs of society's hostility to him. And fate did, indeed, seem to be directing him along a lonely path, offering only submission, abnegation, charity —driving him to 'sacrifice'.

Vincent resolved to transmute his ostracism, his withdrawal and wretchedness into spiritual riches.

At the end of March, Vincent answered a newspaper advertisement for a junior master at a Ramsgate boarding-school. The headmaster, Mr Stokes, engaged him *au pair,* 'and will see later on whether he can give me a salaried post,' wrote Vincent to Theo, adding: 'You can imagine how glad I am to have found something. I shall be sure of my board and lodging.' [10]

Vincent left Paris for Etten, where his father was now pastor. He stayed a few days with his parents, and then Pastor van Gogh went with him as far as Brussels on his way to London and Ramsgate. He arrived there on 16th April, a few days after his twenty-third birthday.

RAMSGATE—ISLEWORTH
17th April—31st December 1876

Most of Mr Stokes' pupils came from poor families; Vincent was to teach languages—French, which he did not know very well, and German—and to collect the boarders' fees. He liked Ramsgate. The sea was close by (the schoolroom window looked out on it); 'most of the houses along the shore are built of yellow stone in simple Gothic style, and have gardens full of cedars and other dark evergreens.'

He took long walks with his pupils. Beside one bay was 'a steep two-storey high ridge of sand and stone. On top of it were old, gnarled hawthorns, their black and grey moss-covered stems and branches all bent to one side by the wind, and a few sloe-bushes ... On our right lay the sea as smooth as a pond, reflecting the light of a soft grey sky where the sun was setting.' [11]

Vincent seemed calmer. 'Indeed,' he wrote to Theo, 'these are really very happy days I spend here; *but still it is a happiness and quiet which I do not quite trust.*'

One hot day in June he set out to walk to London. He stopped at Canterbury, and when night fell he lay down beside a pond with a few large beech trees and elms, and slept there till three in the morning. The birds woke him at sunrise and he set out again, enjoying the cool dawn. He was given a lift on a hay-cart for a mile or two, but the waggoner then stopped at an inn, so Vincent resumed his walk. He reached London that same evening and stayed there for two days, 'calling on various people, including a clergyman to whom I had written.' Then he walked out to Welwyn to visit his sister Anna, who was teaching French at a private school there.

While in London, Vincent tried to see Ursula again; but he learnt that she was married, and went away downcast. Mr Stokes now moved his school to Isleworth, in the suburbs of London; he was worried because the boys' fees were coming in slowly, and despatched van Gogh to collect them from the parents.

The unfortunate young man did not realize what a difficult task lay ahead of him. The homes of most of the pupils were in the East End, and Vincent had his first view of the slums. He compared what he saw with the descriptions in Dickens' novels, but reality was even more distressing than fiction, and Vincent neglected to demand Mr Stokes' fees from the people he visited.

Mr Stokes was not impressed by the lamentable conditions his assistant described, and since Vincent had proved incapable of collecting the money due to him, he could leave.

This was not exactly another failure, for the brutal revelation of working-class wretchedness had made up Vincent's mind for him. He decided that he would become a 'London missionary' when he was old enough; and on 1st July he became assistant-preacher to a Methodist clergyman, a Mr Jones, at another school. He felt no little pride at following in the footsteps of his father, whose example was his constant guide; he remembered the sermons he had heard in the little church at Zundert and wished he could repeat them word for word. Meanwhile he lavished pious advice on Theo, and continually quoted

the Bible, the *Imitation of Christ* and the Acts of the Apostles. With his friend Gladwell, who had now returned to his parents' house at Lewisham, near London, Vincent discussed 'the kingdom of heaven and the Bible'. With Mr Jones' pupils he studied the Scriptures; but he still found time for his long walks.

Comparing his life at the school with his life full of struggle in Paris the year before, he wrote to Theo on 18th August:

'... When shall I come back to that other world? If I ever do, it will probably be for very different work.'

For all his good intentions, Vincent was no orator, and he failed to interest, let alone convince his congregation of poor, uneducated people. But despite all difficulties it seemed to him he had discovered the real purpose of his life—which was to bring the Word of God to those who were suffering.

'Theo, woe is me if I do not preach the Gospel, if I did not aim at that and possess faith and hope in Christ, it would be bad for me indeed; but now I have some courage.' [12]

Vincent's sermons undoubtedly sprang from deep conviction, he had a fervent sense of vocation; but he was gravely handicapped by his instability, his excessive zeal and the exaggeration he displayed in everything he took up. The working-class population was tickled by curiosity, rather than convinced. One day he tried to persuade his hearers that 'sorrow is better than joy'. And on another occasion he dropped his gold watch into the collecting-bag at church. He overdid things to the point of falling ill, but he greeted sickness as a sign from God that he was to draw closer to the weak, the infirm, the destitute.

He wanted, if possible, to become a missionary in a seaport 'such as Liverpool or Hull (where) a preacher sometimes needs helpers who can speak several languages, to look after the sailors and foreigners and visit the sick.' [13] Mr Jones did not hold him back—apparently he realized, perhaps a little late in the day, that he had been heavily overburdening his assistant, and that the latter's preaching did not grip his listeners. Yet Vincent had thrown himself heart and soul into his ministry; did this mean that love, the wish to serve, complete self-sacrifice, were not enough? At the end of December he went home to Etten, exhausted.

Was he sent for by his parents, or did he go of his own accord? This is something of a mystery. Vincent's father expressed frank annoyance at his son's latest failure. Vincent was pale, thin, feverish; his family shrugged their shoulders and sighed. It would be better, both for his own health and for his father's reputation, if he were to settle down in Holland, where some quiet and more remunerative work could be found for him.

Yielding to the entreaties of Vincent's parents, Uncle Cent had again agreed to do something for his nephew, and found him a job in van Braam and Blussé's bookshop at Dordrecht. But Vincent had no intention of giving up his religious vocation. On the 31st he wrote to Theo: 'The change will be that, instead of teaching the boys, I shall work in a bookshop.'

'There are many things that make (the change) desirable,' he wrote in this same letter; 'being back in Holland near Father and Mother and also near you and all the others.'

But he surrendered because he felt that perhaps he still had a great deal to learn and to do if he was to become worthy of his mission.

ETTEN—DORDRECHT
1st January—9th May 1877

After his painful experience as an evangelist, Vincent found peace as a bookseller. His whole life was to be an alternation between excitement and calm, exultation and depression, appeasement and distress. He read deeply in religion and philosophy and lived like a hermit in his little room, where he had hung two prints, *Christus Consolator* and *Remunerator*, presents from Theo.

'It may be that there is a time in life when one is tired of everything and feels, perhaps rightly, as if all one does is wrong—do you think this is a feeling one must try to avoid or banish, or is it "the sorrowing for God", which one must not fear, but cherish to see if it may bring some good? Is it "the sorrowing for God" which leads us to make a choice which we shall never regret?' [14]

Vincent regarded his time in the bookshop at Dordrecht simply as a pause, allowing him to study more thoroughly the problems confront-

ing the evangelist and to get to know himself better as well. He turned a deaf ear to the teasing of the other assistants, or his fellow-lodgers in Tolbrugstraatje beside the Meuse. On 26th February he was greatly cheered by a visit from Theo, and a few weeks later, on 22nd March, he remarked: 'In writing to you of my intentions my thoughts become clear and definite.'

'... I have such a longing to possess the treasures of the Bible, to get to know all those old tales thoroughly and lovingly, and especially to find out what is known about Christ. There has always been—at least, as far back as we can search the past—one who preached the Gospel in our family, which is a Christian family in every sense ... It is my fervent prayer and desire that the spirit of my father and grandfather may be reborn in me, that it be given me to become a Christian, a true worker for Christianity, and that my life may resemble more and more the lives of those named above; for the old wine is good and I wish for no other.' [15]

The sense of continuity was superimposed on the imperative call to evangelism; 'service' should be the bond connecting Vincent with a long line of righteous servants of God. But how could he be worthy of them, and avoid falling short of their example? And how could he succeed in carrying conviction, bringing enlightenment?

These were the problems which agitated Vincent as he puffed away at his perpetual pipe. One day he would exult, buoyed up by self-confidence; the next he would be sunk in despair. Yet he remained determined.

'Oh! Theo, my boy, if I might only succeed in this! If I could have the joy of being released from the tremendous depression caused by the failure of everything I have taken up and by the flood of reproaches I have had to listen to, if one day I could be released from all that and if I were at last given the opportunity and the strength to study, to advance and persevere in the ministry, my father and I would thank the Lord from the bottom of our hearts.' [16]

To his reading of pious and philosophical works Vincent was adding 'the knowledge and love of the work and lives of such men as Jules Breton [17], Millet, Jacque [18], Rembrandt, Bosboom [19] and many others ... also likely to raise a fine crop of ideas.' [20] This curious mix-

ture can only astonish us, for what solace could Vincent find in the example of artists like Jules Breton and Charles Jacque, whose pictures he had seen at Goupil's? Their lives were uneventful and their work second-rate, yet he mentions them in the same breath as Rembrandt! But throughout his life Vincent was prone to errors of judgement, contradictions and misinterpretations. After mentioning these admired names he adds: 'Incidentally, there is a great resemblance between Father's life and that of these men, though I admire Father's even more.' For Pastor van Gogh carried the word of God within him.

Vincent was still living in solitude and retirement, seeing little of anybody except a schoolmaster named Gorlitz who lived in the same boarding-house. Gorlitz was an intelligent, cultivated man, who encouraged Vincent to study theology and take a degree. One evening Vincent confided his plans to Mr van Braam, and was hurt by his scepticism; if he only knew how hard Vincent was making himself work! He needed a thorough knowledge of the Bible, Latin, Greek, modern languages and history, in particular the history of the Reformation. His family doubted whether this unexpected vocation could be taken seriously, but Vincent's father was gradually impressed by his deep conviction, his zealous wish to complete his studies, and was gratified that his son should have chosen to follow in his footsteps and his father's before him. A family council was called to give its opinion, and decided that the future pastor should complete his preliminary studies at Amsterdam and sit for the first divinity examination there. He could stay with his Uncle Johannes, who had just been made director of the naval shipyards. Vincent arrived at his Uncle's on 9th May.

AMSTERDAM—ETTEN—BRUSSELS
9th May 1877—December 1878

Vincent's studying was prolonged and strenuous. Latin and Greek he found particularly difficult. While working he imposed privations upon himself, though he could not manage to give up smoking, and he was so tired out at the end of each day that he could not get up as early as he would have liked in the morning. His trials grew greater day by day and sometimes he thought of giving it all up.

'And yet I go on, but prudently and hoping to have the strength to resist those things . . . and believing that, notwithstanding everything that seems against me, I shall yet reach the goal I have so much longed for, and God willing, find favour in the eyes of those I love and those who will come after me.'[21]

He was taking Greek lessons from Mendes da Costa, a young rabbi who lived in the Jewish quarter of Amsterdam, and was supervised by Uncle Stricker, one of his mother's brothers. For algebra and geometry Vincent was the pupil of Teixeira de Mattos, Mendes' nephew, who gave religious instruction at the Jewish pauper school. He wrote to Theo that he was working 'as patiently as a dog gnawing a bone.'[22] Uncle Johannes found his nephew ridiculous, with his unworldly attitude and his belated studies; he made him keep to one room and scarcely ever saw him, even at meals, which Vincent had to take by himself.

'Now and then while I'm writing, I instinctively make a little drawing, like the one I sent you the other day,' wrote Vincent to his brother.[23]

'This morning, for instance, I did one of Elijah in the desert, with the stormy sky and a few thorn bushes in the foreground. It is nothing special, but I see it all so vividly before me, and I think that at such moments I could speak about it enthusiastically.—May it be given me to do so later.'[24]

Such notes are rare during this period. Vincent admits that he draws 'instinctively'; he is not yet a painter, his future lies in another direction, or so he believes. His letters to Theo are still full of pious counsel, they still present the long, monotonous chronicle of his efforts to study, list all his difficulties, detail his complaints, rehearse his hopes.

He went back to reading Michelet and Renan, thinking that 'a knowledge of history in general, and of particular individuals from certain eras, especially the history of the Bible to that of the Revolution, and from the *Odyssey* to the books of Dickens and Michelet . . .' might help him to become 'an inner, spiritual man'. He added:[25]

'And couldn't one learn something from the works of a man like Rembrandt, and from Breton's *Mauvaises Herbes (Weeds)* or Millet's *The Four Hours of the Day,* or *Bénédicté*[26] by de Groux or Brion,[27] or *The Conscript* by de Groux, or the one by Conscience,[28] or *The Oaks* by Dupré[29], or even Michel's[30] *The Mills and Sandy Plains*?'

Vincent's doubts were increasing. On 30th May 1877 he had written, answering Theo: 'A phrase in your letter struck me: "I wish I were far away from everything; I am the cause of all, and bring only sorrow to everybody; I alone have brought all this misery on myself and others." These words struck me because that same feeling, exactly the same, neither more nor less, is also on my conscience.'

Two months later he gave up his studies, worn out by poring over books; did one really have to learn so much in order to bring God's truth to man? Vincent's father and mother felt some disappointment and bitterness at Vincent's return, which was bound to have repercussions for the pastor himself; but their son looked so unhappy that they did not reproach him. Fortunately, Mr Jones, the clergyman from Isleworth, was visiting Etten just then and helped to comfort him. In the middle of July they both went with Vincent's father to Brussels, where they looked at a Flemish training college which had a three-year course, as against the minimum of six years required in Holland. Vincent was eager to try again. The governors of the Brussels school offered to admit him for three months, 'so they could get to know one another better,' but unfortunately he had to refuse because the fees were too high. He went back to Etten and loafed about, lonely and taciturn as usual, making drafts for sermons or copying 'with pen, ink and pencil' pictures by his favourite painter, Jules Breton.

In Brussels, Vincent had been in touch with the members of the Evangelical Committee, who were perhaps impressed by his faith. In any event, he was admitted a few weeks later to a small school run by Pastor Bockma, at Laeken-lez-Bruxelles, which trained evangelists. His dream was at last coming true, and Vincent was overjoyed. But he was soon to be disappointed.

The causes were his deplorable elocution, his impulsive nature, his irritability and instability. Moreover, he objected to the slightest discipline, and would not accept criticism from his superiors. He was as unsociable as ever, slovenly in his dress, and unintentionally made himself disliked. Pastor Bockma's two other students soon decided that he was most objectionable.

On 15th November, after spending the day with Theo, he sent him a 'little sketch' which 'is not really remarkable', but which he had 'done

instinctively', near Laeken. It shows a wretched tavern, 'Au Charbon-nage', where coke and coal were sold as well as drink. After leaving Theo he had gone home along the tow-path, and describes the scene:

'On the ground lies a skull; and in the background, the bleached skeleton of a horse near the hut where a horse-knacker lives. The sky above is stormy; the day, cold and bleak; the weather, gloomy and dark.

'It is a sad and very melancholy scene, which must affect everyone who knows and feels that one day we too have to pass through the valley of the shadow of death, and that the end of human life is tears or white hair... It always strikes me, and it is very peculiar that at the sight of the most utter, the most indescribable desolation of lone-liness, poverty, the end or extreme of all things, the thought of God comes into our minds.

'I should like to begin making rough sketches of some of the many things that I meet on my way, but as it would probably keep me from my real work it is better not to start.'

Despite his difficulties, Vincent had almost completed his training, and was hoping to be sent to the Borinage; meanwhile he was going for long walks and making many plans for the future. His comments to Theo on painting were as frequent as ever. 'What beauties art has to offer us!' he exclaimed. 'Provided we remember what we see we need never be empty, or really lonely, or ever alone.'

Although he believed Vincent's zeal to be genuine, Pastor van Gogh was concerned about his son. Vincent was now twenty-five, his career had been a succession of mistakes, disappointments, failures, and his father wondered whether he was really cut out to be a missionary.

'It distresses us so much,' his father wrote, 'to see that he knows nothing of the joy of life, but goes about with bowed head, deliberately looking for difficulties.'

Vincent finished his training, but was not appointed to a post, for the Evangelical Committee did not think he would make a good mis-sionary. This was a terrible blow; fearing its effect, his father hurried to Vincent's side, but found that he had already pulled himself to-gether. If the Committee did not want him, he would take up his charge on his own. In December Vincent went to the Borinage, the poorest part of Belgium. He settled at Pâturages, in the mining

district, lodging in the house of a pedlar, van der Haegen, and began his work of preaching.

THE BORINAGE
December 1878—15th October 1880

Here in the Borinage there was poverty on all sides, even worse than Vincent had seen in London. A miner earned no more than two francs fifty centimes a day, and children under fourteen were sent to work in the mines for a pittance.

'A few days ago, it was an intriguing sight to see the miners going by at dusk, against the white snow . . . Their houses are very small, and might better be called huts; they are scattered along the sunken mounds, and in the woods, and on the slopes of the hills. . . . Here blackthorn hedges surround the gardens and fields and meadows. Now, with the snow, the effect is like black characters on white paper—like pages of the Gospel.' [31]

The miners were simple people, and at first the sermons delivered by their curious preacher, with his red hair and fixed gaze, did not strike them as peculiar. Vincent won the affection of his congregation by his kindness, by a gentleness that contrasted with his abrupt movements and harsh voice. Sometimes in the evening he would sit making sketches and giving them to the children as religious pictures, thus gathering a dozen or so boys and girls to whom he would then talk about the Gospel. The news that 'Pastor Vincent is a good man' spread all over the Borinage. Radiant with happiness, he visited the sick, preached, comforted, relieved suffering, brought consolation. In order to live he was doing some copying work, and his father secured him an order for four large maps of Palestine, at a fee of forty guilders. He needed very little money, for he wore old clothes and ate practically nothing; his duties absorbed him entirely.

Such was his zeal that the Evangelical Committee sent him on a temporary mission to Wasmes, not far from Pâturages, at a salary of fifty francs a month. He was to help the incumbent, Mr Bonte, who lived at Warquignies. Van Gogh was delighted.

He lodged with a baker, Jean-Baptiste Denis, but for his sermons he

rented a large room used for dances and meetings. His congregation was small but attentive. 'They listened intently to me,' he told his family in several letters. When he had any time to spare he made drawings of surrounding landscape—a nightmare scene in which he discovered profound beauty—and sent them to his parents or to Theo. He went down a mine and stayed for six hours; the visit fascinated him, although it left 'rather a gloomy impression.'

Vincent was really living amongst the miners. He had long ago given all his clothes away, and now went about in an old military jacket and a shabby cap; he gave away his meagre salary as well. He even found his room in the Denis' house too luxurious and moved to a wretched hut where he slept on straw, on the ground. He neglected to wash, and 'though he was not covered with a layer of coal dust, his face was usually more grimy than a miner's.' [32] This was going too far, it puzzled the miners and aroused their suspicion. The effect on the Evangelical Committee was equally unfavourable, and when he took the part of the men during a strike, Vincent was sharply criticized.

Pastor Bonte did not care for his assistant, and advised him to be less extreme. Vincent complied for a time, but his zeal refused to be checked; he was really 'God's madman', 'St Francis of the mining villages', as René Huyghe puts it, carried out of himself by faith.

In his letters he frequently compares the surrounding country to pictures by Rembrandt, Ruisdael or Michel, or even to those of Maris [33], Mauve [34] or Israëls [35].

'I can find no better definition of art than this,' he writes to Theo. 'Art is man added to nature—nature, reality, truth, but with a significance, a conception, a character, which the artist brings out in it, and to which he gives expression . . . which he sets free and interprets.'

And he adds: 'A picture by Mauve or Israëls says more, and says it more clearly than nature herself.' [36]

Vincent was remembered as an artist in the Borinage. A pastor at Warquignies, questioned by Louis Piérard, said that 'He used to go and sit on the slag-heaps, making drawings of the women while they were picking up coal or as they went away loaded with sacks.

'We noticed that he never drew bright things, those that we take to be beautiful.

'He did some portraits of old women; but nobody paid much attention, it was thought to be just a pastime for him.

'But it did seem that in painting, too, that young man had a taste for what seemed rather poverty-stricken.'

Another witness described him as 'spending his time drawing fautographs (sic) and coal-mining' (sic).[37]

The drawing of *Women returning from the Pit-head*, made by Vincent in 1881, was perhaps prompted by his Borinage sketches, none of which has survived. He doubtless painted water-colours as well, and his sister, Mme Duquesne-van Gogh, writes in her reminiscences that when he came back to Holland Vincent showed his family some drawings touched up with water-colour, illustrating the life of the miners. 'It did not amount to much as yet, he had plenty of other things to take up his time while he was there; but his drawings were vivid: a miner outside his thatched cottage ... A pair of mine-workers, a man and a woman, with arms and legs that looked much too long because they were so thin; on the back of each of them was a filthy sack full of "cobbles", and they were walking along a cinder track.'

In a letter written from The Hague some time later [38], Vincent remarks: 'It's about two years now since I began to draw, in the Borinage.' That was the real beginning as an artist.

While living among the miners, van Gogh underwent a transformation; as a missionary he was appalled by the sight of so much wretchedness, but the artist in him found that the tragedy he was watching aroused new sensations in him. These were still confused, and Vincent was constantly referring to familiar pictures, as though trying to justify his vision by the example of others, while he was visited by memories of his period with Goupil, which had first awakened his sensibility. Among those pictures he had experienced 'violent emotion, to the point of rapture.'

Warned by Mme Denis of the squalor in which his son was living, Pastor van Gogh visited Wasmes; the Evangelical Committee, scandalized by Vincent's behaviour, was on the point of cancelling his mission, and this decision was only averted in the nick of time. Vincent's father secured a promise from him that he would be more reasonable.

On 16th April 1879 there was an explosion of firedamp in a mine at

the nearby village of Frameries. Vincent devoted himself body and soul to the injured; he was everywhere at once, seeing to everything and everyone, with positively superhuman courage.

And at that very moment the blow fell. The Evangelical Committee dismissed Vincent with the excuse that he was not a good preacher. Had he possessed the gift of eloquence, they said in their report, 'M. van Gogh would certainly have been the ideal evangelist.' Vincent submitted without protest against the hypocrisy. He was so exhausted, reduced to skin and bone by his privations, worn out with fatigue and disgust. He went away, leaving the local people to the poverty and suffering which he could do nothing to alleviate beyond sharing it. 'Wasn't he perhaps a bit crazy, our pastor Vincent?' people murmured.

He went away with a radiant face. A few weeks earlier, after the explosion, he had spent night after night at the bedside of a miner who had been terribly injured, bathing his wound, 'begging him to live'. The man recovered. 'Before I left Belgium, in the presence of that man, with his scarred forehead, I had a vision of Christ resurrected.'

At Brussels, Vincent went to ask advice of Pastor Pietersen. The worthy pastor, who took an interest in drawing and painting, was astounded when his visitor, who had come from Wasmes on foot, opened his portfolios and showed him his 'clumsy scribbles'. He had been expecting complaints and lamentations (being a member of the Evangelical Committee which had dismissed Vincent), but Vincent hardly mentioned the subject; he talked all the time about art, and with ardour as fiery as when he used to speak about his religious vocation.

Pastor Pietersen bought two of Vincent's drawings. His great wish was to steer Vincent in a direction where he might at last find security and peace. Then Vincent went back to the Borinage.

In July 1880, not long after his dismissal, Vincent sent Theo an extremely long letter, written in French. He had not written to his brother for nine months and this is a touching confession, with ideas, plans, impressions and opinions all thrown in pell-mell. In it he speaks of his nature ('a man of passions, capable of and subject to doing more or less foolish things'), lists his failures and foretells the turn he is to give to his life. But painting was to make no great change for him; it would provide him with another chance to give, and sacrifice himself.

It was only ten years after writing this letter, to the day, that Vincent killed himself.

My dear Theo,

I feel a little reluctant to write to you, not having done so for such a long time, and for many reasons.

You have become to some extent a stranger to me, and I am perhaps more of a stranger to you than you may think; perhaps it would be better for us not to go on in this way. Probably I would not have written to you even now, if I were not under the obligation and necessity of doing so—if you yourself had not given me cause. At Etten I learned that you had sent 50 francs for me; well, I have accepted them. Certainly with reluctance, certainly with a rather melancholy feeling, but I am up against a stone wall and in a sort of mess; what else can I do?

So I am writing to thank you.

Perhaps you know I am back in the Borinage. Father would rather I stay in the neighbourhood of Etten; I refused and I think I acted for the best. Involuntarily, I have become for the family a kind of impossible, suspect creature, at least somebody whom they do not trust, so in what way could I be of the slightest use to anyone?

... Well, this being the case, what's to be done? Must I consider myself a dangerous man, incapable of anything? I don't think so.

... It is true that occasionally I have earned my crust of bread, occasionally a friend has given it to me out of charity. I have lived as I could, as luck would have it, haphazardly. It is true that I have lost the confidence of many; it is true my financial affairs are in a sorry state; it is true the future looks pretty black; it is true that I might have done better; it is true I've wasted time just in scraping a living; it is true that even my studies are in a pretty sad and desperate state and that I lack more, infinitely more, than I possess. But can that be called going down, can it be called doing nothing?

... My only anxiety is, how can I be of use in the world? Can't I serve some purpose? How can I learn more and study certain subjects profoundly? You see, that is what worries me all the time; and then I feel imprisoned by poverty, unable to share in this or that undertaking,

and certain necessaries are beyond my reach. That is one reason for feeling rather melancholy, and then one feels an emptiness where there might be friendship and strong and serious affections, and a terrible discouragement gnawing away even one's moral energy, and a fate seems to be able to put a barrier to the affectionate instincts, and a tide of disgust rises up in one. And one exclaims 'How long, my God!'

Well, what is to be done? Do our inner thoughts even show outwardly? There may be a great fire in our soul yet no-one ever comes to warm himself at it, and the passers-by see only a wisp of smoke coming through the chimney, and go along their way. Now what is one to do? Must one tend that inner fire, have salt in oneself, wait patiently, though with how much impatience, for the hour when someone will come to sit there—perhaps to stay? He who believes in God must wait for the hour that will come sooner or later.

... As I've accepted what you have given me, if I can be of use to you in any way, you might ask me, it would make me happy, and I should look upon it as a sign of confidence. We are rather far apart and perhaps have different views on some things, but all the same, the hour and day may come when we could be of service to one another.

This letter, written from Cuesmes, is one of the most important in van Gogh's enormous correspondence with his brother.

For months on end, Vincent strayed about, aimless, workless, penniless. His holy and healthy rebellion against misery was dead; nowadays he looked at the mining district and its wretched population with different eyes, and it was true that, as Theo declares, he was 'greatly changed'. His longing for God, which he had tried to assuage by helping the unfortunate, by sharing their lives and preaching the Gospel, had been succeeded by the vocation of the artist.

'I've been making rough sketches of these drawings without advancing very much, but lately it seems to have been improving, and I am hopeful that it will improve even more.' [39]

'So you see I am in a rage of work, though for the moment the results are not very gratifying. But I hope these thorns will bear their white blossoms in due time, and that this apparently sterile struggle may be like the pangs of childbirth. First the pain, then the joy ...'

'Though every day difficulties crop up and new ones will present

themselves, I cannot tell you how happy I am to have taken up drawing again.' [40]

And henceforth he wished 'to learn as soon as possible to make some drawings that are presentable and saleable, so that I can begin to earn something directly through my work.' [41]

Theo, who had a job with Boussod & Valadon in Paris, at once began to send money to his brother, offering him also moral support and encouragement.

Vincent was lodging with a miner, Charles Decrucq, in the Rue du Pavillon at Cuesmes, near Mons. The miner's daughter would hear him 'weeping and groaning at night in the loft he occupied.' He spent the time drawing peasants and scenes of work in the fields, or copying reproductions of Millet's pictures.

One day he decided to go to Courrières, 'perhaps involuntarily, I can't exactly say why,' he admits. In that town there lived one of the men he admired tremendously and regarded as equal to the greatest—the landscape-painter Jules Breton, whose scenes of peasant life had brought him a great reputation.

Vincent went on foot, 'a long weary walk'. He approached Jules Breton's studio but found the outside 'rather disappointing: it was quite newly built of brick, with a Methodist regularity, an inhospitable, chilly and irritating aspect. If I could only have seen the interior, I would certainly not have given a thought to the exterior, I am sure of that.' But Vincent was not able even to catch a glimpse of it, for he lacked the courage to enter and introduce himself. Instead he entered the Café des Beaux-Arts, 'also built of new bricks, equally inhospitable, chilly and repellent', and after examining the inferior frescoes there he went away.

By 15th October Vincent had moved to Brussels, where he took a room at 72, Boulevard du Midi with the money Theo had sent him.

He was now twenty-seven years old. At an age when an artist has generally served his apprenticeship, Vincent had produced only some very commonplace drawings and some indifferent copies, mostly of Millet, whose *Sower* he had copied as many as five times. This picture was a permanent obsession with him, for he produced in course of time no less than twenty-five drawings and seven paintings of the subject.

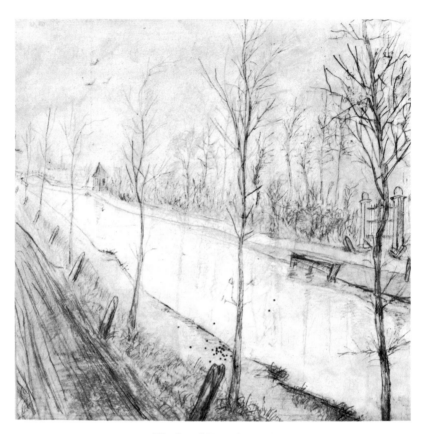

The Canal. Brussels, 1880.

BRUSSELS
15th October 1880—12th April 1881

Drawing was the medium of expression Vincent had now chosen with the intention of proving that he was not an idler, that he had the capacity to work and to persevere in a chosen direction. The great thing now was to improve, so as to be able to earn his living as soon as possible by the sale of his work; meanwhile his father was making him a small allowance, sixty guilders a month.

He began by making a round of the art galleries; at his lodgings he made studies, either from Bargue's *Le Cours complet de dessin* or with

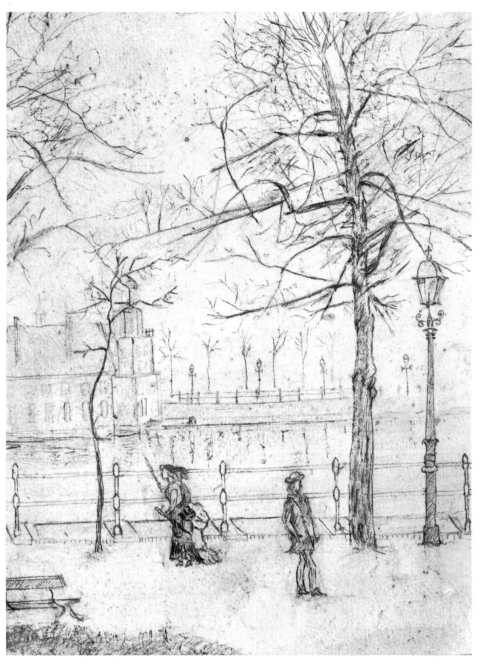

By the Canal. Borinage and Brussels, 1880–81.

the help of Allongé's *Recueil de Fusains;* but he was anxious to meet other painters and profit by their experience and advice. An artist named Schmidt urged him to enter the Ecole des Beaux-Arts, but Vincent brushed aside the suggestion; thanks to Theo he made the acquaintance of a Dutch artist named Roelofs, who undertook to give him lessons. But it was chiefly from Anton G. A. Ritter van Rappart that he received the encouragement and support he was seeking.

On 1st November 1880, Vincent wrote to Theo:

'I have also been to see Mr van Rappard, who lives at 6, Rue Traversière, and had a talk with him. He is a fine-looking man. Of his work, I only saw a few small pen-and-ink landscapes. But, judging from the way he lives, he must be wealthy, and I don't know if he's really a man I could share a roof with, considering the financial question. But I shall go and see him again. The impression he made on me was that he takes things seriously.'

Van Rappart, also of Dutch origin, had worked at Utrecht and Amsterdam before settling in Brussels to study at the Academy. He did not welcome Vincent with any great enthusiasm. Five years younger than Vincent, he was rich and led a comfortable life, painting, for the most part, pictures of workers and peasants. A settled, peaceable and gentle-mannered aristocrat, he was taken aback by his sombrely fanatical visitor, who, as he wrote later, 'toiled and struggled, was often capable of losing his temper and displaying violence, but always deserved friendship and admiration for his noble nature and his great artistic talents.' [42]

Vincent was indeed working frantically and, as usual, in the midst of confusion and disorder. Van Rappart continued to mistrust his character, but gradually grew accustomed to him, perhaps because he divined the unsparing passion to which Vincent was a prey. Vincent tried to order his ideas and work with greater steadiness and regularity, but it was seldom any use.

He was without news of his family; Theo had not written to him for several months, and Vincent wondered 'whether he is afraid of getting into trouble with those gentlemen G. & Co.' [43] by keeping in touch with his brother, or whether he dreaded being asked for money.

Even when Theo did answer his letter, at the beginning of January

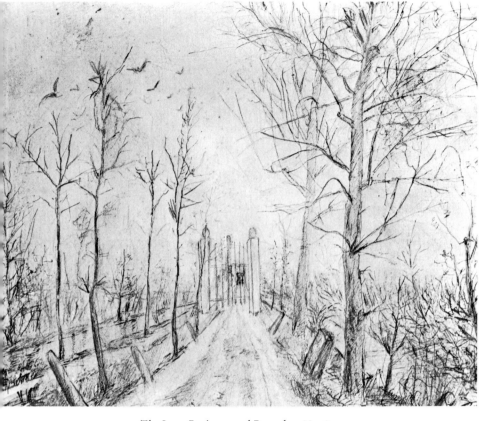

The Lane. Borinage and Brussels, 1880–81.

1881, things did not go very well. Vincent was dissatisfied with his drawings and talked of going to Paris to look for a job. He added: 'But you must also know that I didn't begin drawing in order to drop it, so my chief aim will be to continue and make progress in that direction.'

He was frequently short of money. Uncle Cor turned a deaf ear to his nephew's appeals; the whole family seemed to be holding aloof, and as for van Rappart, 'I thought I noticed,' wrote Vincent sadly, 'that he did not like to be disturbed.'

Once these moments of depression and gloom were over, Vincent would make more plans and describe his hopes in detail—only to sink back again into dejection or despair. This succession of ups and downs

35

did not ease his relationship with his family or with van Rappart. But Vincent had no intention of turning aside from his purpose, which was 'to reach a point where I am more or less able to work on illustrations for newspapers or books.' This he believed to be the only way he could attempt to earn his living.

Van Rappart was about to return to Holland, and Vincent decided that to save expense he would settle in the country, or even at Etten, where his parents lived. He wrote to Theo: 'I would prefer to go somewhere where I could be in touch with other painters, and if possible living and working together, because it is cheaper and better.' And he added, 'Of course I should be delighted to live with you later, but we haven't come to that yet.'

'... A peasant who sees me draw an old tree-trunk, and sees me sitting there for an hour, thinks I have gone mad and, of course, laughs at me. A young lady who turns up her nose at a labourer in his patched, filthy dirty clothes, of course cannot understand why anyone visits the Borinage or Heyst and goes down a coal mine. She concludes in her turn that I'm mad. Naturally I do not care at all what they think, if only you and Mr. T.[44] and C. M.[45] and Father, and others with whom I come into contact, know better, and instead of making remarks about it, say, Your work demands it, and we understand why it is so.

'So I repeat, under the circumstances I don't see why I shouldn't go, for instance, to Etten or The Hague, if that were preferable, though it may be criticized by some gentlemen and silly girls.'[46]

Vincent often heard himself described as 'mad', the term of abuse for those who refuse to conform. But if he lived apart from his fellow-men it was much against his will. He himself asked nothing better than to fall back into the ranks and earn an honest living without being dependent on his relations.

When Vincent first began 'to go to the bad', as his parents regarded it, after his failure as a missionary, they had thought of putting him under guardianship (*en curatelle*) at Gheel, near Antwerp, where there was a lunatic asylum. Vincent knew of this plan, and in a letter written on 1st June 1882, he discussed the subject—in reply to Theo, who had thought fit to put him on his guard against the possibility of such a decision.

'Obtaining a *curatelle* order, which has so often been abused in order to get rid of troublesome or "unpleasant" characters, is not such an easy thing to carry through nowadays. If you ask me, I do not think the family would do a thing like that; but you may say they have tried to do it already, as the Gheel episode proves. Alas, yes—Pa is capable of it, but I tell you, if he dares attempt anything of the sort I shall fight him to the bitter end. I don't care about talk, but it would be another thing if action were to be taken.'

For the moment, said Vincent, he had to work and to 'get hold of a well-paid job'—partly, no doubt, to allay the family anxiety which was as acute as ever, and partly to convince himself that in spite of all that had happened, nothing was lost.

'I'm sending you three sketches,' he wrote to Theo, 'they are clumsy as yet, but they will show you that I am gradually improving. You should take into account that it is only a short time since I started drawing, though I made little sketches when a boy. And that during this winter I thought it most important to make rigidly accurate anatomical studies, not my own compositions.'

Half way through April, Vincent left Brussels for Etten.

HOLLAND
April 1881—27th November 1885

Vincent set to work at once upon reaching home. His enthusiasm cheered the pastor and his wife. They hoped their son would soon find a job, though they were baffled by his very dark drawings, with their convulsive style. Vincent kept up his habit of taking long country walks and did a great deal of reading. In the summer van Rappart came to visit him, and the two young men went for many walks together, holding endless discussions as they strode along. For the moment Vincent was happy, relaxed, at peace.

In August he visited his cousin, the painter Anton Mauve, at The Hague. Mauve encouraged him, and Vincent returned to Etten to work harder than ever, drawing scenes of peasant life, such as *The Forge* and *The Sower,* and doing a portrait of his father. Uncle Cent, with whom he was now in high favour, had just given him a box of water-

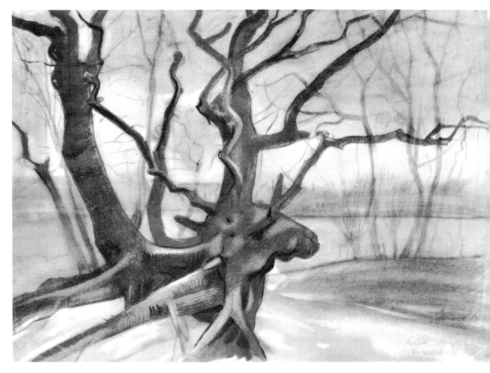

Study of a Tree. The Hague, April 1882.

colours, and with these he made a vigorous sketch of *Windmills near Dordrecht,* touched up with chalks. 'Mauve encourages me to hope that in a comparatively short time I shall be able to make something saleable,' he wrote to Theo a few months later, in December. But meanwhile the time of peace for Vincent had ended.

At the end of August a young cousin, Kee Vos, daughter of Pastor Stricker of The Hague, came to Etten to spend a few days with the van Goghs. She was recently widowed and had a four-year-old child. Vincent had fallen deeply in love with her, but Kee was determined to remain faithful to her husband's memory.

'Then there was a terrible indecision in my heart about what to do,' he wrote to Theo. 'Should I accept her "no, never, never!" or, considering the question not finished or decided, should I keep some hope and not give up?' [47]

Vincent chose the latter course, though all his family, with the exception of Uncle Cent, urged him against it. 'Whatever may be,' he declared, 'I intend to persevere and to put away from me all melancholy and despair.

'Meantime I'm working, even more easily since I met her.'

When Ursula refused him, he had lost his self-control; this time he would be more diplomatic. He decided to make himself indispensable, lavishing solicitude and attentions upon Kee in order to prove his devotion and convince her of his whole-hearted love. When this artless strategy failed, Vincent still persisted, feeling sure that the strength of his feelings would overcome Kee's resistance.

As he wrote to Theo: '. . . you understand that I hope not to leave a single thing undone which may bring me closer to her, and it is my intention to

Love her until
She ends by loving me

Theo, are you perhaps in love too? I wish you were, for believe me, even its little miseries have their value.'

'. . . If you ever fall in love and get the answer "No, never, never!" be sure not to resign yourself to it; but you are such a lucky fellow that I trust it will never happen to you.'

To escape Vincent's persistent attentions Kee went to her family at Amsterdam. Vincent wrote letter after letter, but it was no use, she never replied. Her 'No, never!' caused him cruel suffering; but he was still deceiving himself with false hopes.

'"No, never, never!" How can one answer that: by going on loving! I can't say who will win in the end, God alone knows that; I only know this one thing, *I had better stick to my faith.*' [48] (The last phrase is written in English.)

Vincent's feelings towards Kee met with strong disapproval, not only in his family circle, but in the whole village. His father went so far as to call his love 'incestuous'. But Vincent was unimpressed, for he was concentrating all his efforts on winning his cousin's heart. His feverish excitement was reflected in his work—he was drawing a great deal, peasants in the fields, studies of trees, etc. 'For the moment I'm working a lot in charcoal and pencil. I've tried sepia and wash too,' he

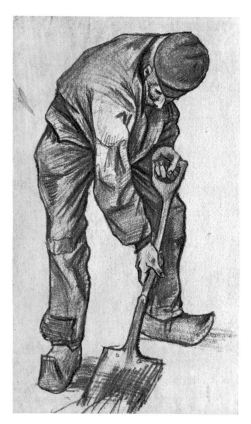
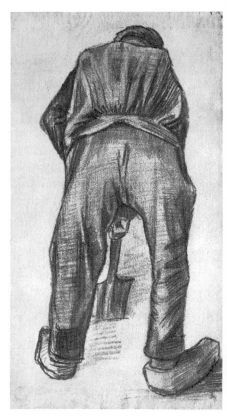

Man digging. The Hague, January 1882. *Man digging.* The Hague, January 1882.

wrote to van Rappart [49], mentioning at the same time that he had made seven large studies of the trunks of ancient pollard willows.

Three days later, on 15th October 1881, he added: 'However, I look upon my present studies purely as studies after the model, they have no pretensions to being anything else.' And he lists the painters he admired at that time—Paul Baudry, Jules Lefebvre and Henner, three cold, academic painters who were then at the height of their fame. But he is even fonder of 'Jules Breton, Feyen-Perrin [50], Ulysse Butin [51], Mauve, Artz [52], Israëls, etc.' He hoped to see Mauve again soon and to work with him.

Vincent said nothing about Kee to van Rappart, but the thought of her underlay every sentence he wrote. He was still pestering her with

insistent letters, and kept Theo informed of his desperate efforts to win her. Vincent's father was outspokenly angry: 'She has said *no,* so you *must stop it.*' Vincent implored Theo to intercede with his family and persuade them to show 'more courage and humanity'. 'A letter from you, with some little joke about that "No, never, never!" would have the best possible effect...'[53] he wrote, adding: 'Since I've been genuinely in love, my work bears a clearer stamp of reality.'

In an undated letter to Theo he writes:

'From the very beginning of this love, I felt I hadn't the slightest chance unless I threw myself into it with no second thoughts, no attempt to keep a way of escape open, with my whole heart, totally and for always, but in spite of having thrown myself into it as I have just said, my prospects are extremely slight. What do I care! I mean, should one, can one, take that into account when one's in love? No—to the devil with all calculation—I love because I love.

'To love—*quelle chose!*

'... When you and I are in love, we love, that is all!'

These impassioned outcries brought no response. Vincent's rapture was greeted with silent disapproval or bitter reproach. More than ever, he was alone. Still, he was not neglecting his work. He was now prepared to listen to other people's opinions, and was grateful when van Rappart criticized a drawing of a sower.

Vincent was still sending Theo letters several pages long, which the latter answered with counsels of prudence and moderation; but how to tame a love so vehement?

Towards the end of November he reached the limits of his endurance and left for Amsterdam. He went to Kee's parents' house, but she was not there. Warned of his arrival, she had fled. 'There was a plate in front of each person, but no extra one, a detail that struck me. I inferred from it that they wanted to make me believe K. was not there, for her plate had been removed. As I knew she was there, I said to myself that this was rather like a play or a farce...'[54]

After a few minutes, when the usual greetings were over, Vincent enquired, 'Well, and where is Kee?'

Uncle Stricker turned to his wife and asked: 'Well, Mother, where is Kee?'

'Kee is out,' replied her mother.

They began to talk, without more ado. Vincent spoke of art and other subjects; after a time the younger members of the family withdrew, leaving Vincent alone with his uncle and aunt. Kee's father, in his pulpit voice, told his nephew that he would now read him a letter he had just finished writing.

'But where is Kee?' Vincent repeated, staring him in the face.

'Kee left the house the moment she heard you had arrived,' Uncle Stricker answered bluntly . . . Then came the letter.

'The document was very reverend and very learned, but all it said, really, was this:

'I was requested to give up all correspondence and to make very energetic efforts to forget the whole matter.

'After that I spoke up, declaring as calmly and politely as I could, that I had already heard such arguments very often—but now—what further?'

Vincent called on the Strickers several times in the next few days, but he never saw Kee, and had to listen to tedious lectures about shameful passions and undesirable literature. On the Sunday morning he paid Kee's parents a final visit and returned to the attack, demanding to see his cousin. When his uncle refused to send for her, Vincent held his hand over the flame of a lamp, threatening to keep it there until Kee arrived. He needed to justify himself at all costs, to demonstrate the sincerity and depth of his love.

There followed a terrible scene. After an instant of stupefaction, the pastor blew out the flame. 'You shall not see her!' he shouted, livid with fury, thrusting him out irremediably 'into darkness and cold'.

'At that I *felt my love die*, it did not die entirely nor immediately, but fairly quickly all the same, and a void, an immense void, has opened up in my heart.'

'From the human and social standpoint the man was lost, a pilgrim solitary and accursed,' writes Jean Leymarie [55], 'but the painter was saved . . . Failure and submission in his life, absolute intransigence in his art and principles, these were the crux of his tragedy.'

But this propitiatory sacrifice was a sign, seven years before the severed ear. Vincent may have regarded mutilation as a means of ex-

orcizing the evil by which he was harried and haunted, and also, perhaps, as a vengeance on himself. For he was much inclined to consider himself to blame for his rejection by Ursula and Kee, to believe that he did not deserve the 'fruitful life' he had dreamt of leading with each of them in turn. Since his dismissal by the Consistory Court he had been a social outcast; was he now to become an outcast in this as well?

He went back to Etten in the depths of despair. He was a mere shadow of himself, deathly pale, hollow-cheeked, often wild-eyed; more irritable, imperious and violent than ever before. He had broken once and for all with religious observance, and even went so far as to attack it. At this his father became angry and accused him, as Uncle Stricker had done, of being addicted to pornographic literature. The gulf between them widened, and Vincent's admiration for his father rapidly diminished. He now realized that his father was narrow in his outlook, weak in character, and ineffective as a pastor. He blamed his parents for conspiring with his Uncle and Aunt Stricker to frustrate his love for Kee.

Early in December, after only a few days at home, Vincent left for The Hague, where his cousins Anton and Arlette Mauve gave him an affectionate welcome. His drawings—vigorous, harsh, expressive, with their inky blacks, as yet stiff and without sense of movement or feeling for proportion—appealed greatly to his hosts, and Mauve taught him the rudiments of oil painting. Vincent painted several still-lifes which he was to finish on his return to Etten; two of these have survived, one showing a pair of clogs, a cabbage, some potatoes and a carrot, the other a jug with a pewter lid and some apples. These are the only two of van Gogh's earliest paintings that have come down to us.

The collapse of his hopes had changed Vincent, by leading him to concentrate entirely on his work and, still more, by leading him to renounce the attempt to win a place in the community and reach an honourable position by marrying, founding a family and doing a job; his failures had set him apart, made him an outcast. He would accept this state of things, and for the rest of his life was to see himself as others saw him—as a freak of destiny.

On Christmas Day, after a violent quarrel with his father, Vincent left Etten and returned to The Hague. There, thanks to Mauve, he

found a studio at 138 Schenkweg, near the Rhine station. He was calmer and more relaxed, but he had no money and applied for some to Theo. Having heard the story of Vincent's departure from their parents, Theo wrote him a severe letter. Vincent replied at once, to exculpate himself. In this very long letter, dated 7th January 1882, he deals with his brother's reproaches, point by point. He speaks very harshly of the pastor and his other relations, whom he is determined never to see again.

His work with Mauve did not always go smoothly, but his cousin introduced him to other young artists with whom he became friendly; they included the landscape painter Theophilus de Bock, van der Weelen, Georges-Henri Breitner and Weissenbruch. The Hague was then the centre of an important literary and artistic revival, the '1880 Movement'. He had also got in touch again with Mr Tersteeg, his one-time employer in the Dutch branch of Goupil's. Vincent was fond of discussion, and felt at home amid all this animation. But he had not forgotten Kee, and if he seemed to have resigned himself to that 'No, never, never,' it was because he knew that his future lay elsewhere.

Unfortunately his health was not good; on several occasions he had to stop working because of 'fever and irritation', followed by 'stubborn headaches and, on top of that, bouts of tooth-ache.' [56] Moreover, he was short of money and could not pay for models, which drove him to implore Theo to help him.

He did not long remain on good terms with the local painters. Their vanity soon began to irritate him, and he found their work too conventional. He gradually drew away from them and, instead of joining them for studio work, began to take country walks, during which he would stop to draw or paint. He often went to the Mauritshuis to admire Rembrandt and Frans Hals.

To Theo he wrote: 'I've reached the point of making a good drawing every week, such as I couldn't have done at all at one time. That was what I was thinking of when I said I had the impression of getting back my youth.

'The conviction that nothing—except perhaps illness—can rob me of this power is beginning to develop in me.'

Mauve's attitude towards Vincent changed abruptly. Their ill-

Sorrow. The Hague, November 1882.

assorted temperaments clashed over their respective attitudes towards drawing, for one was patiently copying antiquities, while the other rebelled against any form of discipline. They quarrelled and were more or less reconciled on several occasions, until one evening in the studio Vincent suddenly grasped one of the plaster casts from which Mauve was in the habit of drawing, hurled it to the ground and threw the shattered pieces into the coal-scuttle. From that moment their parting was inevitable.

The quarrel distressed Vincent greatly; again he was left alone, with only himself to blame. One day later the two met on the dunes and

Vincent invited Mauve to come and see his work 'and then talk things over'. Mauve refused point blank, saying: 'I will certainly not come to see you, that's all over.' And he added, 'You have a vicious character.'

'. . . Mauve takes offence at my having said "I am an artist,"' wrote Vincent. 'I won't take it back, because of course it implies "always seeking without absolutely finding."'

In this same letter [57] he suddenly makes a confession:

'People suspect me of something—it's in the air—I'm keeping something back. Vincent is hiding something that cannot bear the light.

'Well, gentlemen, I will tell you, you who so prize good manners and culture and quite rightly, so long as it is the genuine article: which is more civilized, more delicate, more manly—to desert a woman or to have pity on one who has been deserted?

'This winter I met a pregnant woman, deserted by the man whose child she was carrying.

'A pregnant woman who had to walk the streets in winter, had to earn her bread you can guess how.

'I took her as a model and worked with her all winter.

'I wasn't able to pay her the full fee, but nevertheless I did pay her for the hours she spent in posing, and, thank God, so far I have been able to protect her and her child from hunger and cold by sharing my bread with her . . .

'It seems to me that any man worth a straw would have done the same . . . The woman is now as attached to me as a tame dove.

'I had thought I should be understood without words. I had not forgotten another for whom my heart was beating, but she was far away and refused to see me, while this one walked the streets in winter, sick, pregnant and hungry—I could not do otherwise. Mauve, Theo, Tersteeg, you have my bread in your hands, will you take it from me, or turn your backs on me? Now I have spoken, and I wait for what will be said.'

This was how Christien Hoornik, whom Vincent called Sien, had come into his life. She was thirty-two years old, ravaged by her life and by drink.

Louis Roetland [58] says they met early in December, during Vincent's first visit to The Hague; but in a letter written a few days after

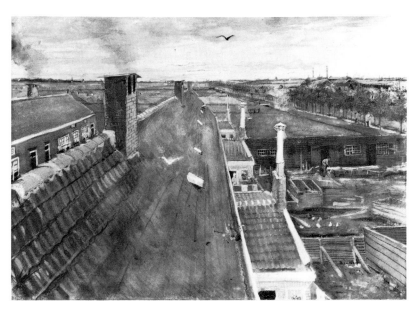

The Roofs. View from van Gogh's studio in the Schenkweg, July 1882.

Road near Loosduinen. The Hague, July 1882.

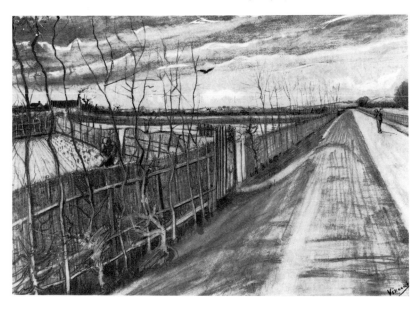

his confession, Vincent puts the meeting towards the end of January, perhaps so that Theo should not imagine the child to be his—for it was to be born in July. In any event, Mauve and Mr Tersteeg already knew of the affair, and had been on the point of telling Theo about it when Vincent decided to write to him. Vincent considered it his duty as a Christian to try to rescue the woman from hunger and degradation. He had no carnal love for women as objects and sources of pleasure; his subsequent relations with prostitutes were undertaken in the interests of his mental and physical balance. A woman was first and foremost a mother in his eyes. He thought of her in the words of Michelet, who wrote that 'woman is above all fruitful life' and regarded maternity as 'woman's great mission here below'. He had immediately proposed marriage to Ursula and to Kee. The former worked in a crèche, which he looked upon as a dignifying occupation, and the latter was bringing up a child, a little boy of four, of whom he was very fond. A childless woman, he quoted later on, 'is like a clapper without a bell,' and his distress at having failed to marry and found a family was so acute that it wrested from him a poignant cry:

'You can give me money, yes, but you cannot give me a wife and child!'[59]

With a woman at his side, sharing his life, Vincent was transformed. For her he denied himself what little he had, and he went with her to the maternity hospital at Leyden for a consultation about her pregnancy. Meanwhile, he was drawing a great deal; 'I am full of ambition and love for my work and profession.' Sien patiently sat to him. Mr Tersteeg, out of charity no doubt, bought ten drawings from him for a guilder, but advised him, if he wanted to sell, to choose more cheerful subjects and to change his style. In other words, he was asking Vincent to 'commercialize' himself, a thing Vincent held in horror, so that he angrily rejected the advice.

In March he had an unexpected pleasure. Uncle Cor, who was an art dealer in Amsterdam, commissioned 'twelve small pen drawings, views of The Hague . . . for two and a half guilders, my own price . . .; what's more, he promises to order twelve more if pleased with these.'

Vincent was writing to Theo every day, trying to persuade him that Sien was an excellent companion, despite her past life. Theo demurred,

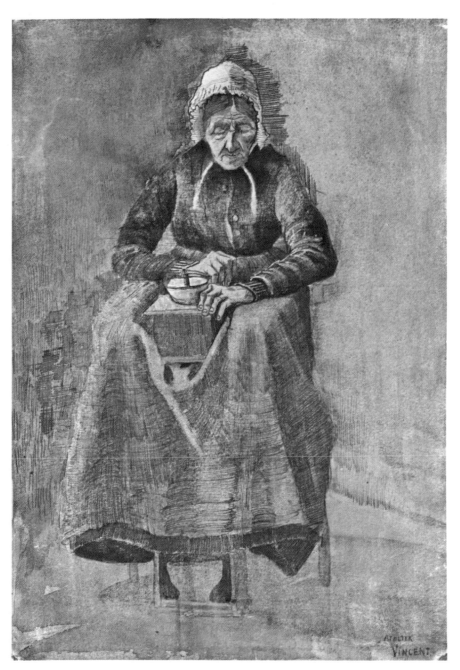

Woman grinding Coffee. 1881.

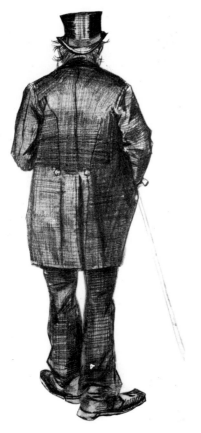
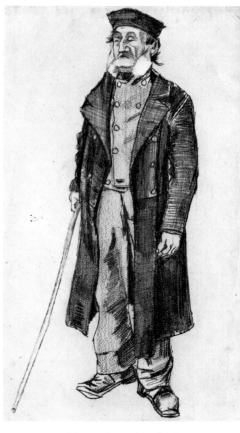

An Old Man from the Almshouse.
The Hague, October 1882.

An Old Man from the Almshouse.
The Hague, October 1882.

trying cautiously, affectionately, to win his brother away from the liaison. Fortunately his parents, who, incidentally, were now disposed to propitiate Vincent, knew nothing about it.

The drawings of Sien are deeply, harrowingly beautiful; two of them, both entitled *Sorrow,* for which she posed in April, when she was six months pregnant, and from which Vincent later made the celebrated lithograph of the same name, are among his first master-pieces. He sent one of these studies to Theo, and it is easy to imagine the latter's reaction to the sight of this woman with hair hanging loose and worn body. Below the drawing, Vincent had written a sentence by

Michelet: 'How can there be one lonely, neglected woman in the world?'

Sien's mother also sat to him. An old woman, accustomed to the most servile tasks, she sat for *The Widow,* a drawing made with pencil, pen and brush touched up with sepia, and for many other studies in which Vincent gives poignant expression to the harsh servitude of labour, the slavery of men and women bound to their heavy toil. All the drawings of this period reflect the same idea, which haunted him ceaselessly.

He was also painting and drawing in the districts of Geest and Slijkeinde, the Whitechapel or Aubervilliers of The Hague, with their squalid streets. The outskirts of the town inspired him too, and the charming little picture entitled *The Roofs,* with its sensitive, delicate colours, shows the view from Vincent's studio in the Schenkweg, painted in July. A few weeks later he set up his easel in front of the bleaching ground at Scheveningen, a neighbourhood where he painted some radiant pictures in marked contrast to his drawings, which were all sombre and harsh.

On 11th May 1882 Vincent wrote in a postscript: 'Theo, I intend to marry this woman, to whom I'm attached and who is attached to me. If this should unfortunately bring about a change in your feeling towards me, I hope you will let me know at least at what moment you will stop helping me, and that you will keep saying frankly and openly what you think. Of course I hope that this will not happen; that you will not deprive me of your help or withdraw your sympathy; that on the contrary we shall continue to join hands like brothers, not withstanding things which the "world" opposes.'

At the beginning of June Vincent went into hospital to be treated for gonorrhea, contracted from Sien; while there, he kept on with his drawing. As soon as he came out he hurried to Leyden, where Sien had just given birth to a 'very nice little boy'. He was radiantly happy, confident and hopeful. He even considered inviting his parents to visit him so that they should see 'the neat house and studio full of the things I am working on'. 'I think all this', he wrote to Theo [60], 'will make a better and deeper and more favourable impression on Father than words or letters.' And Theo too:

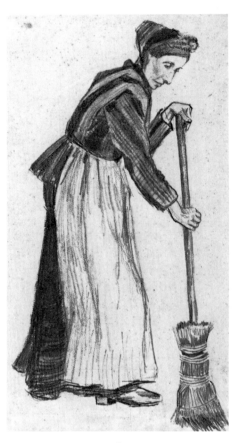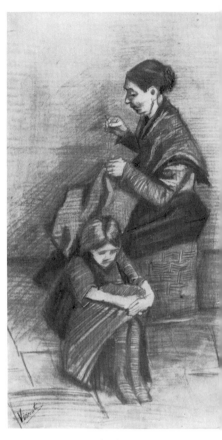

Woman sweeping. The Hague, 1881–83. *Woman and Child.* The Hague, 1881–83.

'When you come to see me you won't find me discouraged or melancholy, you'll come into a home that will appeal to you, I think, or at least won't offend you. A new studio and a couple still young and in full activity. It isn't a mysterious or mystical studio, for it is rooted in the very heart of life. It is a studio which contains a cradle and a baby's chair . . .'

And a few days later: 'And though it was only a hospital where she was lying and where I sat near her, it is always the eternal poetry of the Christmas night with the baby in the stable.'

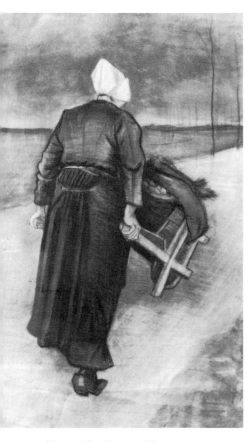

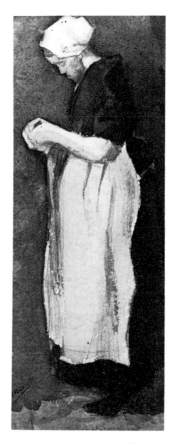

...asant pushing a Wheelbarrow. The Hague, 1881–83.

Fisherman's Young Wife.
The Hague, 1881–83.

The studio was at 136 Schenkweg, and contained Vincent and Sien, the baby and Sien's elder child, a little girl with rickets, whom he included in his affection. Vincent's heart overflowed with happiness in his 'family life'. He had no money, for whatever Theo sent was promptly swallowed up by the household expenses, but he worked from morning to night at vigorous drawings, and began colourful landscapes in oils, which would not have been out of place among the current output of the School of The Hague. Vincent would no doubt soon have achieved a certain local reputation as a landscape or figure

53

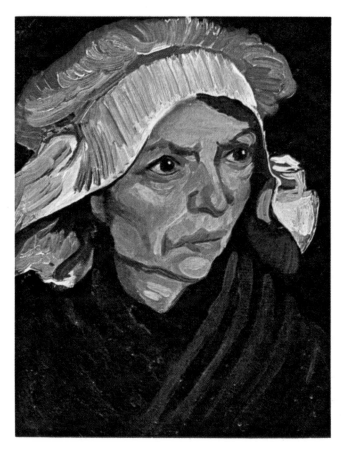

Peasant Woman. Nuenen, January 1885.

painter, but for his need continually to outstrip himself. The warmth and peace of his home gave him strength.

'In spite of poverty, we take the risk. Fishermen know that the sea is dangerous and storms are perilous. When a storm comes and night falls, which is worse? Danger, or the fear of danger? I prefer the reality, the danger itself.' [61]

To paint 'is my ambition; in spite of everything it is prompted less by resentment than by love, and more by serenity than by passion. While it's true that I am sometimes overwhelmed with worries, it is equally true that there is a calm pure harmony and music inside me. I

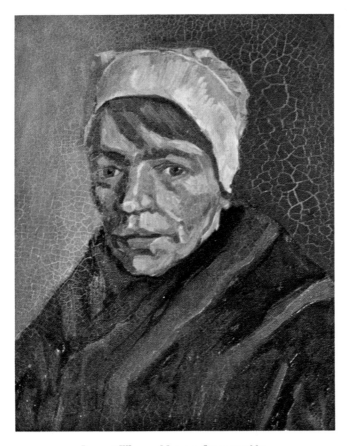

Peasant Woman. Nuenen, January 1885.

see drawings or pictures in the poorest little huts, in the dirtiest corner. My mind is drawn towards these things by an irresistible force.' [62]

Sien was his last chance, the chance for which he had ceased to hope after Kee's refusal. He believed with all his strength that 'what exists between Sien and me is *real*'. But here again, disillusion was soon to follow.

It was at The Hague, working beside Sien and the cradle where the new baby lay sleeping 'with a worldly-wise air' that the painter emerged from the confusion and hesitancy of those first years, deepening his vision, increasing his skill, undisturbed by the contradictory

55

influences of his favourite masters, by the theories of Mauve and his friends at The Hague. He was seeking in all directions, trying every technique and attempting to extract guiding ideas from his drawings of peasants and workmen, the ominous landscapes, the images of destitution or misery which he piled up as though he had taken a vow to express a despairing vision of the world, the grief of the human race, their hard life of toil unrelieved by hope.

'I want to do drawings which *touch* some people ... In short, I want to progress so far that they will say of my work: He feels deeply, he feels tenderly—notwithstanding my so-called roughness, or perhaps even because of it.' [63]

Vincent's enthusiasm for his work increased steadily, as though consolation and confidence were reaching him from his work itself. The outside world was hostile. Mr Tersteeg never tired of criticizing his behaviour, Uncle Cor had not liked his drawings and sent him only twenty of the thirty guilders for which he had hoped, Theo was urging

Men and Women at work, pushing Wheelbarrows and filling Baskets.
The Hague, April–May 1883.

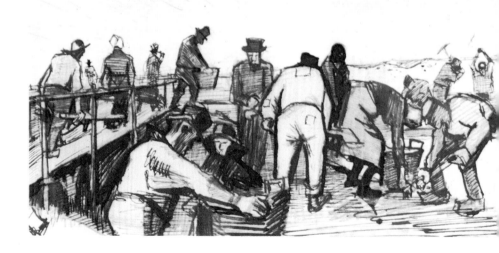

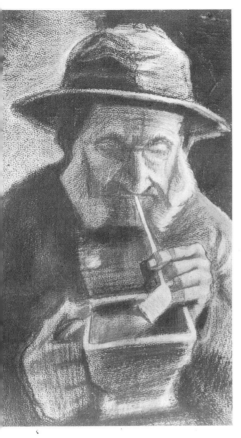

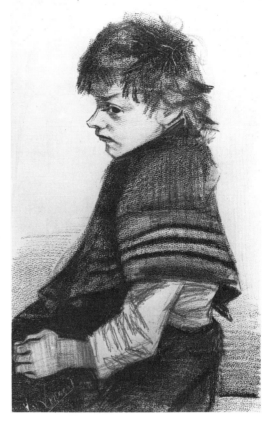

Old Sea Dog. The Hague, January 1883.　　　　*Seated Girl.* The Hague, January 1883.

him more and more strongly to break off his liaison. Had it not been for Sien and the child he could not have endured it. He wrote that people considered him 'a nonentity or an eccentric and disagreeable man, somebody who has got no position in society, and never will have, in short the lowest of the low.' [64]

Fortunately, Theo came to see his brother in August 1882. We do not know what passed between the two—whether, as Vincent hoped, his younger brother 'extended his affection to Sien'. But Theo must have been understanding and generous, for in a letter written 'still under the spell of your visit, not a little pleased to be able to go ahead vigorously

57

with my painting once again', Vincent remarks: 'I now regard myself as fortunate in comparison with thousands of others, because you have removed so many barriers for me.'

For months, Vincent continued to live and work side by side with Sien. He did not find his domestic responsibilities irksome, and his letters to Theo lavish praises on the young woman, although, as the year 1883 went by, her family began to try to persuade her to leave him, suggesting to her that Vincent would abandon her when he tired of using her as a model.

Autumn Landscape. Nuenen, 1885.

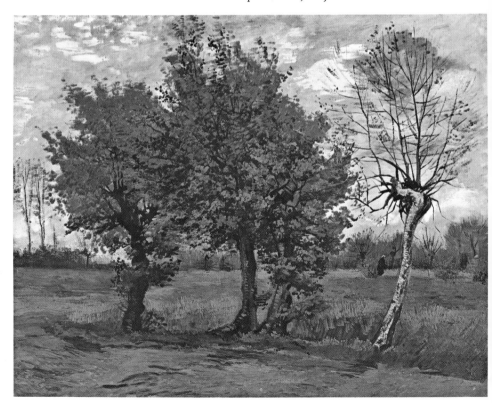

View from van Gogh's Studio Window. The Hague, March 1883.

Despite these troubles, and others such as lack of money and Sien's bad habits (she squandered Theo's monthly pittance on drinks and cigars), this period played a great part in shaping Vincent's life. He was reading an enormous amount—Zola, Hugo, Balzac, Daudet, Dickens, Carlyle and the *Lettres et Journal* of Gérard Bilders—and often spoke of his discoveries and impressions in his letters to his brother. Sometimes he mused over his early life, his native Brabant or the Borinage.

He had two spells of painting, one in the summer of 1882 and one a year later, in the summer of 1883. He began with a group, still very conventional in treatment, painted on the dunes at Scheveningen—little

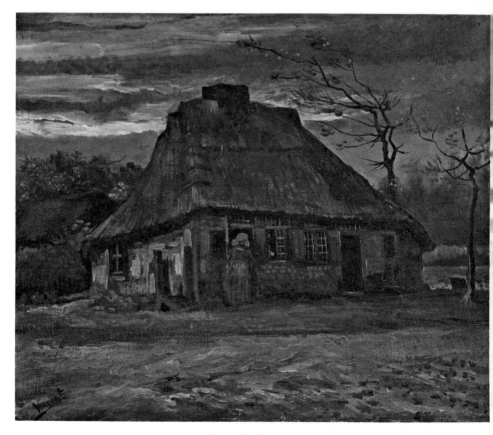

Cottage at Nightfall. Nuenen, May 1885.

seascapes, studies of fishermen, a group called *Mending the Nets,* and another entitled *Girl in the Forest.* His letters to Theo describe his efforts to render certain effects over which he was toiling like a zealous, conscientious beginner. At the same time he was discovering chiaroscuro and the play of values, varying his colours, adding bitumen and bistre to his palette. It was during his last days at The Hague that he painted his *Potato-diggers,* the sketch for a larger composition which he had not the skill to carry out.

Since he could not afford to buy colours and brushes, his efforts were still chiefly concentrated on drawing. He took as his subjects the old men in the almshouse, fishermen, café waiters, peasants at work, and

made sketches of the town's surroundings from his studio window. He also made drawings for which Sien posed, such as *The Great Lady*. In twenty months he produced a score of paintings and nearly two hundred drawings.

What interested him most, what he chiefly looked for, was movement; with this in mind he looked out the drawings he had made at Cuesmes, such as *Women carrying Sacks of Coal, Woman rocking a Cradle* and *Old Man collapsed,* and tried to make them more expres-

The Loom. Nuenen, May 1884.

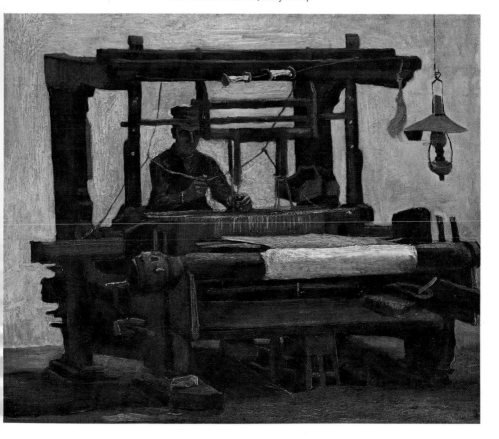

sive. Composition was still very difficult for him, and he generally drew single figures.

Vincent was collecting engravings; he particularly admired Daumier, but he also collected reproductions of work by Charles Jacque, Gustave Doré, Renouard [65]—of whom he had 'some forty examples, large and small'—Morin [66], Montbard [67], Millet, Jules Breton and the English illustrators of *Harper's Weekly* and *The Graphic*. In several letters written to van Rappart between the autumn of 1882 and the summer of 1883 he expresses his opinion of various artists, many of whom were then enjoying a reputation which was to be short-lived.

To van Rappart, in an undated letter probably written in October 1882, Vincent wrote, 'I assure you it is from my collection of woodcuts that I draw the courage to get back to work whenever I feel less inclined; then the energy, the will-power and the free, sound, playful spirit of all these artists pass into me; their work has a high, serious distinction, even when they draw a dung-heap.'

Did Vincent realize that Sien's case was hopeless, that he would never be able to rescue her from her devils? She was often drunk and neglected her baby; but the letters he wrote in the early months of 1883 give no hint of sufferings or fears. On the contrary, he offers Theo affectionate advice about how to treat a young woman in delicate health with whom the latter, now working at Goupil's in Paris, had fallen deeply in love.

Vincent's 'household' left him little spare time, little money and little strength, for his health was bad, he was having trouble with his eyes, and he felt himself being gradually overcome by 'a kind of weakness or weariness which is almost invincible'; but all that he had, he devoted to his work. 'I feel a power in which I must develop, a fire I may not quench, but must keep ablaze, though I do not know to what end it will lead me, and should not be surprised if it were a gloomy one. In times like these, what should one wish for? What is relatively the happiest fate?'

'In some circumstances it is better to be conquered than conqueror—for instance, better to be Prometheus than Jupiter.' [68]

Vincent drew scene after scene of humble life: paupers at the door of a soup kitchen and workmen with wheelbarrows, and landscapes,

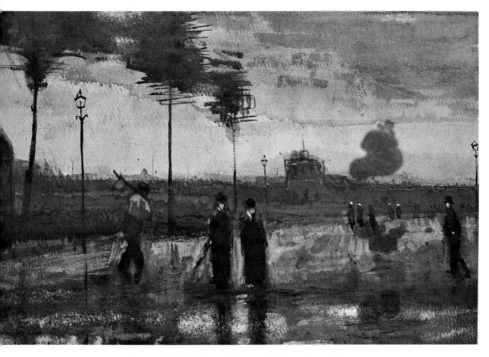

Street in Eindhoven. Nuenen, November 1884.

views of the suburbs or the beach and dunes. At the beginning of May he went to Utrecht to visit his friend van Rappart, who was ill, spitting blood; Vincent wanted to show him his work and to enjoy the warmth of friendship, a thing so rare in his life. He came back full of confidence and enthusiasm, and by the end of May he had four drawings in hand—*Les Bourbiers, The Sand-pit, The Refuse-dump* ('really a subject for a tale by Hans Andersen') and *Loading Coal*—of which he sent Theo long, detailed descriptions. On several days in succession he set off to work at four in the morning.

Theo still tried to persuade Vincent to leave Sien, who was again pregnant. Vincent did not dare to ask himself by whom, for he knew that in spite of all the love he had lavished on her she was not faithful to him. But his reserves of charity and forgiveness were infinite, his pity for Sien seemed to increase with each wrong she did him, and he could always find excuses for her.

Van Gogh's Studio in the Garden of the Presbytery at Nuenen.

To remove her from the bad influence of her mother and other relations, he ingenuously planned to 'settle with her in some small village, where nature would be continually before her eyes.'

The prospect of a country exile did not encourage Sien to mend her ways; she went on drinking, neglecting her home and children, and indulging in 'fits of unbearable bad temper'. Urged by Theo to put an end to his degrading liaison, Vincent at last began to think of parting from Sien; not, indeed, that his feelings towards her had changed or that he regarded his responsibility for her as over, but because he could not give her any more, and the thought harrowed him. Had he the right to leave her, considering that 'there is still a bond between us, in spite of everything?' Sien herself planned to get domestic work; Vincent, with or without her, would go to the Drenthe, a district in northern Holland, whose austere beauty had been described to him by van Rappart.

Vincent's concern was in vain. Sien and her mother wanted her to return to the life from which he had rescued her. Vincent confided:[69]

'Oh, Theo! you will understand how I feel these days; so very melancholy because of the woman and the children . . .

'She is not nice, she is not good, but neither am I, and there was a serious affection just the way we were, notwithstanding everything. I must set to work and hope to hear from you soon.' In a postscript Vincent mentions that he 'will go on placing advertisements for as long as it is necessary and do all I can to be useful and helpful to them. If I *can* do so, I shall pay a few weeks' rent for them before I go to give them more time to carry out their plan. But I did not yet *promise* that I intended to pay these things for them, because I do not know whether I shall be able to do so. It will depend on circumstances.

'And for her I strongly advise a marriage of convenience with a widower, for instance, but I have told her that in that case she will have to be *better to him than she was to me*.'

And in a later letter: 'Theo, my mind will not be easy about her when I go. I am anxious because I know she will wake up only when it is too late, and have an ardent desire for something simpler and purer only when the moment to attain it is past.'

Vincent left The Hague. 'I must go forward, otherwise I shall sink too, without getting any further.' The autumn light fell on red roofs, workshops, fields, trees and factory chimneys as Vincent looked out, for the last time, from the window of his studio in the Schenkweg, where he had lived for nearly two years and which he had long believed would be the setting of a happy life for him. One of his few friends at The Hague, a young surveyor named Furnée who used to go out painting with him on Sundays, came to fetch him and accompany him to the station. He was parting from Sien because 'it is really impossible to trust her'.

Vincent went to Hoogeren and from there to Nieuw-Amsterdam, in the Drenthe, where he spent two months, drawing and painting melancholy landscapes which reflected his state of mind. He was transported by the sombre beauty of his surroundings, a region of harsh contrasts where 'everything melts into an exquisite range of greys'. He worked wherever his walks led him, at Stuifzand and Zwartschaap, drawing 'shepherds, furnaces, turf-thatched cottages' or sometimes 'Ostade types' with 'faces like pigs or crows'. As he could not find the

right models to finish his large composition, the *Potato-diggers*, begun a few months before, he made the best of what came to hand. But he still grieved for Sien.

'Theo, when I meet on the heath such a poor woman with a child on her arm or at her breast, my eyes get moist. It reminds me of her, her weakness; her untidiness, too, contributes to making the likeness stronger.'

'. . . How much sadness there is in life! But one must not give oneself up to melancholy, one must seek distraction in other things, and the right thing is to work.' [70]

Before his supply of colours gave out he painted several canvases, including *Peasants burning the Grass, The Peat-boat,* and *Cottages with Mossy Thatch,* and he made about a dozen drawings. He read 'a very beautiful little book of Carlyle's,' *Heroes and Hero-Worship.* He felt that he was at the start of a new period in his life, that there was a change in him. His surroundings 'ordered, fixed, regulated, renewed, enlarged' his thoughts.

Winter was drawing in. The sky was leaden and darkness came early to this grim, lonely countryside where the shadows took on fantastic shapes, and distressing memories continued to wring Vincent's heart. Fortunately his father, who had been sent to Nuenen, was in a mood for reconciliation and sent for him. The prodigal son, at the end of his strength, set out in December for Brabant, the scene of his childhood, arriving exhausted and miserable. His family's welcome was cool, and not altogether trustful. 'They feel the same dread of taking me in the house as they would about taking a big, rough dog. He would run into the room with wet paws—and he is so rough. He will be in everybody's way. *And he barks so loud.*' [71] Relations with his father were uneasy, as Vincent felt he was not understood.

His painting was as sombre as ever, for this was 'the period of poor people, dark landscapes, resigned things.' [72] He fitted up a studio for himself in the house of the sacristan of the Catholic church—which did not improve his standing with the Protestant community—and set to work drawing and painting weavers and other humble people.

On 17th January Vincent's mother broke her leg in getting out of a train. Vincent cared for her devotedly, interrupting his work on stud-

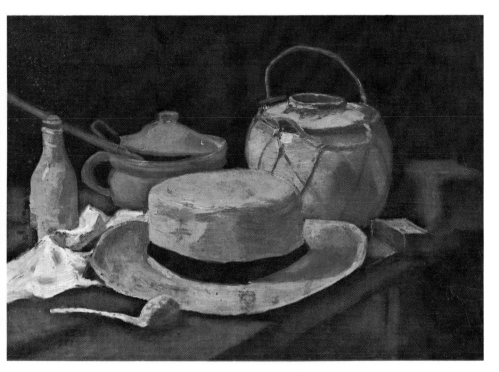

Still-life with Hat and Pipe. Nuenen, 1884–85.

ies of weavers, and painting a picture of the little Protestant church at Nuenen with its hedge and trees for her. But the truce did not last, and Vincent's quarrels with his father about religion became more and more frequent and violent. Vincent's gloom deepened and he began to write critical, carping letters to Theo, accusing him of being a mere financial protector towards himself and of following in the footsteps of their father.

February was mild; Vincent went out to paint a little country grave-yard and made some pen drawings of weavers. He was rebuked by his family for making no effort to sell his work, but as he wrote to van Rappart, 'this question leaves me indifferent, since I am concentrating all my strength on forging ahead.' The villagers at Nuenen looked at him askance—a shabby, unwashed dauber whose bursts of anger could often be heard beyond the walls of his home. His untidy studio, a

jumble of strangely-assorted objects, deepened their suspicion. One day he received a visit from a local tanner named Kerssemakers. Vincent's work gave the man a shock, he found himself afterwards seeing 'his studies in my imagination all the time'. He went again to visit the painter, being 'as it were drawn towards him'. Intrigued but doubtful, he did not hesitate to inform Vincent that in his opinion 'he could not draw or completely neglected the drawing of figures . . .' Whereupon Vincent laughed and replied: 'You will think otherwise later on.'[73]

Van Rappart came to Nuenen in May. He expressed unqualified admiration for Vincent's paintings, and greatly cheered and encouraged him.

The Wood Sale. Nuenen, January 1884.

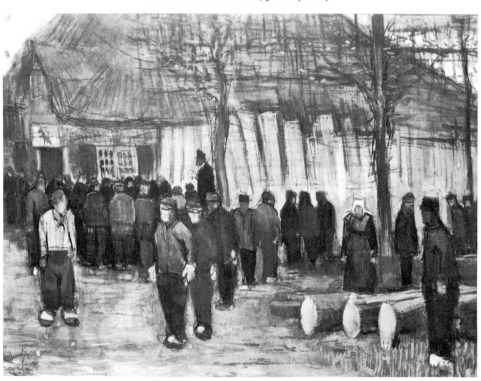

The dark violence of these scenes of village and peasant life astonished van Rappart even more than the deliberately ascetic existence Vincent was leading.

Vincent's interest in technical problems was growing steadily; he had turned his attention to colour-relationships, and during the summer of 1884 he wrote frequently to Theo and to van Rappart, describing his impressions, expressing his views and making criticisms. At first, he had taken the 'local tone' as his guide in painting, but now, little by little, as he discovered each successive problem for himself, he began to grope over what for him was unexplored territory, noticing that 'a reddish-grey, hardly red at all, will appear more or less red according to the colours next to it. And it is the same with blue and yellow.' Consequently, 'One has to put but a very little yellow into a colour to make it seem very yellow, if one puts that colour in the middle of or next to a violet or a lilac tone.' [74]

He was reading two books by Charles Blanc, *Les Artistes de mon temps* and *Grammaire des Arts du Dessin*, books on art by Fromentin, the Goncourts, etc., and advised van Rappart to read the poems of François Coppée or Jules Breton.

This period of intense study was disturbed by an unforeseen event. Margot Begemann, the daughter of a neighbouring family, fell in love with Vincent. She was about forty years old and not at all pretty, but full of admirable qualities. She had had a lonely life, with good works as her sole occupation, and, like Vincent, she was driven by the desire to devote herself to others. All Vincent's old enthusiasm awoke in response to this unaccustomed affection, and he and Margot became deeply attached to each other and spoke of marriage. But this was reckoning without the Begemann family, who felt that Margot was disgracing herself. Margot's nerves were far from steady; in her distress she poisoned herself with strychnine and had to be rushed to a clinic at Utrecht, where Vincent went to visit her. Bitterly Vincent blamed society and orthodox religion for ruining her life by their harshness.

In October van Rappart again visited Nuenen. This was fortunate, for the local people blamed Vincent for Margot's attempted suicide and would have nothing to do with him. But in the neighbouring

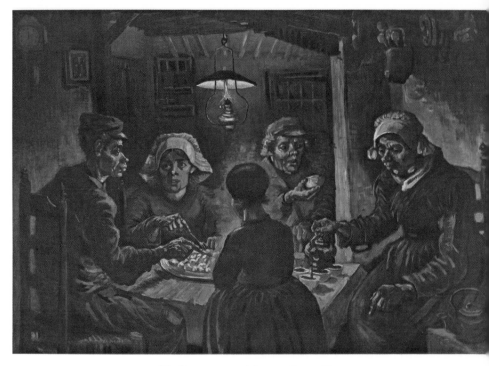

The Potato-eaters. Nuenen, May, 1885.

village of Eindhoven he had made two friends, the tanner Kersse-makers and a retired goldsmith called Hermans; delighted to make himself useful, Vincent was giving them lessons in painting—even some-times taking the brush from their hands, as Kerssemakers related in after years.

Meanwhile, Vincent himself had asked a local organist to give him music lessons,[75] he was also painting busily—the water-mill at Gen-nep, an old tower, some thatched cottages, a bullock-cart, peasants at work, and 'an avenue of poplars with yellow autumn leaves, and the sun casting, here and there, sparkling spots on the fallen leaves on the ground.' He decided to paint six panels of pastoral scenes for Her-mans' dining-room, Hermans supplying the materials. Vincent was more than ever eager to succeed one day to Millet's position as the out-standing painter of peasant life and, in addition, 'the guide and coun-

sellor of young painters in all things.' 'It has not been in vain,' he wrote, 'that I spent so many evenings at the houses of the miners, and peat-cutters, and weavers, and farmers, musing by the fire, unless I was too hard at work for musing.'[76]

All winter he kept on with his studies of peasants; it was his ambition to have it said of these, as it was of Millet's, that they 'seem to be painted in the earth they are sowing.' He also painted still-lifes composed with the help of 'beautiful objects' lent by Hermans—jugs, vases, pottery, clogs, copper basins, tobacco jars or birds' nests. Everyone around him interested him: blacksmith, basket-maker, a woman sweeping or grinding coffee, peeling vegetables or scouring a pot, or a man smoking his pipe or just sitting on a bench. He sometimes used lead pencil, at other times chalk, charcoal, water-colour or oils; in everything he did, he revealed an original and passionately sincere temperament. In the spring he wrote to Theo: 'I will not send the picture of the potato-eaters unless *I know for sure* there is something in it. But I am getting on with it, and I think there are things in it that you've never been able to see until now in my work, at least not so clearly, I mean the life especially. I paint *from memory on the picture itself.*'

On 26th March 1885, Pastor van Gogh died suddenly of a stroke.

Vincent had hoped to send *The Potato-eaters* (page 70) to his brother on 1st May as a birthday present; but at the end of April the picture was still unfinished. Vincent sent van Rappart a lithograph of it, printed at Eindhoven by Gertel, who had a workshop for printing cigar-bands. To his surprise, van Rappart's response was sharp criticism, ending:

'You dare to mention the names of Millet and Breton in connection with work like this? Oh, come! It seems to me that art is something too sublime to be treated in such an off-hand manner.'

The following day, Vincent sent this letter back. Although his pride was hurt he wrote to van Rappart on several occasions during the next few weeks. Their five-year-old friendship dragged on for a little longer, but it was dying, and their letters finally ceased.

The Potato-eaters was a kind of tribute to the peasant life whose painter van Gogh wished to be, and was at the same time the culmi-

nation of study and experiment which had gone on from October 1884 to the spring of 1885. Earlier versions include a small sketch on cardboard, showing four figures, which was made in March, shortly before the pastor's death, and two compositions with five figures, the first painted in April 1885 and the second, which is larger and more finished, in May. The first draft of the picture with five figures is described, with a sketch, in a letter written to Theo in late February or early March; and there are also several pencil and pen studies, with variations. It was in April 1885, between the two early versions, that Vincent made his lithograph, 'in one day, from memory'.

His letters to Theo and van Rappart tell the story of this painting —ending, in the case of the latter, after the lithograph had been sent. In May 1885 he wrote to his brother: 'I have tried to emphasize that those people eating their potatoes in the lamplight, have dug the earth with those very hands they put in the dish, and so it speaks of *manual labour*, and how they have honestly earned their food.'

During his last days in the asylum Saint-Rémy-de-Provence, three months before his death, Vincent tried to reproduce his picture from memory, making a drawing of it.

While the 'painter fellow' (*schildermenneke*), as they called him at Nuenen, was working at his potato-eaters, the village was making his life a burden. The Catholic priest forbade his flock to pose for Vincent, and it was even rumoured that he was the father of the child of a prostitute, Gordina, who had sat to him. So after living in the village for two years, he began to think of leaving it, either for the Drenthe or for some city where he could sell his work—such as Antwerp, or even Paris, where Theo, at his request, had shown a few of his brother's studies to the picture-dealer Portier, who admitted that they showed 'character'.

Vincent felt more self-confident than ever; his technique had become surer, and he was handling colour with mastery. 'My palette is thawing out,' he wrote triumphantly to his brother. 'I look on my studies simply as a kind of exercise to take me up and down the colour-scale.'

On 15th October 1885, Theo wrote to his sister Elisabeth: 'Vincent is one of those who have looked closely at the world, and he has with-

drawn from it. We must wait to discover whether he has genius. I believe so . . . If his work improves he will be a great man.'

Just at this time Vincent and Kerssemakers went for three days to Amsterdam, where they visited the museum. Vincent was in raptures. He wrote to Theo particularly of Rembrandt's *Jewish Bride*, painted *'d'un main de feu'*, *Captain Reynier Reael's Troop*, by Frans Hals, and two pictures by Israëls.

Before leaving Holland, where he was never to return, Vincent summed up the past few years in his last letters to Theo from Nuenen.

'Just now my palette is thawing, the barrenness of the early time is over. True, I still often blunder but the colours follow of their own accord, and taking one colour as a starting-point, I have clearly in mind what must follow and how to get life into it.

'. . . To study from nature, to wrestle with reality—I don't want to do away with it, for years and years I myself have done just that almost fruitlessly, and with all sorts of sad results. I should not like to have missed that error.

'. . . One starts with a hopeless struggle to follow nature, and everything goes wrong. One ends by calmly creating from one's palette, and nature agrees with it and follows.' [77]

A few days later, after long discussion of his mother's health and of the Goncourts' book *L'art au XVIIIème siècle*, Vincent writes:

'As I have been working absolutely alone for years, I imagine that, though I want to and can learn from others, and even adopt some technical things, I shall always see with my *own eyes*, and render things originally.

'. . . I have painted continuously here *to learn painting*, to get firm notions about colour, etc., without having much room in my head for other things.

'. . . A painter's life is often hard enough.' [78]

The catalogue of his Nuenen period lists 240 drawings, all dealing with life in the country—outdoor scenes, interiors, still-lifes, portraits. There are approximately 180 paintings, nearly a quarter of Vincent's entire output; these include some fifty landscapes, about forty still-lifes, nearly a hundred figures or 'character' studies, and finally that magnificent fresco of the soil, *The Potato-eaters*. Nor is this list com-

plete, of Vincent's work at Nuenen we know only what he sent to Theo, took with him to Antwerp or placed in safe keeping. All the paintings and drawings left behind in his studio were sent to the paper-mill to be pulped, or scattered by junk-dealers. In May 1886, when Vincent's mother left Nuenen, packing-cases containing a number of his pictures were left with a pork-butcher at Breda, and subsequently sold by auction. A few of them were rescued by being knocked down to a Mr Mouwen, a local tailor. Perhaps no other artist in the entire history of painting has worked as hard as did van Gogh at Nuenen.

Had Vincent been calmer, more balanced, and less conscientious— had he made more effort to show his work and sell it before getting as far as he wished, he could perhaps have found a niche in The Hague school of painters. His inspiration and technique were similar to theirs, but he had more passion, a more ardent vitality than those of its members to whom he came closest, such as Suze Robertson and Breitner. He would no doubt have been warmly accepted among them; the exhibition of their works at the Municipal Gallery in Amsterdam in 1948

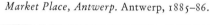

Market Place, Antwerp. Antwerp, 1885–86.

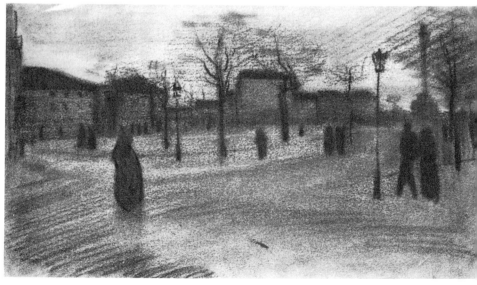

included many painters whom Vincent admired and often spoke about —Bosboom, Israëls, Weissenbruch, the Maris brothers, Mauve, S. Robertson, Breitner. The painter whose work was an act of social faith reflecting humanitarianism, indignation at working class conditions and Protestantism was quite in the tradition of Dutch painters—men like van Ostade, Pieter de Hooch, Vermeer and Peter Aertsen, the last named of whom, especially, was a penetrating interpreter of peasant life. But Vincent had actually lived among the miners and shared their hardships, and the work he did in Holland was at once a cry of horror and an appeal.

Before becoming one of the masters of French painting of the end of the 19th century, he had shown his own country that there would be a new form of expressionism, based not only on the observation of life, but on bold innovations of form and colour as well, and developing out of national traditions, of which Sluijters, Toorop, and later Hendrik Chabot were other exponents.

But he could not and did not stop there. The Nuenen period was only a stage in his progress; he was to fulfil himself elsewhere, in the bright light of the south, where he found his artistic element and his creative powers could expand. Still, it was in Holland that he became a painter, it was there that he found his means of expression and his impulses were formed. 'Who are you?' someone asked him at Antwerp, and he answered: 'I am Vincent, a Dutch painter.' [79]

He left Nuenen for Antwerp on 27th November 1885. 'It will be especially a matter of hard work,' he wrote to Theo before leaving the village. 'But there is something curious in the very feeling that one has to enter the fight.'

ANTWERP
28th November 1885—February 1886

Vincent soon found a small room for twenty-five francs a month at 194 Rue Longue des Images. He was almost penniless and ate practically nothing, spending his days in the art gallery, where he discovered the dazzling paintings of Rubens, with their singing, vibrant, shimmering colours and the baroque gusto of entwined bodies flooded with

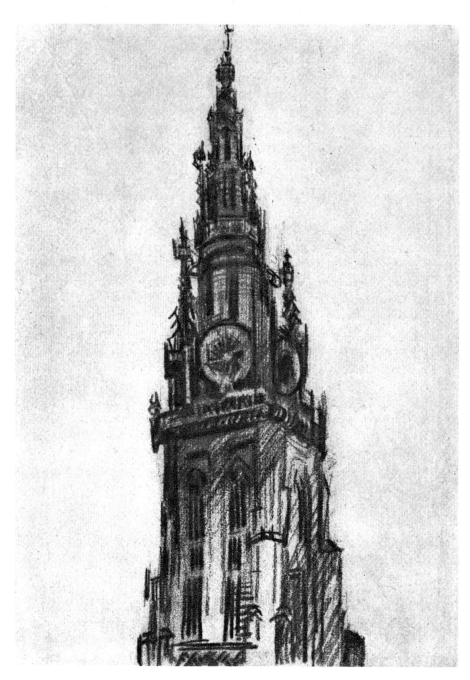

A Steeple. Antwerp, 1885–86.

light. He came without transition from the placid interiors, the soft, golden glow, the withdrawn piety of the Dutch painters to this profusion and exuberance, magnificence and rapture, just as he emerged from his peaceful village on the lonely heath, from the silence of winter in the countryside, to a large, turbulent, colourful octopus of a city with a cosmopolitan and noisy population.

He walked, keenly observant, about the harbour among the sailors, dockers and prostitutes, he wandered into drink-shops where a pianola would be jangling while women of every colour gossiped in every conceivable language, offering their charms amid peals of laughter, or heaping insults on one another.

'I have walked along the docks and quays in all directions,' he wrote to Theo. 'Especially when one comes from . . . a country village where one has been living quietly for a long time, the contrast is strange. It is an incredible confusion . . . Those docks are a famous Japonaiserie, fantastic, peculiar, unheard of—at least one can take this view of it . . . I mean the figures are always in movement, one sees them in the queerest surroundings, everything fantastic, and at all moments interesting contrasts present themselves.' [80]

Knowing himself well, he wrote: 'Well, it will never hurt knowing Antwerp a bit; it will probably prove to be like everything everywhere, namely disillusioning but with its own atmosphere.' [81]

He began by painting some views of the town, chiefly the cathedral and the harbour. Then, his brother having sent him a little money, he was able to take on a model, a girl from a café-chantant, a 'live Rubens' with splendid black hair, whom he tried to show as 'both voluptuous and at the same time cruelly tormented'. The paintings he had brought with him from Nuenen he now thought too sombre. From his window he painted a view of the old quarter of the town which seems touched by a new gentleness.

On the wall of his studio Vincent pinned Japanese prints. More than twenty years later than Baudelaire, after Manet, the Goncourts and Degas, he wondered at the naive charm of these pictures, their clear colours, with no half-tones or transitions. In this makeshift studio he produced several self-portraits, the earliest so far as we know. Some of them are painted in oils, others drawn; all show him with tense fea-

tures and an energetic, strained expression. To the end of his life, Vincent never gave up this anxious questioning of his own face.

At the same time he was drawing landscapes, views of the Steen and the cathedral; but he much preferred figure studies. Unhappily he lacked money to pay his models; he considered offering the finished portrait in return for sittings, but with one exception his models were not appreciative of his work. He wrote to Theo: 'If I paint peasant women, I want them to be peasant women; for the same reason, if I paint harlots I want a harlot-like expression.' [82] His realism was without concessions, but his palette grew lighter as he gradually emerged from the murky period of Nuenen and The Hague.

He was tormented by his dependence on his brother. But when he took a view of *Het Steen* to the picture-dealers, 'two of them were not at home, one did not like it, and one complained bitterly that in a fortnight literally not a single person had shown his face in the shop.' The anxiety exasperated him, and Theo, who had put off sending him a small sum of money in order to pay some bills of his own, received reproaches which he did not deserve, especially as he had just sent his brother a money-order for 150 francs.

'Am I less than creditors? — who must wait, they or I? If one of us must wait, which belongs to the human possibilities . . . A creditor is *no friend*, to be sure, and I, even if you do not know it *for sure*, at least I am perhaps. And do you realize how heavy are the burdens which the work demands every day, how difficult it is to get the models, how expensive the painting materials are? Do you realize that sometimes it is almost literally impossible for me to keep going? And that I *must* paint; that too much depends on continuing to work on here with aplomb, *immediately* and *without hesitation?*' [83]

The two pictures by Rubens in the cathedral, *The Deposition from the Cross* and *The Elevation of the Cross,* greatly interested Vincent, although 'nothing touches me less than Rubens expressing human sorrow,' he wrote to Theo. 'Rubens is extraordinary in painting ordinary beautiful women. But he is not dramatic in the expression.

'But I still love it because he is the very man who tries to express, and succeeds in expressing, a mood of cheerfulness, of serenity, of sorrow, by the colours, even if his characters are sometimes hollow, etc.

'And it is really very interesting to study Rubens, because his technique is so very simple or rather seems to be so. His means are so simple, and he paints, and particularly draws, with such a quick hand and without any hesitation. But portraits and heads and figures are his speciality. There he is deep and intimate too.'[84]

Vincent had never felt so certain of being on the right path, even though his days were a succession of mistakes and failures. From this time on, the man and his work were fused together, his fate was that of his painting. Vincent was to spend his four remaining years not in living, but in struggling to keep himself alive in solitude and poverty in order to create.

Vincent often spoke of his destiny and his brother's as inseparable. Theo came more and more under the strong spell of his brother, with his combination of fanaticism and lucidity. It finds expression in a curious letter where Vincent refers to 'Theo the mother' and suggests a 'lawful' union between them, the fruit of which will be his own work.

It was by means of colour that Vincent gave full expression to his visionary power. His paintings, like his sermons earlier, shocked because of their unconventional boldness. But what concerned him for the moment was to take Rubens as his example and shake off his 'black' style of painting, and he was making a close study of the action of complementary colours, as a first step towards this liberation. Not that he regretted his apprenticeship; indeed he was grateful for the example of the Dutch artists with whom he had worked, and realized that 'one has to search for a long time to find the light.' Following his instinct, he took the path of painstaking, persistent study and meditation; he scrutinized the works of the masters, read what the critics had to say, compared and commented upon all he saw. His painting emerged from all this as a great revolution results from piecemeal conquests.

The van Gogh 'miracle' is a figment of the imagination of some of his biographers. His work was the outcome of toil, striving, reflection, disquiet, endurance and courage. His strange personality and his 'madness' are not to the point. The latter part of his existence was fed by the ferments of the earlier period—the lessons he had learnt, the examples he had seen, before coming to Antwerp. What he learned from his disappointments and failures he used to fertilize his work.

In order to buy colours and brushes, Vincent was practically starving himself—eating nothing but bread and smoking all the time to take his thoughts off his hunger. Thus weakened, he had spells of dizziness and violent pains in the stomach. 'We will try and remedy it', he wrote to Theo. 'You see I am not stronger than other people in that if I neglect myself too much, it would be the same with me as with so many painters . . . I should drop dead or worse still—become insane or an idiot.' [85]

The memory of his vexations and adversities at Nuenen caused him suffering, and he was going through 'a period beset with difficulties', added to his health troubles; but he was 'in good fettle all the same' and planning to concentrate on the study of the nude. He was greatly consoled by a doctor whom he had consulted 'about a few things which sometimes made me fear that I was not long for this world.' Vincent spoke of his constitution in general, and the doctor, taking him for an ordinary workman, said 'I suppose you are an ironworker.' 'That is just what I have tried to change in myself,' wrote Vincent jubilantly. 'When I was younger, I looked intellectually overwrought, and now I look like a bargeman or an ironworker. And to change one's constitution so that one gets "a tough hide" is no easy matter.' [86]

Unhappily he still had no money to pay for models. The best thing seemed to be to enter the Academy, and he was advised by the director, Verlat, to enter the painting class. He was admitted on 18th January 1886.

Vincent cut a strange figure among the students, with his gaunt face and fixed gaze, cattle-drover's blue smock and fur cap, 'a short pipe stuck in the midst of a tough, ill-trimmed beard,' to quote the description given by a fellow student, Richard Baseleer.

There were about sixty students in the class, including some ten Germans and a few Englishmen. Nearly all of them came from middle-class families, and were astonished by Vincent, with a board torn from a packing case for a palette. Victor Hageman, a fellow-pupil, has described Vincent's arrival. Two wrestlers were posing, and Vincent 'started painting feverishly, furiously,' laying on his paint so thickly that it dripped on to the floor. Verlat was dumbfounded.

'Who are you?' he asked.

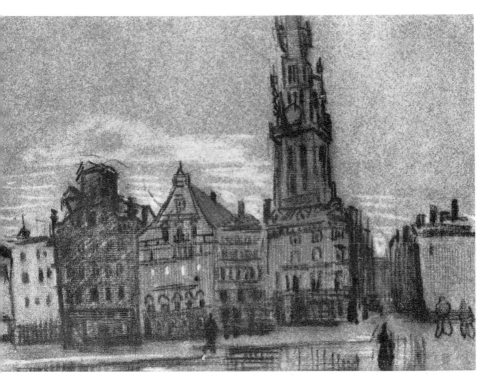

A Corner of Antwerp. Antwerp, December 1885.

'Well,' van Gogh replied, 'I am Vincent, a Dutchman.'

'I won't correct such mistaught dogs,' said Verlat. 'Go to the drawing class quickly.'

Vincent obeyed. The drawing class, run by the painter Eugène Siberdt, spent its time making copies from the antique. In the evenings he worked from the living model in a class directed by another painter, Frans Vinck. But here again he was pursued by the sarcastic or ill-natured remarks of the other students. He made only one friend, a young Englishman called Levens, who made a water-colour portrait of his emaciated, angular face with the hollow cheeks, beak of a nose and thin lips. This was no doubt the first time Vincent had been painted by a fellow-artist; the portrait was reproduced in the first number of the Flemish magazine *Van Nu en Straks,* but the original has vanished.

Vincent's health was bad and his work irregular. He now put to Theo an idea that had been maturing in his mind for some time—that he should join him in Paris. Theo did not refuse, but showed little enthusiasm. He knew he would have his brother completely on his hands, and also that Vincent was becoming more and more difficult to get on with. He suggested that Vincent should wait until July, but Vincent himself wished to move at once.

All the same, Vincent was glad he had come to Antwerp, for he was well aware that he needed to improve his technique. He found himself 'much too clumsy' in comparison with the other students at the Academy.

Another idea was developing in his mind, that of founding a studio with Theo, though he realized the difficulties of such an undertaking. 'And once we begin it, we must have a certain confidence, after all, left us after a long series of lost illusions.

'And such a studio—in starting it one must know that it will be a battle, and that most people will be absolutely indifferent, so one ought to begin it feeling confident of some power—wanting to be somebody, wanting to be active, so that when one dies one can think, I go where all those who have dared something go—well, we shall see.' [87]

He returned to the subject in a letter written a few days later, suggesting that they should postpone taking a studio for the first six months, but adding, 'I am very sympathetic to founding a studio, inasmuch as one might combine with other painters to take models together. The more energy the better. And in hard times especially one must look for friendship and co-operation.'

Vincent suggested that as soon as he came to Paris ('I'm impatient to revisit the Louvre, the Luxembourg, etc., where everything will seem new to me') they should take 'a room with an alcove and a garret or corner of an attic.'

He added [88] 'You could have the room and alcove, and we could make ourselves as comfortable as can be. And during the daytime the room would be used as a studio, and the garret would serve for various more or less unsightly implements, and for dirty work; besides I could sleep there, and you in the alcove . . . I don't know for certain whether we shall get along together, though I don't despair of it, but it will be

much more comfortable for you to come home to a studio than to an ordinary room which is always more or less dreary, and that dreariness is our worst enemy. The doctor advises me to try to get back my strength, and there's no doubt that you'd be wise to do the same. For you are not happy either, you don't feel in good form; let us call things by their names, you have too many cares and too little prosperity.'

'... For you too there will come a moment when you know for sure that all chance of material happiness is lost, fatally and irrevocably. I feel sure of it, but remember that at the same moment there will be a certain compensation in feeling the power to work within oneself.'

In another letter, written a few days later, he says:

'If we were together soon I should disappoint you in many things, that's certain, but not in everything, and not in my way of looking at things, I suppose.'

In Vincent's eyes, Theo and he were one, and he unhesitatingly assumed the right to know and criticize all his younger brother's actions. When Theo expostulated or objected, Vincent grew angry and heaped accusations and reproaches upon him, to which Theo submitted in silence. Indeed, with every day that passed, Vincent's influence on his life deepened, and his will asserted itself more strongly. As early as December 1883, Vincent wrote: 'Can Theo possibly be unconcerned about things that worry me?' And by this time he was saying: 'We need to live more fully, in my opinion; we must throw our doubts and our lack of confidence overboard.'

This identification was especially evident when Theo was suffering from ill-luck with women. Then Vincent would offer him advice on meeting the difficulties so familiar to himself.

On one occasion, in the summer of 1886, Vincent even went so far as to offer to replace his brother with a young woman who was causing him anxiety in order to relieve him of her, 'preferably *without* having to marry her, but if the worst comes to the worst, even agreeing to a marriage of convenience.' [89]

At the beginning of March Theo received a scribbled note: 'Do not be cross with me for having come all at once like this; I have thought about it so much, and I believe that in this way we shall gain time. Shall be at the Louvre from midday onwards, or sooner if you like.

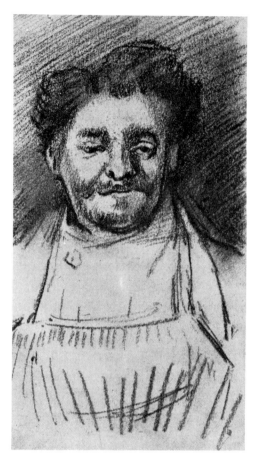

Man's Head. Antwerp, 1885–86.

'Please let me know at what time you could come to the Salle Car-rée. As for the expenses, I tell you again, this comes to the same thing. I have some money left, of course, and I want to speak to you before I spend any of it. We'll fix things up, you'll see.

'So, come as soon as possible.'

On a sudden impulse, Vincent had left Antwerp for Paris.

A few days earlier, at the Academy, he had taken part in a drawing competition which consisted in copying a plaster cast, a head of Germanicus. The results were not announced until several weeks after his departure to France. By the unanimous decision of the examiners he

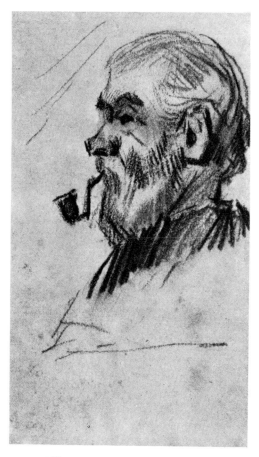

Old Man's Head. Antwerp, 1885–86.

was relegated to the beginners' class—a humiliation which never came to his knowledge.

When Vincent moved from Antwerp, he simply left most of his pictures behind him. Only a dozen have survived, including two self-portraits, some studies of men and women painted in a sweeping style, the paint thickly laid in light colours, several views of the town and harbour, some of them dark and gloomy, others vivid, with suggestions of colour laid on more lightly than hitherto, in small, flowing, rapid touches slightly reminiscent of the Impressionist technique. There are also a few still-lifes of ghoulish subjects, such as *The Skull with the*

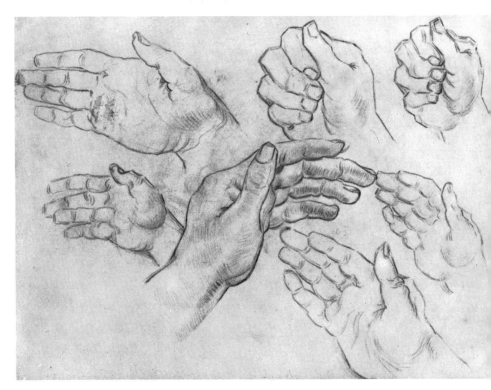

Sheet of Studies of Seven Hands. Antwerp, 1885–86.

Cigarette and the little drawing entitled *Dangling Skeleton,* which may have been prompted by the tales of Hoffmann or Poe. They recall the taste for morbidity of Flemish painters in the latter half of the 19th century—artists such as Antoine Wiertz, Félicien Rops and James Ensor.

According to Vincent's letters, he had also made a great many drawings and sketches, views of the Steen, various nudes and women's heads, studies from plaster casts and of heads and hands based on sketches by Rubens, and a number of scenes of street-life, quay-side cafés and dancehalls. Only about a dozen of these have survived.

Antwerp marked the first stage in Vincent's conquest of light, and in addition, he showed then the earliest signs of the Expressionism which was later to appear, through 'memories of the North', in the paintings at Saint-Rémy.

Antwerp was also the period of Vincent's first prophetic dreams: 'We are living in the last quarter of a century that will end again in a colossal revolution.

'But suppose both of us see its beginnings at the end of our lives. We certainly shall not live to see the better times of pure air and the rejuvenation of all society after those big storms.

'But it is already something not to be deceived by the falsity of one's time, and to scent the unhealthy closeness and oppressiveness of the hours that precede the thunderstorms.

'And to say, we are still in the closeness, but the following generations will be able to breathe more freely.' [90]

PARIS
March 1886—20th February 1888

Twelve years previously, a group of painters who had almost all had their work rejected for the Salon or disliked that institution for its narrow academicism, had held their first exhibition in the shop of the photographer Nadar, in the Boulevard des Capucines. The name 'Impressionists', given them by one of the critics, had stuck, though it referred to a technique adopted only by a minority, most of whom, moreover, soon abandoned it. But Impressionism stood for the victory of light, colour and life over the academicism favoured in official circles and by the public.

Vincent had been in Paris in the following year, 1875; there was no Impressionist exhibition that year, but on 24th March some pictures by the group were put up for auction at the Hôtel Drouot. In 1876 Vincent left Paris a few days before their second exhibition opened; but he often discussed the movement with Theo. His painter friends in Brussels frequently spoke of it too, and Vincent considered that no artist could ignore it.

At the beginning of 1886 the group—joined in the intervening twelve years by a number of new members, by no means all of whom had adopted the Impressionist technique—was about to hold its eighth and last exhibition.

Vincent met Theo at the Louvre according to plan, but was disap-

pointed to learn that he would not be able to work in Theo's flat in the Rue de Laval (now the Rue Victor Massé), which was very small. Since he could not set up a joint studio he had to make the best of it, and on his brother's advice he enrolled himself—Vincent the uncompromising individualist—at the most 'official' of all the studios, directed by Fernand Cormon, a vain and mediocre academic painter who specialized in reconstructions of prehistoric life, and enjoyed a considerable reputation. At the age of forty-one, this artist was a member of the selection board for the Salon, along with such painters as Bonnat, Bouguereau, Cabanel, Carolus-Duran, Detaille, etc., all of whom detested Impressionism and bright-coloured painting, which they regarded as 'filth' and a disgrace to French art.

Vincent had not learnt his lesson at the Academy at Antwerp, and had to go through the same humiliations and misfortunes again.

François Gauzi, one of Cormon's students, has left a description of Vincent's early days at the studio: [91]

'For a long time van Gogh contented himself with drawing; there was nothing eccentric about his drawings, no special tendency to make them remarkable; then, one Monday, he put a canvas on the easel; he was going to paint at the studio for the first time.

'On the model's platform was a woman seated on a stool; van Gogh roughed out his drawing quickly on the canvas and took up his palette.

'... Turning the stool into a sofa, he sat the woman [92] on a piece of blue material, a vivid, unexpected blue, which contrasted with the golden-yellow tone of her skin, juxtaposing fierce, unaccustomed colours which exacerbated each other. He worked in a spasmodic fury, throwing the colours on to the canvas with feverish haste. He scooped up the paint as though with a trowel and it trickled down the brush till his finger-ends were sticky with it. He did not stop painting while the model took a rest. The turbulence of his study astonished the whole studio and left the classicists dumbfounded.'

Emile Bernard, another of Cormon's pupils, then a boy of eighteen, caught Vincent one afternoon 'when the deserted studio became a kind of cell for him; he was sitting in front of a cast from the antique, copying its beautiful lines with angelic patience.' [93] Bernard stood watching in surprise; Vincent was so absorbed in his work that he had not

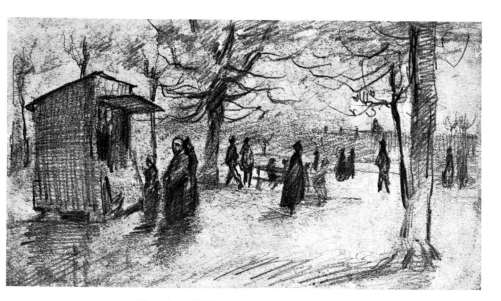

View of the Tuileries Gardens. Paris, 1886–88.

noticed him. 'He was determined to master those lines, masses and curves. He corrected, flung himself on the work again, rubbed out, until at last the indiarubber made a hole in the paper.'

Vincent became friendly with some of the students—Louis Anquetin, John Russell, an Australian, and especially a strange little man who waddled on spindly legs, a twenty-two-year-old aristocrat, polished and mocking, whose close-cropped hair topped an engagingly ugly face, and whose short-sighted eyes sparkled with intelligence and humour: Henri de Toulouse-Lautrec Monfa.

Toulouse-Lautrec had persuaded his parents to let him study the 'principles' of drawing and painting in Paris; but Cormon's principles struck him as tame and cold, and he said as much, bluntly, to the taciturn, unsociable Dutchman, who intrigued him considerably. They were joined in their discussions by Anquetin and Bernard. Vincent was far from being the most voluble, but his silences were often more expressive than the impassioned diatribes of Toulouse-Lautrec. He had left Antwerp to escape from the conservative teaching at the Academy . . .

'But it is even worse here!' Bernard would answer with impatience.

'Oh, don't worry!' Vincent would say, indicating the plaster casts, the subject of such endless copying, 'I don't want to become an antiquarian, but I hope I shall soon be French!'

In his eyes, France stood for light. Although it was winter, he had discovered in Paris an unusual brightness which enchanted him. He confided his enthusiasm to Theo, saying he found the city, its bustle, its life, far more interesting than on his two previous visits (October— December 1874 and May 1875—March 1876). During those few months he had seen little of Paris, for he was still suffering from his parting with Ursula Loyer and, when not working at Goupil's, would spend hours reading the Bible. But now that he had become a painter he had come out of himself, and was open to the wealth and beauty of the world.

Theo had a good position with Boussod & Valadon, in the Boulevard Montmartre; he showed fashionable pictures, but since his employers left him freedom of choice, he also exhibited the work of Renoir, Pissarro, Monet and Degas, which sold much less readily and at consider-

The Terrace of the Tuileries. Paris, 1886–88.

ably lower prices. Theo's was not an adventurous disposition, he did not defy convention. He was a peaceable, rather secretive man of settled habits; his emotional life, though by no means exemplary, was less stormy than his brother's, and was hidden behind a screen of rigid, almost priggish Protestantism. His taste was not outstanding, but he realized that Impressionism was a promising development, and this conviction lent him a power of persuasion and an enthusiasm which infected some of his customers; they would come in to buy a Henner or a Carolus-Duran and go away with a Pissarro or a Monet.

In Theo's eyes, Vincent was still at the stage of experiment and investigation and he was waiting to form an opinion until his brother should fulfil himself. He did not really understand Vincent's vehement, passionate character, and had the choice been his, he would no doubt have been glad to exchange Vincent's untapped genius for ordinary talent of a more placid and profitable type.

It was through him that Vincent really became acquainted with Impressionism, and he hailed it as the path of salvation. 'It is a necessary to go through an Impressionist phase as it once was to go through a Paris studio.' As a result, he stayed only three months with Cormon. Soon afterwards, when the studio was temporarily closed, Toulouse-Lautrec left in his turn.

A few days after Vincent came to Paris, Theo introduced him to Pissarro, one of the founders of the Impressionist movement, whom he had known since the previous year. Pissarro was in his early fifties; he had not yet achieved fame, but at least he was working in peace, living beside the Oise where the pearly light enchanted him. Pissarro was interested in Seurat's theory of the decomposition of light (illustrated by *Sunday at the Grande Jatte*—which, despite some opposition, was about to be shown at the eighth Impressionist exhibition in 1886), and he spoke to Vincent about this.

Vincent, for his part, showed his latest paintings to Pissarro, who looked closely at them but said nothing. In later years he said he had felt that Vincent would either 'go mad or leave the Impressionists far behind'. 'But I did not suspect,' he added, 'that both these presentiments would prove correct.' [94]

Vincent kept up his old habit of strolling, wandering about Mont-

martre, then a village huddling close to its church of Saint-Pierre and surrounded by a belt of gardens and vegetable-patches, interspersed with pleasure gardens and cottages in picturesque confusion. At the summit of the hill, where the sails of several windmills were still turning, the scaffolding that marked the erection of the Sacré-Cœur rose steeply above the quarries overhanging the Rochechouart district. The other side, the west, was a no-man's-land of wooden huts and thickets, with thieves' hide-outs and the studios of struggling artists. In his evangelizing days Vincent could have found plenty of tormented souls here—but those days were far away now. Yet the new Vincent was not so very different from the preacher of the Borinage; the 'St Francis of the mining villages' had simply channelled his gift for self-sacrifice into art. The brotherhood he had tried to establish through the Gospel he was now striving to express in his painting.

Theo often shared his brother's walks. They would go for lunch or dinner to the little restaurant kept by 'la Mère Bataille' in the Rue des Abbesses, where several painters were squeezed in shoulder to shoulder —among them Toulouse-Lautrec and a young Dutchman, André Bonger, known as Dries, whose sister Johanna was to become Theo's wife. Writers and politicians also came to the restaurant, including Clovis Hugues, Jean Jaurès, Catulle Mendès and François Coppée. At other times the van Gogh brothers visited the cafés up on the Butte or the brasseries on the Boulevards. These first months in Paris were a time of perpetual exploration for Vincent, but since the two brothers were living together no letters passed between them and we know less of the painter's impressions and plans than at any other period of his life.

Life shared with a man like Vincent van Gogh could be no bed of roses, as Theo soon found out. Repeatedly urged by his brother, who declared he could not work in the little flat in the Rue de Laval, he finally found rooms at 54, Rue Lepic. The brothers moved in in June.

The entrance was under an arch, down a paved alley lit by two old-fashioned street-lamps, through another archway and into a courtyard surrounded by walls faced with tiles that had lost their glaze; beyond this lay a big garden with lilacs and rose bushes. The van Goghs' flat was on the third floor. It had four rooms, three of them a good size, and a kitchen, with a view over Paris, its sea of roofs extending to the

92

View of Paris. Paris, 1886–88.

horizon. Vincent took the largest room as his studio. It contained '. . . a collection of quite good paintings of the romantic school,' wrote Emile Bernard[95], 'and a number of crepons, Chinese drawings and engravings from Millet. There was a big Dutch bureau, with drawers full of balls of wool, twisted together in the most unexpected colour-schemes; this large desk also contained drawing, paintings and sketches by Vincent himself. I was particularly struck by some Dutch scenes; everything was clear-cut, precise, vigorous and full of style, and those astonishing faces of working people, with their enormous noses, thick lips and foolish, savage expressions, of which *The Potato-eaters,* an appalling picture, was the outcome . . .'

During the summer Vincent often sat by the window to draw or paint the view of the city; or he walked down the quiet streets border-

ed by gardens, past little cottages hidden among leaves and flowers, across patches of waste ground striped with wide bands of ochre-coloured sand and dotted with street-lamps. He painted three pictures of the *Moulin de la Galette* in the Rue Girardon (page 97), its *buvette* a dull red, the yellow street and grey sky with the sails of the wind-mill. Gradually his palette became airier, brighter, and his drawing less ponderous—as in the canvas *Montmartre* (page 99), which shows a terrace edged with lamps, overlooking Paris. An opalescent mist softens the outlines, tones down the colours and gives a strange, ghostly aspect to a scene which, though not picturesque, has an engaging flui-dity and simplicity. Here Vincent shows how well he had perceived the subtle atmosphere of Paris.

We have nothing to tell us how Vincent spent his time in the winter of 1886—7, whether he was happy or depressed, anxious or melancholy, or whether he was satisfied with his work; all we know is that the Impressionists were influencing him more and more, and that he often went to look at pictures by Monet, Pissarro, Sisley and Seurat. A nude (see page 95), painted in the Rue de Laval, probably while Vincent was at Cormon's studio, shows an ugly woman lying on a bed with her arms behind her head; the twisted pose accentuates her misshapen figure.

Van Gogh seldom painted nudes; we only know of three drawings for which Sien posed in April 1882—*The Great Lady* and two versions of *Sorrow*— a lithograph of *Sorrow* made in November of that year, four paintings from the Paris period, and a few drawings.

In spite of some inevitable clashes with Theo, this must have been one of the most peaceful periods of Vincent's life; he had no money worries, he had friends, he was experimenting enthusiastically in his work, and the possibilities of colour were stimulating his creative in-stinct. He had given up the thought of love and a family, and his sexual needs were satisfied by the Montmartre prostitutes. Theo was doing his best to put up with this all-invading, tyrannical brother. During the summer of 1886 Theo wrote to his mother:

'We are very pleased with our new flat. You would not recognize Vincent, he has changed so much, and it strikes other people more than it does me... He makes great progress and has begun to have some success. He is in much better spirits than before, and many people here

like him ... He paints chiefly flowers especially to make the colour of his next pictures brighter and clearer. If we can continue to live together like this, I think the most difficult period is past and he will find his way.'⁹⁶

Vincent was alternating his flower-pictures with still-lifes and landscapes. About fifty paintings of bunches of flowers followed one another from the summer of 1886 to the spring of 1888, when he left Paris for Provence. 'Bunches of flowers offered him juxtapositions of colours which he practised until he could render any and every colour to be found in light, under any conditions,' wrote Théodore Duret.⁹⁷ '... They awoke positive emotion in him. If the pictures he painted of flowers could be placed in chronological order, they would show the changes that took place in his changing circumstances.'

The still-lifes also form a series throughout this period, though they

Reclining Nude. Paris, 1886–88.

were more frequent in the last six months of 1887. They also mark the appearance of symbolic themes in Vincent's work. *The Sunflowers,* 'spread out and curling over the table like germinating stars'[98], herald the blaze of sun at Arles; their power, still restrained, gives promise of future explosions. The *Pair of Boots*[99] (page 103) have a special meaning too; these down-at-heel objects recall the endless wanderings of the vagabond seeking in vain for a haven of rest. Vincent painted them four times during his Paris period, and before that he had done a *Still-life with Clogs.* Later, at Arles, he again painted a pair of shoes, and another pair of clogs. A *Still-life with Boots,* found and exhibited at Brussels in 1946, probably belongs to the Paris period.

The pictures entitled by Vincent *The Yellow Books (Parisian Novels), Still-life with Statuette* and *Still-life with Bread, Cheese and Wine* symbolize and bring together his two kinds of nourishment, intellectual and physical. In the *Still-life with Statuette* there is perhaps a connection between the naked female torso and the two novels, *Bel Ami* by Maupassant and *Germinie Lacerteux* by the Goncourts, in both of which the 'eternal feminine' plays the principal role. The Goncourts' book reappears later in a portrait of Dr Gachet, painted at Auvers.

The *Still-life with Bread, Cheese and Wine* offers evidence of Vincent's staple diet. In *Absinthe,* alcohol makes its appearance, as the painter's tribute to a new companion which was to be of increasing help to him. He had previously found a means of release in his letters to Theo; without them, he carried his need to confide and his taste for introspection into his work.

In the Borinage and the Drenthe he had depicted harsh toil in his studies of weavers, ploughmen and sowers, and nature had provided him with a melancholy or grim setting for human grief. Now he was thrown back on himself, to be henceforth the hero of the story of van Gogh the painter.

With what delicacy and subtlety he handles a subject such as *Fête at Montmartre,* producing a symphony of subtle, gay colours, where the line is of positively oriental elegance! He has travelled far from the gloomy thatched cottages of Nuenen to that brilliant masterpiece,

The Moulin de la Galette. Paris, 1886–88. ▶

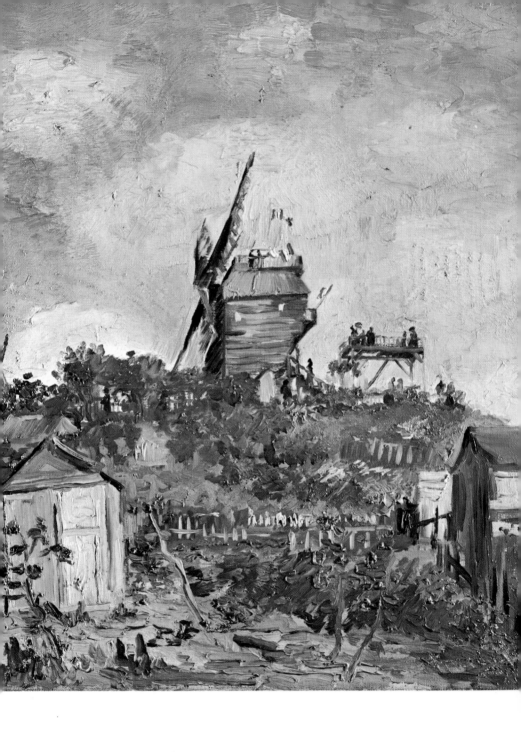

Little Gardens in Montmartre in Winter. He uses the Impressionist technique less rigidly, applying the colour in small, straight touches, using their direction as a means of holding the composition together and balancing it; the colours are harmonized according to the principle of complementaries. Vincent's quick eye has been well served by nimble drawing, and the whole picture has a poetic freshness; Vincent had given up 'black' painting and seemed to have dismissed his sad and gruesome subjects as well. He was finding great stimulus in his surroundings.

He exclaimed in admiration at the Rembrandts, the Delacroix, and the paintings by Rubens in the Galerie Médicis—while Seurat's *Sunday at the Grande Jatte* opened fresh colour-prospects to him. In Delarebeyrette's gallery in the Rue de Provence he discovered the lyricism of Monticelli, who had just died at Marseilles on 29th June 1886; and at Bing's, in the same street, he pored wonderingly over Japanese prints.

Vincent borrowed here and there what was best suited to his temperament, adapting it to his own outlook, striving to feel his way through to new concepts of art. Monticelli, above all, made an extraordinary impression on him. He painted some *Flowers in a Blue Vase* which were very similar to Monticelli's picture of the same name, where the touches of colour, laid on thickly, intertwine and cross one another in brilliant harmonies. [100]

He was prompted to curious pastiches or copies by the Japanese prints, with their meticulous line and their pure colours laid on flat; these include *The Bridge and Flowering Plum-tree*, after Hiroshige, and *Oiran* (The Actor) after Keisai Yeisen. The influence of these prints is also seen in the background of some of his pictures, such as the *Portrait of Père Tanguy*, the *Woman with the Tambourines*, *Self-portrait with Bandaged Ear*, *Self-portrait with Japanese Print*, etc. In this Vincent was like many other painters of his day, on whom Japanese art had a considerable influence; before him there were Degas, Manet, Whistler, Berthe Morisot, Mary Cassatt and Monet, and after him, Toulouse-Lautrec and the 'Nabis'.

Through his brother and the picture-dealer Portier, who had a flat on their floor in the Rue Lepic, Vincent had come to know most of the

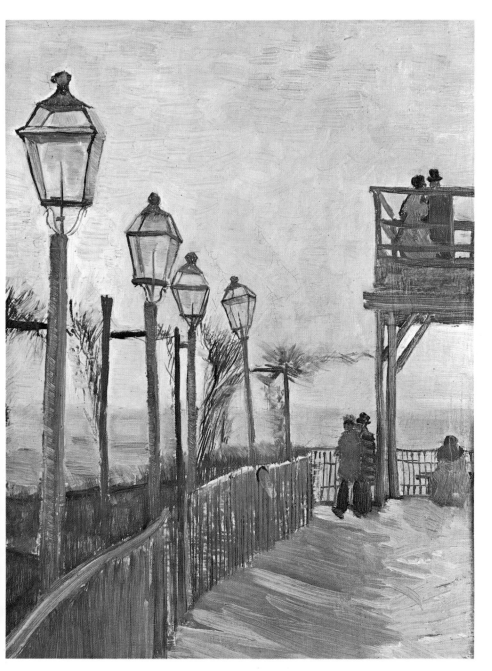

Montmartre. Paris, 1886.

Impressionist painters. He often visited Guillaumin, who lived on the Ile Saint-Louis, and spent hours at a time in his studio. Guillaumin was the steadiest and most level-headed of the whole group, and he found Vincent's almost perpetual excitability a little embarrassing; he admitted later that van Gogh's behaviour kept reminding him of Delacroix's picture, *Tasso in the Madhouse*. Gustave Coquiot relates that 'Vincent would tear off his clothes and fall on his knees to make some point clearer, and nothing could calm him down. So Guillaumin was always on the alert. One day in Guillaumin's studio Vincent noticed some canvases of *Men unloading Sand;* suddenly he went wild, shouting that the movements were all wrong, and began jumping about the studio, wielding an imaginary spade, waving his arms, making what he considered to be the appropriate gestures.'

In the autumn of 1886 Theo introduced his brother to the painter Paul Gauguin. Gauguin's rough, outspoken manner was in contrast to the modesty and hesitations of the Impressionists. Vincent was quite overpowered by his eloquence and confidence. It was then three years since Gauguin, at the age of thirty-eight, had thrown up family life and financial security, to embark upon his tumultuous career as an artist. He had just returned from Pont-Aven, in Brittany, where he had worked hard, penniless but determined not to swerve from his vocation, and van Gogh could not but admire a man who, though so different from him in many ways, was like himself in having given himself completely to painting.

After this the two men often met in some café, discoursing, arguing, clinking their glasses of absinthe in a cloud of pipe-smoke. And Vincent still thought of sharing a studio and working with a 'brother artist'. He could have made no more unfortunate choice than Gauguin.

Vincent paid frequent visits to a little shop selling artist's materials in the Rue Clauzel, behind Notre-Dame-de-Lorette. This was a meeting-place for young painters and for a few collectors of 'new painting'. It was probably Theo who introduced his brother to the owner, Tanguy, a former *communard* who now called himself an anarchist; he had ground colours in another shop before setting up on his own. In the first period of his independence he had peddled his materials round the countryside, making the acquaintance of Monet, Renoir, Pissarro

and Cézanne, who painted on the banks of the Oise. Vincent was able to see the work of most of the Impressionists in his shop, and soon he began to bring his own.

Père Tanguy believed in 'his' painters. He regarded Pissarro and Cézanne as unrecognized geniuses, who would sooner or later triumph. To them and to others he showed boundless generosity, letting them buy paint and canvas on credit, keeping open house for them, and generally encouraging and helping them in every possible way. At the first meeting he understood Vincent, and believed him to be the peer of the greatest. Later, he introduced him to the man who, in his opinion, surpassed all others—Paul Cézanne.

Cézanne, at the age of forty-seven, was as fiercely independent as Vincent; he was not easy to approach and it was unwise to contradict him, for his rage was terrible. Vehement, often rude, headstrong in his beliefs, furiously and passionately a painter, he had so far met with nothing but irony and insult. At Aix-en-Provence, where he was born and where his family still lived, he was considered by most people to be a failure and a little 'wanting'. This left him indifferent, since he had little regard for other people's feelings and opinions.

One afternoon, during one of his rare visits to Paris, he happened to be in Tanguy's shop at the same time as Vincent, who was dressed as usual in workman's overalls, gloomy faced, sucking his pipe and looking, as Coquiot puts it, 'really as though he were a little apart from all the rest of us'. Cézanne was always on his guard at the prospect of a new acquaintance, and regarded him suspiciously.

Vincent, who had often admired Tanguy's Cézannes, showed the painter some of his own work. Cézanne gazed in silence at the landscapes, still-lifes and figure studies. At length he said with a sigh: 'You certainly paint like a madman.'

Vincent wanted to show his pictures elsewhere than at Tanguy's. Portier, his neighbour, put some of them in his gallery, and Vincent himself hung several in the foyer of the Théâtre Libre, opened the year before by Antoine in the Rue de l'Elysée des Beaux-Arts, a sinister alley near the Place Pigalle. Two others who consented to show some van Goghs were Père Martin, who after beginning life as a bricklayer at Louveciennes had opened a shop in the Rue Saint-Geor-

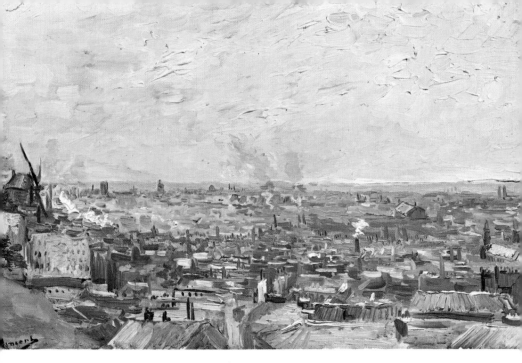

View of Montmartre. Paris. 1886.

ges, where he had been welcoming 'pioneers' for over twenty years, and a former wine-merchant called Thomas, who had premises in the Boulevard Malesherbes. The 'madman's' painting attracted only scorn and derision.

In a letter he wrote (in English) during the summer of 1886 to H. M. Levens, the young English painter he had met at Antwerp, Vincent summed up his first few months in Paris.

'. . . I have lacked money for paying models, else I had entirely given myself to figure painting. But I have made a series of colour-studies in painting, simply flowers, red poppies, blue corn flowers and myosotys, white and rose roses, yellow chrysanthemus, seeking oppositions of blue with orange, red and green, yellow and violet, seeking *les tons rompus et neutres* to harmonize brutal extremes. Trying to render intense colour and not a grey harmony.

'Now after these gymnastics I lately did two heads which I dare say are better in light and colour than those I did before.

'So as we said at the time: in *colour* seeking *life* the true drawing is modelling with colour.

'I did a dozen landscapes too, frankly green frankly blue.'

Vincent regarded Impressionism as a stage to pass through, not as an end in itself. His taste for research carried him beyond it, in the direction of Monticelli's explosive lyricism and the experiments with colour of Seurat and Signac; Vincent's work shows signs that he was inspired by the first of these painters and influenced by the two last named. He was also interested by Gauguin's treatment of colour, and Toulouse-Lautrec's realism can be traced in several pictures showing the night-life of Montmartre. But Vincent fully assimilated these trends in his work.

Still-life with Boots. Paris, 1886–88.

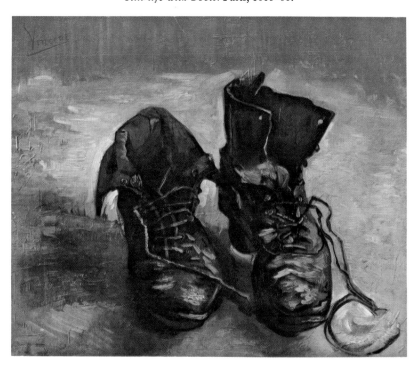

'However I have faith in colour,' he wrote to Levens in the letter quoted above. 'Even with regards price the public will pay for it in the long run. But for the present things are awfully hard.'

'... What is to be gained here,' he added, 'is *progress* ... I dare say as certain anyone who has a solid position elsewhere let him stay where he is. But for adventurers as myself, I think they lose nothing in risking more. Especially as in my case I am not an adventurer by choice but by fate ...'

While Theo was away on his yearly trip to Holland, Vincent expressed [101] great concern about a mistress his brother had left behind in Paris, and of whom he was trying to relieve him, even by marrying her himself if necessary.

Theo had met another young woman in Holland, and Vincent was urging him to marry her; but the plan fell through and Theo came back to Paris, his disappointment aggravated by his uncles' opposition to his scheme for setting up as a picture dealer in partnership with Bonger. Life in the Rue Lepic resumed its former course.

Vincent was still unable to sell his work. Since the 'bourgeois' visitors to the galleries did not want it, he would show it to the humbler public who, as he said to Emile Bernard, were usually offered nothing but 'vile colour-prints'. In contrast to the Impressionists, who had exhibited their work in or near the *grands boulevards,* he decided to form the *'groupe du Petit Boulevard'* with Gauguin, Seurat, Signac, Emile Bernard, Lautrec and Anquetin, and hold exhibitions in the Boulevard de Clichy where, he believed, the café public could be expected to take an interest in their paintings. He arranged their first exhibition in a huge, cheap restaurant. But again, it was a fiasco; the poor, like the rich, showed no interest in the works.

Vincent tried again, this time in a tavern, 'Le Tambourin', also on the Boulevard de Clichy. It was a disreputable place, run by a handsome young woman of Italian parentage, Agostina Segatori, who had posed for Corot and Gérome. Agostina was amiable, languid, and easy of approach. The establishment had not been open long, and Vincent had helped with the decorations, an odd mixture of tambourines decorated with verses and drawings, and Japanese prints that he provided. He painted two portraits of Agostina, the first a sturdy, forth-

right presentation foreshadowing the figures of his Arles period; the second, *Woman with Tambourines*, is softer and more vaporous, showing the influence of Toulouse-Lautrec and the Impressionists.

Agostina soon became Vincent's mistress, and he was enthusiastic about the prospects for art exhibitions held in this unlikely place. Toulouse-Lautrec chose the Tambourin as the setting for his portrait *Poudre de riz*, and made a pastel of Vincent seated at a table there, with a glass of absinthe in front of him. Among its other customers were Emile Bernard, Gauguin, who called it 'a real cutthroats' den', Anquetin, and a number of the artists and poets who lived on the Butte Montmartre—Caran d'Ache, Steinlen, Maurice Rollinat, Alphonse Allais and others. Vincent felt very much at home, and would hold forth and try to draw the other customers, rather surprised by his vehemence, into violent arguments. They soon left him to carry on his dissertations without contradiction. Gustave Coquiot noticed him one evening, arguing away by the side of a man whose dozing was constantly disturbed by Vincent's shouts 'as he threw his opinions in his face'.

The winter of 1887 brought cold, fog, melancholy and anxieties. The peace and security of the first few months were giving place to instability and over-excitement, which soon regained the upper hand. Vincent's impulsive character revealed itself in fierce invective, fits of rage, and reproaches that drove Theo to the verge of rebellion. In his exasperation he wrote to their sister Anna:

'My home life is almost unbearable. No-one wants to come and see me any more because it always ends in quarrels, and besides, he is so untidy that the room looks far from attractive. I wish he would go and live by himself. He sometimes mentions it, but if I were to tell him to go away, it would just give him a reason to stay; and it seems I do him no good. I ask only one thing of him, to do me no harm; yet by his staying with me he does so, for I can hardly bear it.

'It seems as if he were two persons, one marvellously gifted, delightful, gentle, the other egotistical and hardhearted. They present themselves in turns, so that one hears him talk first in one way, and then in the other, and always with arguments on both sides. It's a pity he is his own enemy, for he makes life hard not only for others but also for himself.'

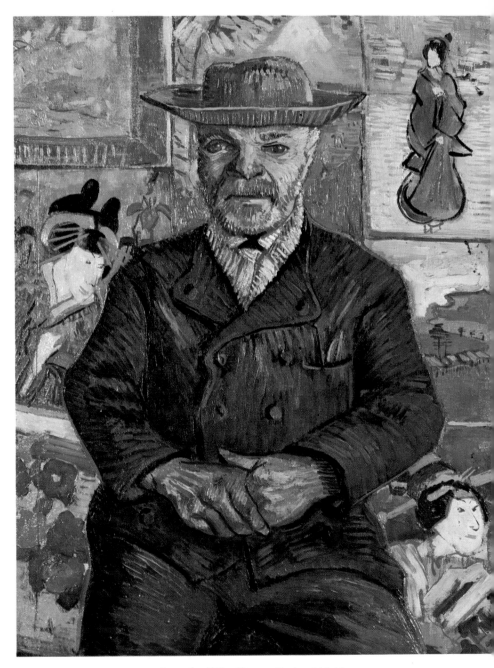

Portrait of Père Tanguy. Paris, 1886–88.

Anna replied urging Theo to leave his difficult brother, but he had not the courage. 'It is a peculiar case,' he wrote back. 'If only he had another profession, I would long ago have done what you advise me. I have often asked myself if I have not been wrong in helping him continually, and have often been on the point of leaving him to manage as best he could. I thought it over again after reading your letter and came to the conclusion that I shall just have to go on. There's no doubt he's an artist; even if what he makes now is not always beautiful, he will benefit by it later, and may do magnificent things. It would be disgraceful to prevent him from going on ... I'm firmly resolved to continue as I have done so far, but I do hope that he will change his lodgings in some way or other.' [102]

Very few of Theo's letters have been published by his family; most of them seem to have been sharply critical of Vincent. What we know about the latter makes this more than likely. This adds to the merit of Theo's devotion. But for his help, Vincent would no doubt have sunk rapidly into destitution.

When the winter was over, van Gogh began to paint again. 'He would set out from home with a big canvas on his back,' writes Emile Bernard, 'and divide it into compartments according to his subjects; in the evening he would bring it back, completely covered, like a little portable gallery where the whole day's emotions were recorded.' There were stretches of the Seine, crowded with boats, islands with blue seesaws, trim restaurants with colourful awnings and oleanders in pots; corners of some deserted park or estate up for sale. The poetry of spring breathed from these scraps, touched in so lightly.

Vincent's favourite places for painting were Asnières, Chatou and Joinville, with Signac and Bernard. The latter had a little studio in his parents' garden at Asnières, where the Dutchman painted one of his three portraits of Père Tanguy, who was posing for Bernard at the same time. He began a portrait of Bernard too, but 'having picked a quarrel with my father, who refused to take his advice about my future,' Bernard relates, 'he became so angry that he gave up my portrait and carried off Tanguy's unfinished, tucking it under his arm with the paint all wet.'

The pictures painted in Vincent's second Paris springtime are fresh,

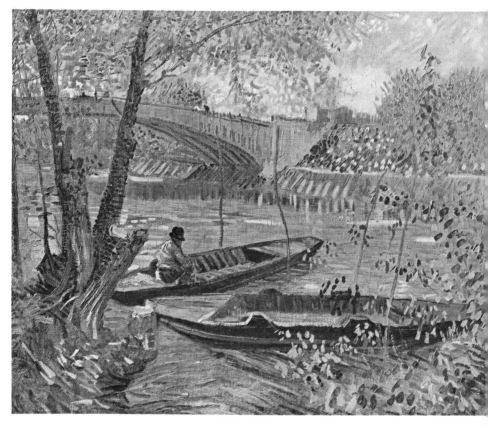

Fishing in Spring. Paris, 1886–88.

happy, full of colour. They include *Fishing in the Spring, Little Gardens on the Butte Montmartre*—exquisite in its subtlety, the masterpiece among those of his landscapes which were inspired by Impressionism —*The Boulevard de Clichy, Interior of a Restaurant*—where Seurat's influence is seen in the pointillist technique—*The Restaurant de la Sirène at Joinville* (page 109), and the extraordinary *Wheatfield Lark*.

'A stretch of corn bent before the wind, with above it the wings of a single bird placed like a comma—what painter, not strictly a painter, could, like van Gogh, have been bold enough to tackle a subject so disarmingly simple.' [103]

The passion for painting, now restored to him, did not slacken for a

moment. He was always out of doors, looking for a subject, loaded with 'a canvas so huge that passers-by thought he was carrying a sign-board' [104]; then sitting down in the open air, slashing at his canvas with great brush-strokes, growing more and more excited, even shout-ing and gesticulating, to the great alarm of any curious spectators. In the evening, as he walked back to Paris with Signac, he would wave the canvas about so carelessly in the heat of argument that he infuriated people by dabbing them with paint.

All the exhibitions at Le Tambourin were failures. And Vincent's

Restaurant de la Sirène. Paris, 1887.

affair with Agostina Segatori, though brief, left him embittered. To make his escape, Vincent left behind him the pictures then on the walls. As for Agostina herself, Vincent wrote [105]: 'She is in a bad way, being neither free, nor mistress in her own house, and worst of all she is ill and in pain.'

On 14th July the flag-decked streets prompted him to an amazing picture, a thing of broad, hasty brush-strokes, of harsh colours crushed furiously on to the canvas—Vincent van Gogh's first 'Fauve' painting.

Vincent's troubles were beginning again; Mme Tanguy was scolding her husband for his generosity towards him, and Theo's matrimonial plans had been revived, which threatened to put an end to their intimacy and, still more alarming, to Theo's financial help.

In another letter written in the summer of 1887, Vincent says: 'As for me, I feel I am losing the desire for marriage and children, and now and then it saddens me that I should be feeling like that at thirty-five, just when it should be the opposite. And sometimes I have a grudge against this rotten painting.

'... And at times I already feel old and broken, and yet still enough of a lover not to be a real enthusiast for painting. To succeed one needs ambition, and ambition seems to me absurd.'

For the first time he speaks of going away 'somewhere down south, to get away from the sight of so many painters that disgust me as men.' He concludes his letter by saying:

'And if you fall very much in love, and then get married, it doesn't seem impossible to me that you will rise to a country house yourself someday, like so many other picture dealers. If you live well, you spend more, but you gain ground that way, and perhaps these days one gets on better by looking rich than by looking shabby. It's better to have a gay life of it than to commit suicide.'

Vincent had already thought of suicide. After one of his violent quarrels with Theo during the previous winter, he had gone to share lodgings, we do not know for how long, with a young English painter, Alexander Reid, who was also learning the picture-dealing business. The two had met at Cormon's studio and made friends at once; they were very much alike and were often mistaken for one another. Vincent painted two portraits of this friend.

Cornfield with Lark. Paris, 1887.

It was no doubt while living together that they suddenly had the idea of a joint suicide[106], Reid on sentimental grounds and Vincent impelled by his money worries. Fortunately they did nothing to put the idea into action.

During the summer or autumn of 1887, Vincent wrote a long letter to Willemien, the only one of his sisters with whom he kept up a fairly regular correspondence. At the time of his devotion to Kee, Willemien had tried to help him by reporting that young woman's comings and goings; and during his equally fruitless courtship of Margot Begemann, 'Will', as she was called, showed an affectionate understanding of Vincent which he never forgot. It was she whom he asked, a few weeks before his death, to try to arrange for him to give Margot one of his pictures.

'If only she would get married!' Vincent often wrote to Theo, 'If only she could marry an artist!' But Will never did marry, and until the day of Vincent's suicide at Auvers she continued to serve as an affectionate link with his family in Holland.

It was a sad letter that van Gogh wrote to her in 1887, giving her an account of his behaviour, experiences, work and reading, with the melancholy admission that he had failed all along the line, had given up hope, and was making swift progress 'towards growing into a little old man.'

'But what does it matter! I have a dirty and hard profession—painting—and if I were not what I am, I should not paint; but being what I am, I often work with pleasure, and I have an inkling that I may one day paint some pictures with a little freshness and youth in them, even though my own youth is one of the things I have lost.

'If I did not have Theo I shouldn't be able to work my way to what I want; but seeing that he is my friend I believe I shall make still further progress, and give free rein to it.

'... I don't want to belong to the melancholy, the soured, bitter, acrimonious. To understand all is to forgive all, I think if we knew everything we should attain some serenity.'

'... What is inside oneself "will out"; for me, for instance, it is a relief to paint a picture, and without it I should be more miserable than I am.'

He had resolved to go away; in the long run he had come to feel nothing but contempt or distaste for the painters of Paris, as for those of The Hague and Antwerp. In spite of so many meetings, so much friendliness and discussion, Vincent felt as lonely as ever. At first the light of the Paris region had fascinated him, but later, wearied by its disconcerting subtleties, he had reacted suddenly and violently, and his *Fête of 14th July*, with its savage brush-strokes and fiery colours, seems to herald the explosions that came when he moved south. 'He wanted to paint the sun itself, not its rays,' said Emile Bernard.

He did a great deal of work during the winter of 1888, in particular a *Woman by a Cradle* for which he used an unknown sitter but which conveys, perhaps, a kind of echo of the melancholy he felt at the thought of the 'fruitful life' which could not be his. The pretty young

bourgeoise with an air of distinction, who sits dreamily beside a white-curtained cradle, is not Kee, Margot or Sien; she is perhaps the wife and mother of Vincent's fondest, most ambitious dreams, the symbol of an unattainable happiness.

Vincent painted twenty-two self-portraits while he was in Paris, each of them a reflection of his state of mind at the time. Each time, he gazed at his own face in the effort to understand himself better, and sometimes, also, to calm himself. This accounts for the difference of touch from one portrait to another; he adapted his technique to his feelings. The expression is sometimes calm, but more often anxious or even wild.

His canvas was also a testing-ground. Whenever Vincent tackled a new technique, he used it on his own face, taking his features as a means of mastering something he had learnt or discovered for himself, particularly in the expression of the eyes (compare the self-portraits in the Louvre and in the Basle Museum). In his *Self-portrait in a Soft Hat* he is trying to integrate the face into a kind of circular rhythm, the course of which he marks with small, straight touches, placed close together or superimposed. The idea of a picture as an almost perfect circle, favoured in the 18th century, had been ousted by the symmetrical balance beloved of David and his school; Vincent, in reviving it, was propounding a theory based on the use of the circle—one to which he often reverted, especially during the Saint-Rémy period.

During his time in Paris Vincent painted two hundred pictures and made some fifty drawings; they give a sort of retrospective display of all the techniques adopted by his immediate forerunners and his contemporaries, which he had first absorbed and then shaped according to his own personality, till they produced the passionate experiments of the portraits, the expressionism of *Fête of 14th July,* or the brilliant spontaneity of the *Wheatfield with Lark.* In the *Portrait of Père Tanguy* which is now in the Musée Rodin, he achieved an astonishing synthesis between the traditional style of figure-painting and his own language of form and colour, culminating in a dynamic rhythm of extraordinary nobility. The arrangement of the coloured planes and the distribution of the lines, together with the way in which the central figure stands out motionless against a moving background, makes an

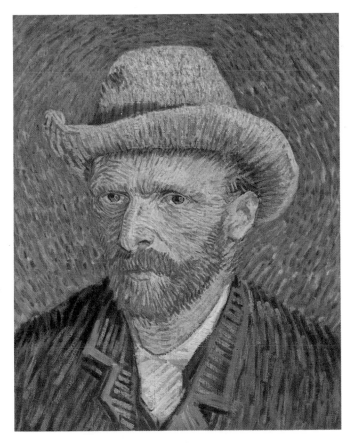

Self-portrait in a Soft Hat. Paris, 1887.

impression of fervent humanity, gentle and pure as a prayer. Indeed, this portrait is in its way a work of piety, where the painter's gratitude to Tanguy as a kind of 'donor' is expressed with all the devoutness of a primitive.

The fact is that Vincent had nothing left to learn from Paris and its painters, and was more than ever tormented by the mirage of the south, the pull of light that he had felt ever since his departure from Nuenen. The brotherhood of artists should be set up in the South of France.

◀ *The Fourteenth of July in Paris.* Paris, July 1887.

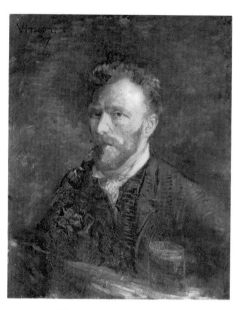

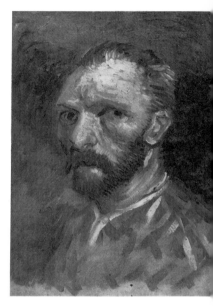

Self-portrait. Paris, 1886–88.

Self-portrait. Paris, 1887.

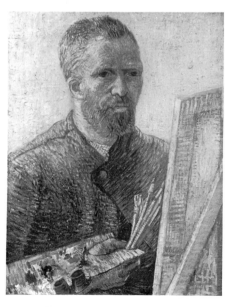

Self-portrait. Paris, January 1888.

One evening in February 1888 he said to Emile Bernard: 'I'm leaving tomorrow, we'll arrange the studio together so my brother will think I'm still here.' He nailed some Japanese crepons on the walls of the little flat in the Rue Lepic, put some canvases on the easels, and handed Bernard a batch of Chinese paintings he had found in a junk-shop. Bernard expressed anxiety about this sudden departure; Vincent told him he had decided to settle at Arles, a small town where life was fairly cheap and which Toulouse-Lautrec had told him was charming. He was glad to think it was almost half-way between Aix, where Cézanne lived, and Marseilles, where Monticelli died. And he hoped that Gauguin, Bernard and various others would come to visit him.

The two men walked down to the Avenue de Clichy together. There they shook hands, and Vincent turned away and vanished into the crowd. Next day, 21st February, Vincent arrived at Arles to find it covered with snow.

ARLES
21st February 1888—3rd May 1889

'I have seen some splendid red stretches of soil planted with vines, with a background of mountains of the purest lilac colour. And the landscapes in the snow, with the summits white against a sky as luminous as ⎯⎯⎯⎯ just like the winter landscapes that the Japanese have ⎯⎯⎯⎯ South of France, which had been described to him ⎯⎯⎯⎯ ny, was snow-covered. But he was not sorry to have ⎯⎯⎯⎯ it seemed to him 'almost impossible to work ... un- ⎯⎯⎯⎯ place of retreat where one can recuperate,' and he ⎯⎯⎯⎯ d often come to see him.

⎯⎯⎯⎯ country beautiful. Arles, he judged, 'does not seem ⎯⎯⎯⎯ reda or Mons.' But the cost of living was higher than ⎯⎯⎯⎯ he would need at least five francs a day for board ⎯⎯⎯⎯ out allowing for paints, canvas, etc. He relied more ⎯⎯⎯⎯ who, indeed, sent him a fifty franc note a few days ⎯⎯⎯⎯ les. Vincent had taken a room at Carrel's, at 30, Rue ⎯⎯⎯⎯ -restaurant near the railway station. Physically he ⎯⎯⎯⎯ ; in Paris he had been drinking far too much ab-

ADMISSION FC=0.00 16.00
DETROIT INSTITUTE OF ARTS
ENTER 10-10:30AM 10:00A
SPONSORED BY
DAIMLERCHRYSLER
5200 WOODWARD AVE.
MON MAY 22 2000 10:00A
'VAN GOGH: FACE TO FACE'
SEAT L3104; ROW/BOX A
SECTION/AISLE
DI0522 10:00A L3104 A
EVENT CODE
15.0 22' VI 22'
3.1: L3104;
10:00 0141950
A 5APR0

sinthe, and seems to have contracted an infection from Agostina Sega-tori. He was relying on the quiet life of a country town to help him recuperate.

He had no sooner arrived than he set to work, and after only a few days was able to send Theo a list of work in hand or completed—an old Arlésienne, a snowy landscape, a view of a bit of pavement with a pork-butcher's shop. 'The women here are beautiful, that's no fable,'

Le Pont de Langlois. Arles, March 1888.

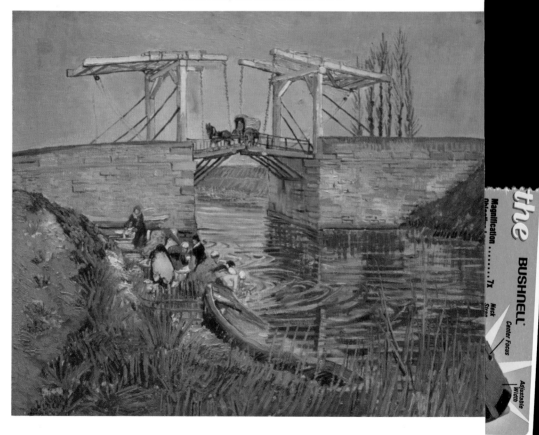

Le Pont de Langlois. Arles, April–May 1888.

Le Pont de Langlois. Arles, March 1888.

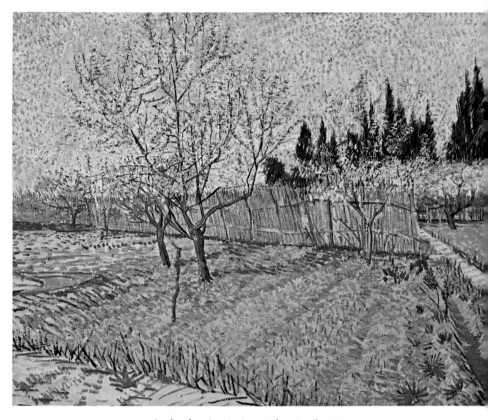

Orchard in Springtime. Arles, April 1888.

he added; but 'the art gallery at Arles is atrocious, a bad joke, and ought to be in Tarascon.'

His little room was on the top floor of the hotel and looked out to the sky. Despite the cold, he was filling his lungs with pure air, and felt happy. What a contrast to Paris, with its heavy, feverish atmosphere, the fogs that got into one's bones; here he would live more freely, feel less oppressed, and he hoped his friends, too, would leave the city and come to paint peacefully by his side. A local grocer and a magistrate, both amateur painters, had been along to welcome their new '*confrère*', but Vincent did not look too kindly on them. At the

moment he was much concerned with the business side of art, and his letters to his brother were prodigal of advice. 'But you know perfectly well,' he wrote to his brother in February or March, 'that Tersteeg is as much at home in English business as a fish in water, so it would be perfectly possible for him to manage the sale of these new pictures over there. Really, in that way Tersteeg and the London manager [108] would have a permanent exhibition of Impressionists in London, you would have one in Paris, and I would begin at Marseilles.' All this came to nothing, at any rate for Vincent.

Gauguin, with whom he was counting on living and working, was ill and penniless. But spring came early after the snow, bringing Vincent fresh courage, and he made 'two little studies of an almond branch that is already in blossom.' He went for several walks, to choose subjects for pictures, and wrote suggesting that his brother should send 'the two big landscapes of the Butte Montmartre' to the Salon des Indépendants—though he left the final decision to Theo, adding 'It is all more or less the same to me.' [109]

'When in heaven's name shall we see a generation of artists with healthy bodies! Sometimes I am really furious with myself, for it's not good enough to be either more or less ailing than the rest. The ideal would be a constitution strong enough to live to be eighty, with blood that was really good blood.

'It would be some comfort, however, if one could feel that a generation of more fortunate artists was to come.' [110]

Vincent hoped soon to be able to send Theo the first roll of canvases, probably about a dozen. Meanwhile he had made friends with a young Danish painter, Mourier Petersen. 'His work is dry, but very conscientious, and he is still young,' he wrote to Theo. He had not lost sight of his aim, an association of artists; the plans were slowly taking shape in his mind, and he hoped to establish it before long. He counted on support from Tersteeg, for he felt that a dealer could be very useful in a matter of this kind.

From the point of view of sentiment he was as bereft as he had been in Paris. He had renounced love, and would confine himself henceforth to the emotions that nature aroused in him. He simply became a client of a brothel in the Rue des Récollets, in the old district beside

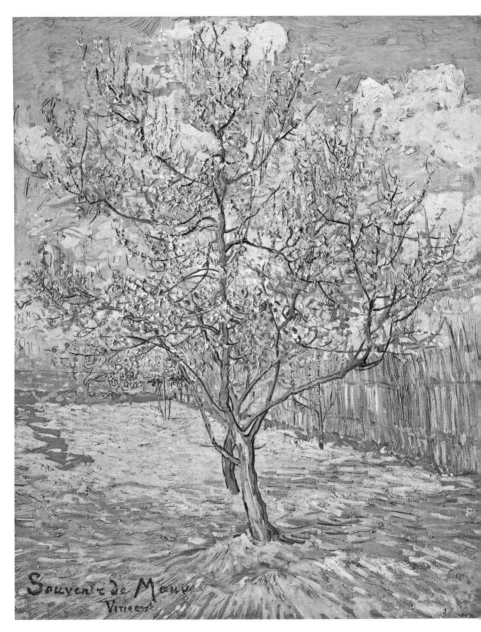

Pink Peach Trees. (Souvenir de Mauve). Arles, April 1888.

the Rhône. The streets delighted him with their liveliness and bright colours. He admired the portico of St Trophime (which he mistook for Gothic), but it struck him as 'so cruel, so monstrous, like a Chinese nightmare'; and he expressed mingled admiration and astonishment at 'the Zouaves, the brothels, the adorable little Arlésiennes, going to their first Communion, the priest in his surplice, who looks like a dangerous rhinoceros, the people drinking absinthe', all of whom seemed to be 'creatures from another world'.

By about the middle of March he had painted a dozen pictures. In a letter to Emile Bernard, written in early April, and sent with letters to Theo and Toulouse-Lautrec, he complains that he cannot live as cheaply as he had hoped, although 'it might perhaps be a real advantage to many sun-loving artists to emigrate to the South of France.' At the head of this letter he sends his friend 'a little sketch of a study that engrosses me, because I want to make something of it: sailors returning with their sweethearts to the town, with the strange silhouette of the suspension-bridge against an enormous yellow sun.' This suspension-bridge was the Pont de Langlois [111] over the Arles canal, at Bouc; it had something both Dutch and Japanese about it which appealed to Vincent; he painted four versions of it and made two drawings—one with a reed pen and one in pencil—and a water-colour.

'I'd like to be able to put colours in it like those of stained-glass windows, and draw with firm lines.' That was the direction in which he was now turning; for since his arrival in the South his style had been transformed, he was gradually leaving the Impressionist influence behind him.

The bright light, without shadows, the sharp outlines, the extraordinarily brilliant colours were compelling him to revise his interpretation of nature, to undertake a simplification that brought him very close to the Japanese. He had travelled far from the dark style of his Belgian and Dutch period, with its 'social' implications, and far from the subtlety and flowing movement of the Paris paintings; in the course of a few days he had turned his back on his past experience, he no longer drew inspiration from anyone else, he had become himself. In the radiant light of those first days of spring, the meaning of his latest step was revealed to him, he saw what road he must now take.

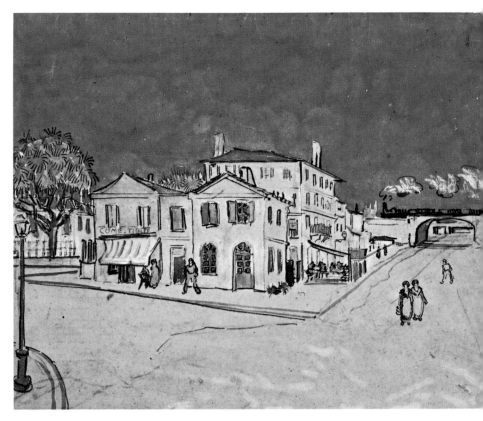

Vincent's House at Arles. Arles, September 1888.

'You will understand,' he wrote to his sister Willemien, 'that nature in the south cannot be painted with the palette of a Mauve, for instance, who belongs to the North and is, and will remain, a master in grey. Now the palette is distinctly colourful, sky-blue, orange, pink, vermilion, a very bright yellow, bright green, wine-red, violet.

'But by intensifying *all* the colours one arrives once again at calm and harmony ... You will be able to get an idea of the revolution in painting if you think, for instance, of the brightly-coloured Japanese pictures that one sees everywhere, landscapes and figures.'

The orchards were in bloom and Vincent, in a state of joyous ex-

citement, worked without pause. He would repeat the same theme several times, in oils or with the reed pen.

One evening, when he came home after 'working on a size 20 canvas in the open air in an orchard—lilac ploughland, a reed fence, two pink peach-trees against a sky of glorious blue and white', he found his sister had sent him 'a Dutch notice in memory of Mauve', who had just died. He added in his letter to Theo: 'Something—I don't know what—took hold of me and brought a lump to my throat, and I wrote

View of Arles with Irises in the Foreground. Arles, May 1888.

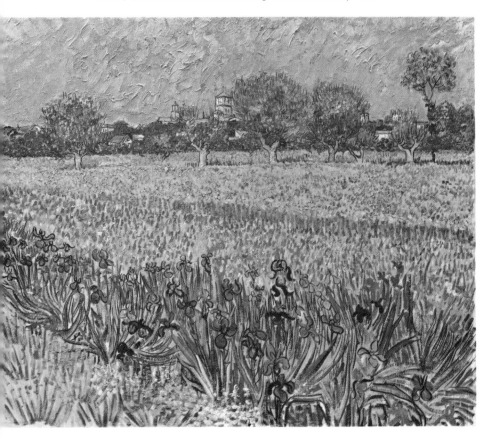

on my picture *Souvenir de Mauve, Vincent Theo* and if you agree, we two will send it, such as it is, to Mme Mauve.'

The idea was charming and expressed the union of the two brothers, but in fact Vincent wrote only his own name on the picture he chose. Why he left out Theo's is an unsolved mystery; but it illustrates the inconstancy of his disposition and shows how puzzling some of his actions must appear if we always rule out the possibility of selfish motives.[112]

Vincent instructed his brother to send him canvases and paints. His most urgent order was for thirty-eight tubes of various colours, but his requirements were much above that, over a hundred tubes, some double and some small. If Theo would buy the paints himself, 'it will reduce my expenses here by more than 50 per cent,' he explained.

The peremptory tone in which Vincent addresses his brother may seem surprising, but is explained by his attitude towards their partnership and the meaning he attributed to it. Vincent's work was a joint achievement, shared equally by both. Vincent often speaks of 'our work' and 'our pictures', and even goes so far as to say, when asking his brother for paint or money, 'Do the best you can... that's if you think it is to our advantage to work like four.' Or: 'We have put so much money into this wretched painting already that we must not forget it has to come back in the form of pictures.'

About 20th April he wrote to Bernard that he was 'working on nine orchards: one white, one pink, almost red; one white-blue; one greyish-pink, one green and pink'; and he mentioned that he intended to paint at Marseilles.

In May he moved from the Rue Cavalerie to the nearby Place Lamartine, where he rented the right wing of a detached house, four rooms, two of them small. 'It is painted yellow outside, whitewashed inside, on the sunny side, I have rented it for 15 francs a month.' He would have liked to have shared it—with Gauguin, for example—but 'the studio is too public for me to think it might tempt any little woman, and a petticoat crisis couldn't easily end in a liaison.' Theo would have no reason to fear a repetition of the incident with Sien. On 4th May 1888 he wrote to Theo:

'I think something could be done here in the way of portraits. Al-

126

though the people are blankly ignorant of painting in general, they are *much more artistic* than in the North in their own persons and manner of life... Now, as for portraits, I am pretty certain they'd take the bait. But first, before I dare start along that line, I want my nerves steadier, and also to be settled in so that people can come to the studio.'

His removal caused him nothing but trouble. In the first place Carrel, the hotel-keeper, tried to make him pay more than the agreed price, and the magistrate had to be called in to settle the matter; secondly, Vincent had no bed, so he was obliged to sleep at a carter's inn until he could afford to buy one. Still, he had been able to buy two chairs, a table, and a little food. As usual, his letters to Theo go into the details of his various mischances; sometimes he made excuses for them, at other times he tried to explain, to show himself in his true light, for he did not want to be regarded as disorderly or wasteful.

'The money that has already been spent in earlier years ought to yield some return also, at least in kind,' he wrote to Theo. With his letter he sent a roll of pictures, asking Theo to 'Put aside the best things in what I have sent, and consider these pictures as a payment to be deducted from what I owe you, then, when the day comes when I have brought you in something like 10,000 francs in this way, I'll feel happier.' [113]

He was working harder than ever. To Emile Bernard, [114] then doing his military service, he described some still-lifes, one of them 'a variation of blues, livened up by a series of yellows that go as far as orange'; another, 'lemons in a basket against a yellow background'.

'Further a view of Arles. One sees nothing of the town except a few red roofs and a tower, the rest is hidden by the green of fig-trees, far away in the background, and a narrow strip of sky above it... But what a subject, hein! That sea of yellow with a band of purple iris, and in the background that coquettish little town of the pretty women! Then two studies of roadsides—later—done with the mistral raging.'

'...The painter of the future will be *a colourist* such as has never yet existed,' he wrote to Theo on 5th May. 'Manet was working toward it, but as you know the Impressionists have already got a stronger colour than Manet.

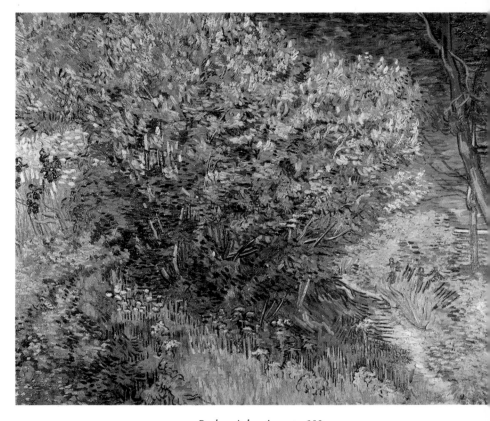

Bushes. Arles, August 1888.

'... But I think I am right when I feel that in a later generation it will come, and that as for us we must work as we can towards that end, without doubting and without wavering.'

With summer 'the aspect has changed and nature has become much harsher. But such verdure, and such a blue!' exclaimed Vincent. He had not expected such an explosion of sunshine, and for a moment he was baffled as to how to convey the fierce, dazzling quality of the light. If only several artists were to study it together, perhaps they might get the better of it! Gauguin had written to Theo that he was ill and in financial difficulties. Why shouldn't Gauguin come to Arles?

Vincent and he could help each other until times improved, not only in their work, but in practical matters. To persuade Gauguin, Vincent wrote to him through Theo; he praised the climate and added that though 'life is more expensive here, on the other hand the chances of getting more pictures done are better.' He suggested that Gauguin might send Theo one picture a month in return for their keep.

In his frenzy of work, Vincent produced picture after picture at fantastic speed. The *View of Arles with Irises*, described in his letter to Bernard, was followed by other landscapes of equally astonishing

Boats at Les Saintes-Maries. Arles, June 1888.

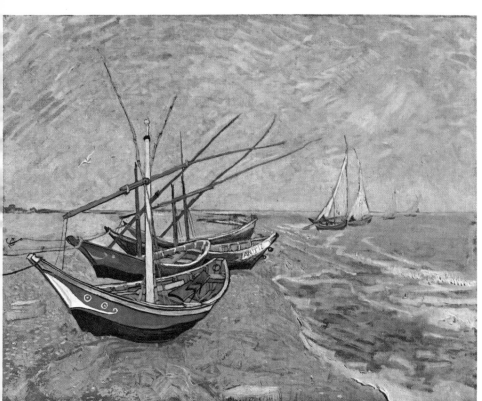

authority, clear statements in his new language. Then there were the still-lifes—with coffee-pot, with majolica-pot, with lemons—in which restraint, deliberate severity and simplicity of form, were allied with colour harmonies of unpretentious delicacy. In June he was working on 'a landscape with wheatfields... in the style of the two Butte Montmartre landscapes which went to the Salon des Indépendants, but I think it has more firmness and rather more style,' and then on a farm and some ricks. 'Everywhere now there is old gold, bronze, copper, one might say, and this with the green azure of the sky blanched with heat: a delicious colour, extraordinarily harmonious, with the blended tones of Delacroix.'[115]

Gauguin, who was ill, was slow in making up his mind whether to come to Arles; Vincent then thought that the painter MacKnight, a friend of Russell's, who was living a few miles from Arles at Font-

The Tileworks. Arles, *c.* April 1888.

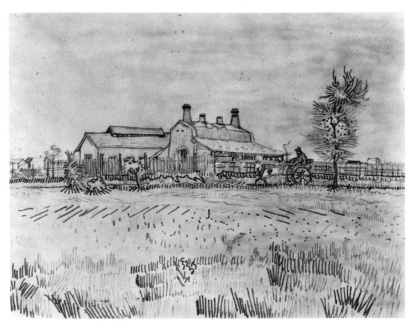

vieille, and whom he had visited, might agree to come and live with him; but this plan fell through. As soon as he had a little money to spare Vincent went off to Les Saintes-Maries-de-la-Mer.

At Les Saintes-Maries, where he spent a whole week at the beginning of June, he painted several seascapes and a view of the village, and made some drawings (page 129). He described the beauty of the colours:

'One night I went for a walk by the sea, along the empty shore. It wasn't gay, but neither was it sad, it was beautiful.

'The deep blue sky was flecked with clouds of a blue deeper than the fundamental blue of intense cobalt, and others of a clearer blue, like the blue whiteness of the Milky Way. In the blue depth the stars were sparkling, greenish, yellow, white, pink, more brilliant, more sparkling gem-like than at home—even in Paris: opals you might call them, emeralds, lapis lazuli, rubies, sapphires.

'The sea was very deep ultramarine—the shore a sort of violet and faint russet as I saw it, and on the dunes . . . some bushes, Prussian blue.' [116]

To Emile Bernard, at the end of June 1888, Vincent wrote: 'More and more it seems to me that the pictures which must be made so that painting should be wholly itself, and should raise itself to a height equivalent to the serene summits which the Greek sculptors, the German musicians, the French novelists reached, are beyond the power of an isolated individual; so they will probably be created by groups of men combining to execute an idea held in common.'

But Vincent's work had become invigorated. In this radiantly sunlit landscape where he was like a wondering pilgrim, the life of humble things had thrust itself upon him; he had discovered the vibration of nature in the blossoming almond-trees, the iris, the orchards, the fields of ripening wheat, the villages, the colourful streets of Arles, and the slow rise and fall of the sea 'on the sandy beach, little green, red and blue boats, so pretty in shape and colour that they made one think of flowers.' The promises Vincent had seen in the brilliant springtime were fulfilled by summer.

At Arles everything vibrated, palpitated, shuddered and flamed beneath his brush, even the stars, and his soul exulted as the sun's fire

penetrated him. 'One must exaggerate the colour still more,' he declared, still unsatisfied; and he worked 'even at full noon, in the full sunshine, with no shade at all, in the cornfields.'

He tried to look critically at his work as before, but he soon found he was unable to do so. 'It's so tiring, the sun down here!' he exclaims in a letter to Emile Bernard. 'I'm entirely incapable of judging my own work. I can't see whether the studies are good or bad.' But none the less he felt at last that he was master of himself and his form of expression, which was his alone.

During June, as well as the pictures Vincent brought back from Les Saintes, he painted *Farm in Provence, The Cornfield, Haystacks, Marketgardens on the Crau, The Sower, The Washerwomen*, etc. He also painted his first Provençal portrait, a Zouave he met in a brothel, 'a boy with a small face, a bull-neck and the eye of a tiger.' In several letters written to Emile Bernard in the second fortnight of the month he comments extensively on each of these pictures, all of which reveal the most delicate and penetrating sensibility. 'I have had a week's hard, close work in the cornfields in the full sun,' he wrote to Theo; and indeed he was doing nothing but work from morning to night.

In July he announced to Bernard 'seven studies of cornfields, and unfortunately much against my will, nothing but landscapes. Yellow-and-old-gold landscapes, done quickly, quickly, quickly, like a reaper who is silent under the burning sun, concentrating on his corn-cutting.' But, he adds in a letter to Theo, 'quick work does not mean less serious work, it depends on one's self-confidence and experience.' He often returned to this point: 'Is it not emotion, the sincerity of one's feeling for nature, that draws us? And if the emotions are sometimes so strong that one works without knowing one works, when sometimes the strokes come with a continuity and a coherence like words in a speech or a letter ... one must strike while the iron is hot.' Faced with his subject Vincent forgot himself, became like a sleepwalker recording the emotional shock that impelled him forward. Vincent did not select, did not judge, his work was a crucible into which his innermost feelings were poured, released. He came home from these working expeditions exhausted, 'completely abstracted and incapable of doing the most ordinary things.'

But van Gogh was not bereft of control, or at the mercy of blind or mechanical forces; his work is logical as well as lyrical, it combines reason with effervescence, drive with spontaneity: '. . . Labour and dry calculation, in which one's mind is extremely tense, like an actor on the stage in a difficult part, where one must think of a thousand things at the same time, within half an hour.' It is impossible to dissociate the creator and the work of art that vibrates within us with its own moving life.

All is colour. In 'a glorious strong heat', 'a sun, a light that for want of a better word I can only call yellow, pale sulphur yellow, pale golden citron', with the 'glow of pale sulphur' there spring up the sun-flowers, emblems of sun-worship, fiery disks that blaze like the sun itself. And the stars that Vincent scatters over the sky of his *Café Terrace at Night* (page 134) and *Starry Night,* like the oil lamps of his *All-Night Café* (page 143) are so many suns, revolving or fixed.'[117]

'Oh! The fine sun there is here in full summer,' he wrote to Bernard. 'It beats on your head and I've no doubt it drives you crazy. But being that already I just enjoy it.'

In the evening, when Vincent emerged, exhausted, from 'the furnace of conception', he would either drag from café to café to allay his tension 'with a good drink and by smoking very hard', or, as in the old days, sit at home for hours, reading *Mme Chrysanthème, L'Année Terrible,* Balzac or the Bible. He wrote at great length to his brother, nearly every day.

The Café de la Gare, kept by M. and Mme Ginoux, was the one he visited most often. He had made a few friends there, including Roulin, the postman, 'a big bearded face, very like Socrates', and Milliet, a second-lieutenant in the Zouaves, home on leave. These, with Mac-Knight and a thirty-three-year-old Belgian painter, Eugène Boch, 'face like a razor-blade, green eyes, an air of distinction', were almost the only people he saw at Arles. And even so, he regarded MacKnight and Boch, who lived at Fontvieille, as mediocre artists, lacking in personality, who wasted their time chatting in cafés.

Vincent had to take these few friends as models, for the local people refused to sit for him; they thought his pictures 'badly done'. In one of the brothels he discovered 'a rather beautiful model . . . the expression

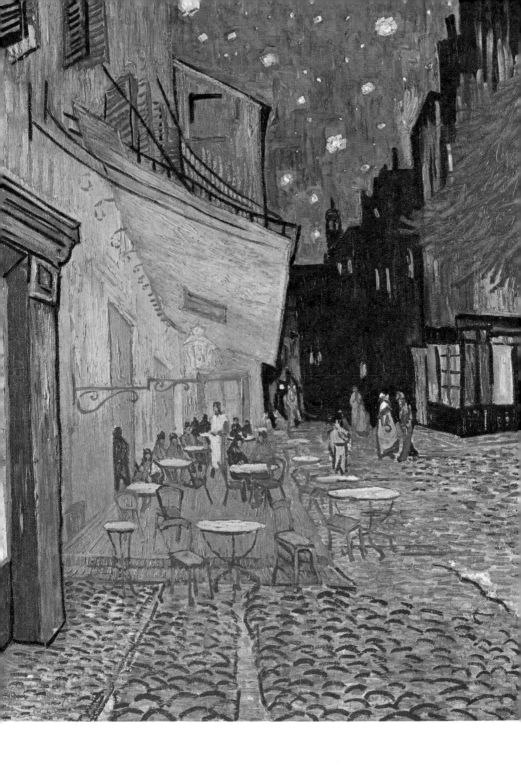

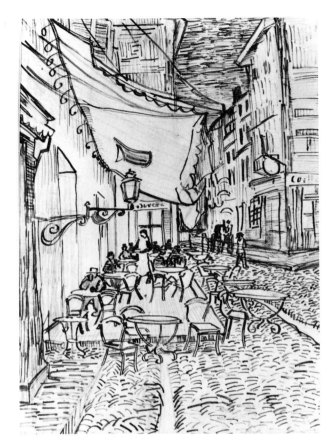

Café at Arles. Arles, 1888.

like that one by Delacroix, the figure primitive and strange.' She first promised to pose for him, then refused. Vincent complained that 'the poor little souls are afraid of being compromised and that people will laugh at their portraits.'

Vincent painted portraits of Milliet, of Boch as a poet, with 'his fine head with that keen gaze' standing out 'against a starry sky of deep ultramarine', the postman Roulin and his family, Madame Ginoux, an unnamed peasant, Patience Escalier, and a few others who have not been identified, including a little girl of twelve or so whom he asked to

◀ *Café at Night.* Arles, September 1888.

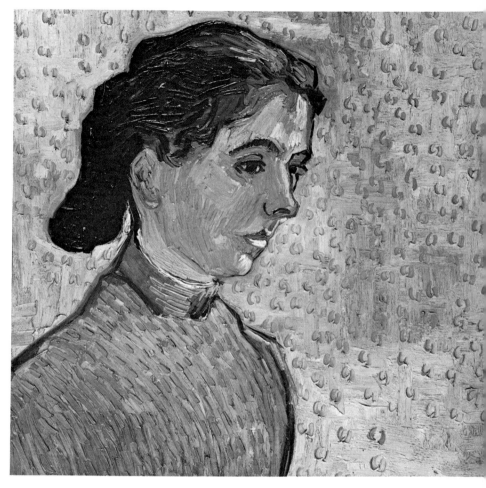

Portrait of a Girl on a Pink Background. Arles, August 1888.

pose in Japanese dress, and the Zouave. He painted the Roulins most frequently, and their three-month-old daughter Marcelle and their two sons, Camille, aged ten, and Armand, sixteen.

All these people posed exactly as they would for a photograph, usually full face, staring out of the picture in the most inexpressive attitude. The backgrounds were often plain, but Vincent carefully

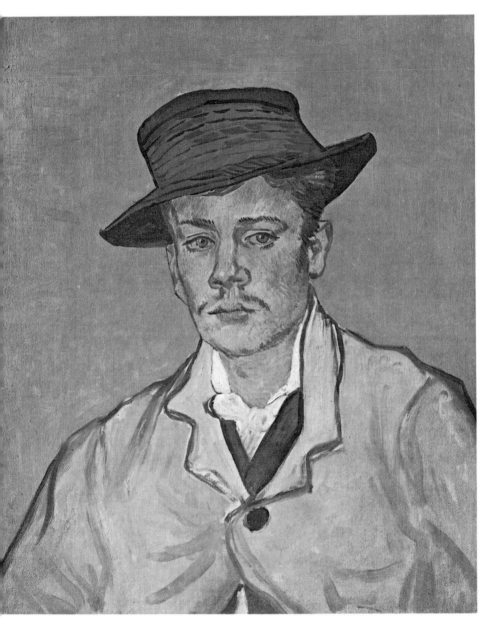

Portrait of Armand Roulin. Arles, November 1888.

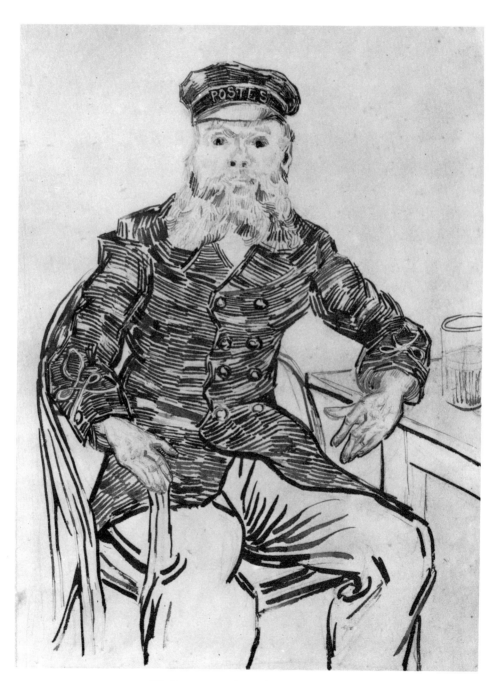

The Postman Roulin. Arles, August 1888.

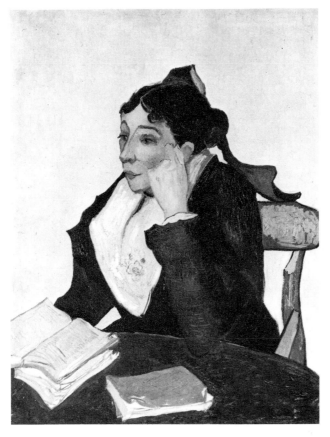

The Arlésienne (Madame Ginoux). Arles, November 1888.

chose the colours for them to suit his model's dress and personality. In some cases he composed the picture carefully, as in the *Portrait of Père Tanguy*, whom he placed in front of some Japanese prints, as calm as a Buddha. The green background of Mme Roulin's portrait is picked out with flowers and acanthus leaves to which he has given a Japanese atmosphere. In another portrait the young model, 'a very countryfied woman with a great air of virginity', sits in profile against a greyish-mauve, green-flecked background that echoes the pattern of her dress. Milliet has an emerald green background, on which Vincent has paint-

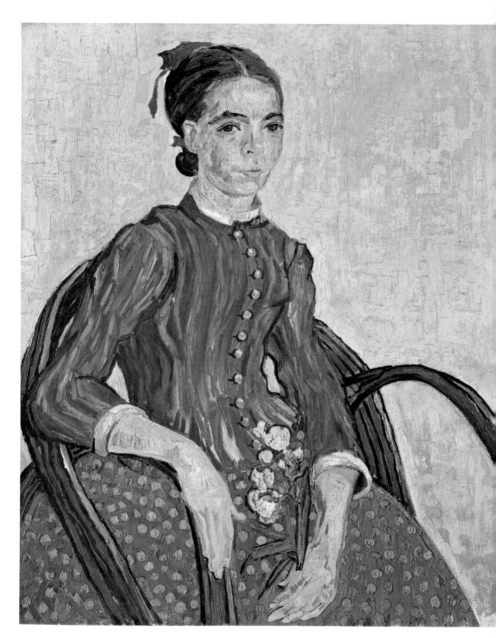

La Mousmé. Arles, July 1888.

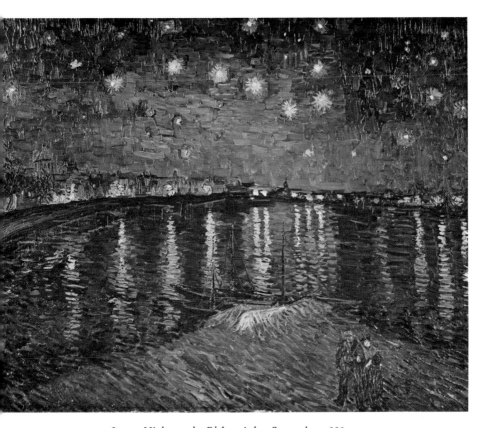

Starry Night on the Rhône. Arles, September 1888.

ed, in yellow, the crescent and star of the colonial army. The assortment of colours is extraordinarily bold, the painting full of style and assurance, the line unerring. Vincent was constantly surpassing himself.

While working on the portrait of his friend Boch, he wrote to Theo: 'To finish it, I'm now going to be an arbitrary colourist. I exaggerate the fairness of the hair, I even get to orange tones, chromes and pale citron-yellow. Behind the head, instead of painting the ordinary wall of the mean room, I paint infinity.' [118]

Vincent was tired out, eating next to nothing, living under a perpetual strain. 'The more ugly, old, vicious, ill and poor I get, the more I

want to take my revenge by painting in brilliant colours, well-arranged, resplendent.'[119]

Perhaps in this statement there is one of the keys to Vincent's character.

MacKnight and Boch, the only two people with whom he could talk about painting, even a little and with small satisfaction, went away. August was torrid, September not quite so hot, but depressing. He was alone, he missed his friends, and feared that in such solitude he might work himself dry. Vincent even contemplated joining Gauguin at Pont-Aven since he would not come to Arles, but was deterred by the thought of 'staying at the inn with the English and the people from the Ecole des Beaux-Arts that you argue with every evening. It is a storm in a teacup.'[120]

At the beginning of September Vincent began his 'starry nights' series. First came the *Café Terrace at Night,* showing a café in the Place du Forum. This was followed by *Starry Night on the Rhône* and by *All-Night Café*—the Café de l'Alcazar, where he was still sleeping for lack of a bed in the 'yellow house'.

He wrote to Theo[121]: 'The *All-Night Café* carries on the style of the *Sower,* as do the heads of the old peasant and the poet also, if I can manage to do this latter picture.

'It is colour not locally true from the point of view of the delusive realist, but colour suggesting some emotion of an ardent temperament.

'When Paul Mantz saw at the exhibition the *La Barque de Christ* by Delacroix we saw in the Champs-Elysées, he turned away from it exclaiming, "I did not know that one could be so terrible with a little blue and green."'

Theo now sent him a little money, three hundred francs, from a small sum left to him in someone's will. Vincent bought two beds, one of walnut, the other of plain deal boards, twelve chairs, a looking-glass and 'some indispensable trifles' and at last settled into the little house in the Place Lamartine.

He wrote to his brother daily, sometimes twice, and this after working for as much as twelve hours at a stretch. 'Again today from seven in the morning till six in the evening I worked without moving except to go a few yards for a scrap of a meal That's why the work

goes on fast . . . Not a sign of fatigue, I could do another picture this very night, and bring it off . . . the present studies really *come straight off the brush*.' [122]

In his painting of the *All-Night Café*, Vincent 'tried to express the idea that the café is a place where one can ruin oneself, go mad or commit a crime. So I have tried to express, as it were, the power of darkness in a low public house by soft Louis XV green and malachite, contrasting with yellow-green and hard blue-greens, all this in an atmosphere like the devil's furnace, of pale sulphur. And all with an appearance of Japanese gaiety, and the good nature of Tartarin.' [123] Night fascinated him, he saw it as 'far more alive and richly coloured than day.' He would settle himself on the bank of the Rhône, sticking candles on the brim of his hat to give light, and paint the stars, his noc-

The All-Night Café. Arles, September 1888.

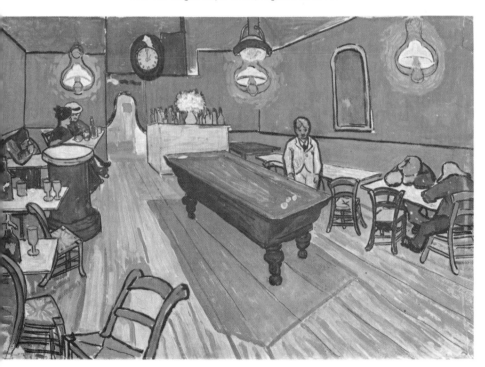

turnal sunflowers. At home, he scrutinized his own face in the mirror, his hollow cheeks and close-shaven skull, making a portrait of himself '*almost colourless,* in grey tones against a background of pale malachite.'

He also set up his easel in the public gardens. One picture in a garden, 'quite close to the street of the kind girls', was 'painted with pure green, nothing but Prussian blue and chrome yellow.' He extolled the simple beauty of the place, 'without any flowering bushes such as oleanders', and with 'ordinary plane trees, pines in stiff clumps, a weeping tree, and the green grass. But it is all so intimate; Manet has gardens like this.' [124]

He thought of Gauguin continually; and of whether he would join him in Arles. The 'house of friends', 'studio of the South' were waiting. But Vincent was no longer seeking encouragement or asking for advice. He had found fulfilment. But he writes to Theo, with perfect simplicity: 'That does not prevent me having a terrible need of—shall I say the word?—of religion. Then I go out at night to paint the stars and I am always dreaming of a picture like this with a group of living figures of our comrades.'

Though he had lost his faith in God, Vincent had achieved faith in himself; in his work he could sense the vibration of his spirit, eager to discover its mission and carry it out. He was taking visible things as a starting-point from which to attain to the heights of revelation.

'I am beginning to feel quite different from when I first came here; I have no more doubts, I don't hesitate about starting a thing ... I have so much happiness with the house, with the work ...'

But the lines of his pictures are pure, restrained, and the colour-scheme, though often vivid, is not exaggerated either in its juxtapositions or in its contrasts; the composition is firm and the touch, which is free and smooth, bears no resemblance to his earlier manner with its streaks, its cross-hatching and its jerky effects. Now there is 'nothing but flat tints, which blend together'; he is striving for a monumental balance founded on measured harmonies, all his means patiently attuned. Without the slightest violence of form, colour is raised to a maximum of tension and seems to conquer the canvas rather than cover it.

144

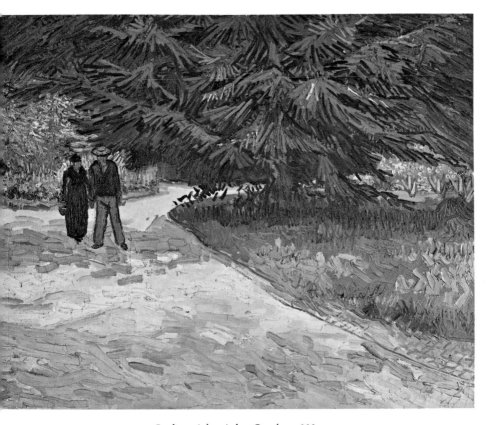

Park at Arles. Arles, October 1888.

In one of the finest pictures he painted in the summer of 1888, *Harvest (Plaine de la Crau)*, Vincent succeeded in expressing the absolute calm symbolized by the brusque halting of light below a torrid sky. Nothing in the picture is haphazard or fortuitous; even on the verge of madness, and painting in a kind of trance of nervous tension, the passionate Vincent remained the most watchful, reflective and lucid of painters. In his creative activity, admiration, enthusiasm and astonishment were never divorced from meditation; his excitement was always controlled by a kind of inner logic that supervised and guided it. Vincent never 'let himself go'; even in the most tense and

145

Harvesting near Arles. Arles, February 1888–May 1889.

La Crau from Montmajour. Arles, May 1888.

Harvest in Provence. Arles, June 1888.

brilliant of his pictures he knew just how to proportion the contrasts, how to balance his colours, moderating a shrill note by placing a cold touch beside it, how to apply the theory of complementary colours.

'Looking at a picture,' he declared, 'should rest the mind, or rather the imagination.' That is something Poussin might have said; and Matisse, fifteen years later, was also to advocate a balanced art, a kind of sedative for the brain. Van Gogh maintaining that painting should soothe the mind—this is a far cry from the romantic view of him as 'possessed', 'mad with colour', and of his pictures as uncontrolled outbursts, and equally far from the opinion of his work as the fruit of his

147

pathological activity. The psychopathic episodes in Vincent's life left no trace except in a few of the pictures he painted at Saint-Rémy while in the asylum, and at Auvers-sur-Oise; apart from these, his work is undeniably lucid, logical and sound, it progresses steadily, by assimilation and revelation, not in fits and starts.

At last, on 20th October, Gauguin came to Arles. Theo paid for the journey and bought three hundred francs' worth of pottery from him, as well as promising to send him a small sum every month. Vincent was delighted and immediately appointed Gauguin 'head' of the school of the South, which so far had only two members—who would later be joined, Vincent hoped, by Emile Bernard, Seurat, Charles Laval—a young painter friend of Gauguin's—and perhaps by Theo himself.

Vincent and his guest were very dissimilar in character and behaviour, and still more so in their artistic aims and expression; their lives, on the other hand, had much in common. Both had taken up painting comparatively late, Vincent at the age of about thirty and Gauguin at thirty-five. Both were unsociable, eager to withdraw from the world and live among understanding friends who could encourage and help them. In this respect, both failed; with the exception of a few close friends, their contemporaries regarded them as madmen. They both experienced distress of spirit, misunderstanding and poverty, and the lives of both were overshadowed with anxiety for the future.

Between the two Theo formed a link. With kindness and compassion he continued to support them,[125] and when he helped them to settle down he hoped not only that their troubles would be lightened by companionship, but also—very naturally—that the drain on his own pocket would be reduced; that, as Vincent wrote, 'the burden will be a *little* lighter and, I venture to believe, *much* lighter.'

Both van Gogh and Gauguin had been intoxicated by sunshine, dazzled by light—the first by the brilliance of Provence and the second by the pearly glow of Brittany. But there the resemblance ends. For while Vincent could hardly bear to be alone and unsupported, Gauguin adopted the haughty air of an outlaw, declaring he needed nobody. Striking attitudes and speechifying, he was at the opposite pole from Vincent, who was modest and simple. Vincent, impressed by Gauguin's forceful personality, looked upon him as a guide, counsellor,

leader; Gauguin for his part regarded his visit to Arles simply as a means of recovering his health and cutting down expenses.[126]

Gauguin did not like Arles, and Vincent's house shocked him by its disorder and by what he regarded as a kind of affectation. When he saw that Vincent had written on one of the walls:

Je suis Saint-Esprit Je suis sain d'esprit

'I am the Holy Spirit—I am whole in spirit' (i. e. in mind), he shrugged his shoulders at this naivety. Now and again he would venture an acid comment or criticism, mocking or contemptuous. A few days after his arrival in November, he wrote to Emile Bernard: 'It's funny, Vincent thinks one could do work here in the style of Daumier, while I think one could do some highly-coloured Puvis mixed with Japanese . . . In any case there is a source of fine *modern style* here.' A month later he took this back, admitting, again to Bernard, 'I am quite out of my element at Arles, I find everything so small, so petty, landscape and people alike. Vincent and I disagree about most things, especially in painting. He is romantic and I am more inclined to the primitive; from the point of view of colour he sees the accidental effects of the paint, as in Monticelli, while I loathe fiddling about with a picture.' Vincent, for his part, told his brother 'that there are already a few studies of mine that he (Gauguin) really likes.' This was not much, but to Vincent it meant a great deal. And at last he had a friend living under the same roof, company for the winter whose solitude he so much dreaded, and the 'studio of the South' was coming into existence. He had not been so happy for a long time, and he almost revelled in his submission to the vain, domineering Gauguin.

Gauguin fell readily into his role of 'master'. He interrupted, laid down the law, and was more apt to shock Vincent than to convince him. He did not respond to nature with the same eager rapture as Vincent, and since Gauguin could not bear anyone to differ from him, Vincent shrank from arguments, giving way to his tendency to submit to others, to sacrifice himself.

'Gauguin interests me very much as a man—very much,' he wrote to Bernard towards the end of October, adding with a certain artlessness, that 'with Gauguin blood and sex prevail over ambition.' But he was more baffled than he cared to admit by the man of instinct, who was

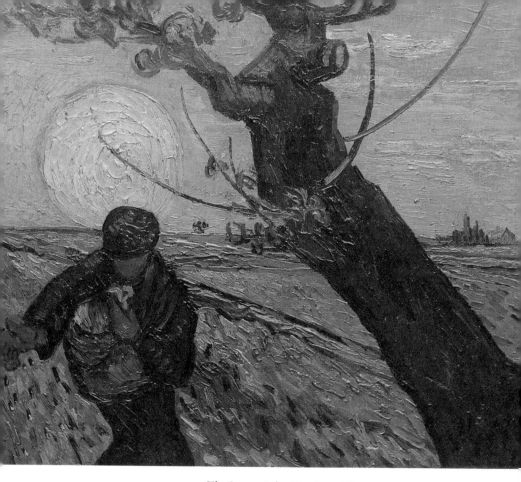

The Sower. Arles, October 1888.

attempting to convert him, almost forcibly, to his own aesthetic theories, to the 'syntheticism' he had elaborated with Emile Bernard at Pont-Aven.

Though he did not choose to admit it, it was chiefly from Bernard that Gauguin had derived his pictorial symbolism, a matter of the broad application of flat tints, harmonizing in a way that helped to bring out the decorative value of the composition.

'When I first came to Arles,' he declared later,[127] 'Vincent was up to the neck in the neo-Impressionist school and bogged down in it,

150

which made him unhappy; not because that school is bad, any more than any other school, but because it did not suit his nature, which lacked patience and independence.' He added, 'I took it upon myself to enlighten him, which was easy, for the soil was rich and fertile. Like all original natures, with the stamp of personality, Vincent was not in awe of other people and not in the least obstinate. From that day on, my van Gogh made astonishing progress; he seemed to glimpse all that was in him, and this led to that whole series of suns upon suns in full sunshine.'

Oleanders. Arles, 1888.

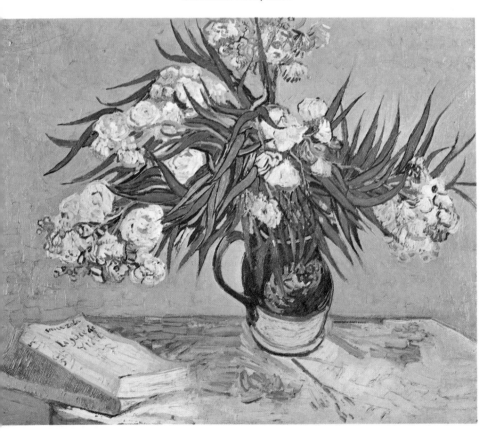

Gauguin seems to be implying that Vincent had done nothing worthwhile before following his advice. It is true that, whether out of resignation or docility, Vincent obeyed his instructions without protest. He adopted the system of *'cloisonnement'* in painting *The Reader of Novels,* where the flowing, ornamental line is combined with unexpected yellow and green tonalities of a strange, mysterious beauty, and in the portrait of *Madame Roulin and her Baby.* But his *Promenade at Arles (Memory of the Garden at Etten)* (page 154) 'with cabbages, cypresses, dahlias and figures', painted entirely from imagination, which is unusual with Vincent, does not seem to be a particularly successful application of Gauguin's theories. 'Gauguin gives me the courage to imagine things,' he wrote to Theo, 'and certainly things from the imagination take on a more mysterious character.'

Vincent explained his intentions in a letter to Willemien, written in the second fortnight of November, 1888, in which he describes his *Promenade at Arles:*

'I don't know whether you can understand that one may make a poem only by arranging colours, in the same way that one can say comforting things in music.

'In a similar manner the bizarre lines, purposely selected and multiplied, meandering all through the picture, may fail to give the garden a vulgar resemblance, but may present it to our minds as seen in a dream, depicting its character, and at the same time stranger than it is in reality.'

Vincent also painted at this time—but following his own inspiration—the *Red Vineyard* (page 156), turned crimson by the autumn and setting sun, and a portrait of Madame Ginoux of the Café de la Gare in local dress.

Gauguin, who had been hunting for suitable subjects ever since his arrival, finally sat down beside him and both of them proceeded to paint that good-natured woman.

'Madame Ginoux, Madame Ginoux,' said Gauguin, 'Your portrait will be hung in the Musée du Louvre in Paris!'

The good lady laughed heartily at this, while Gauguin nodded his head. He was right, for the canvas is now in the Louvre.

Vincent painted his former landlady several times, with only a few

changes of detail; his first portrait of her was done in November, the others later, at Saint-Rémy. It was probably Mme Ginoux who sat for *The Reader*, and she is also seen in *The Promenade*.

Gauguin's domineering manner was at last becoming irksome to Vincent. He realized that the other man's theories were no use to him, since they went against his temperament. He had accepted his friend's teaching as relating to an experiment parallel to his own, but he could not accept it when Gauguin tried to force it upon him as the only valid aesthetic expression. He rounded on Gauguin in protest. Gauguin retorted arrogantly; he was in bad health, and his temper, never too good, became worse as a result of violent attacks of liver trouble. Their quarrels grew frequent and serious, and Vincent even began to wish his friend would leave him.

Writing in the *Mercure de France*, Gauguin gives his views about the cause of these disputes in his usual peremptory style:

'In spite of all my efforts to discover in his confused brain some logical grounds for his critical opinions, I could never quite account for the contradiction between his painting and his opinions. For example, he had a boundless admiration for Meissonier and a deep hatred of Ingres. Degas reduced him to despair and Cézanne was a mere charlatan. Thinking of Monticelli, he would shed tears.

'One thing that infuriated him was that he had to admit I was very intelligent, although I had a low forehead, a sign of imbecility. With all this there went a great sweetness, or rather an altruism worthy of the New Testament.'

In his letters to his brother, Vincent tried to conceal the true state of affairs. 'We get on very well together,' he wrote. 'He (Gauguin) is a *perfect* cook.' 'He is a very great artist and an excellent friend.' And he told Emile Bernard, '. . . We are very happy together. He gives me a lot of encouragement to work, often completely from imagination.'

During December the two painters visited the Montpellier art gallery, one of the finest in the provinces. For a long time they gazed at pictures by Ricard, Tassaert and Cabanel etc., and especially at the *Odalisques* and *Study of a Mulatto Woman* by Delacroix, and the Courbets—*Village Girls, Woman Spinning* and others. As frequently happened, they soon fell into an 'electric' argument, disputes which

Promenade at Arles (Memory of the Garden at Etten). Arles, November 1888.

Vincent said left them 'with our heads as exhausted as a used electric battery.'

Gauguin had settled down to work seriously, and Vincent kept Theo informed of his subjects. He mentions among many other pictures 'a portrait of me which I don't include among his fruitless undertakings.' At the end of November Gauguin was working on 'a very original nude woman in the hay with some pigs.'

Vincent painted two pictures which were to be regarded a few months later as premonitory signs. One was of a yellow chair, his own, standing on the red-tiled floor, and the other was of Gauguin's arm-

chair. On the yellow chair, a pipe and some tobacco in a screw of paper; on the armchair, two novels and a candle. 'I tried to paint his *empty place,*' wrote Vincent in 1890 to Albert Aurier, the critic. But his own place, too, is empty. Soon Vincent would be alone again, waiting for winter to arrive with its cold and its melancholy.

To Theo, on 23rd December 1888, Vincent wrote: 'I think myself Gauguin was a little out of sorts with the good town of Arles, the little yellow house where we work, and especially with me.

'As a matter of fact, there are bound to be grave difficulties to overcome here too, for him as well as for me.

'But these difficulties are within ourselves rather than outside.

'Altogether I think he will either go away once and for all, or settle down once and for all.

'I told him to think it over and make his calculations all over again before doing anything.

'Gauguin is very powerful, strongly creative, but just because of that he must have peace.

'Will he find it anywhere if he does not find it here?

'I am waiting for him to make a decision with absolute serenity.'

That day Gauguin finished a portrait of Vincent, which showed him painting sunflowers. Vincent inspected it silently, withdrawn into himself. Then he said, 'It's me all right, but me gone mad.'

In the evening the two went to a café and sat together, talking animatedly but in low tones, each with a glass of absinthe in front of him. All at once, Vincent seized his glass and hurled it at Gauguin, who dodged it, stood up, took Vincent by the arm and dragged him off homewards.

Vincent allowed himself to be led like a sleepwalker. Back in the yellow house, he went to bed and fell asleep immediately.

When he woke up next morning, 24th December, Vincent could not remember what had happened the night before, and his head was swimming.

However—always according to Gauguin, who tells the story—he apologized.

'I'm quite ready to forgive you,' Gauguin replied, 'but it might happen again, and if I were hit I might lose my self-control and

throttle you. So please let me write to your brother and tell him I am coming back to Paris.'

Gauguin got ready to leave. In the evening, wanting fresh air, he went out for a stroll; but he had scarcely crossed the Place Lamartine when he heard 'short, quick steps' behind him. Vincent was hurrying towards him with an open razor. Gauguin looked at him sternly, and Vincent stopped short as if hypnotized, hung his head, then turned about and ran back to the house. Gauguin became alarmed at the

Red Vineyard. Arles, November 1888.

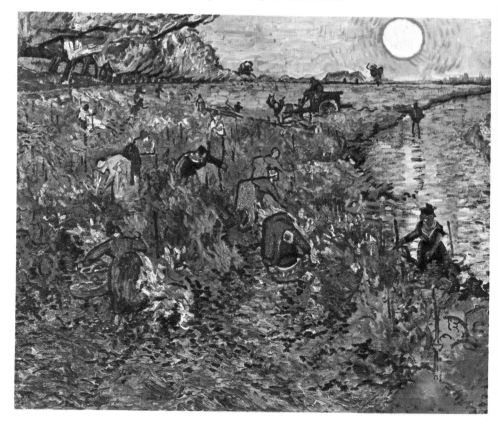

thought of remaining under the same roof with him and decided to spend the night at a hotel.

Writing of this later on, he asks, 'Was I cowardly at that moment, ought I not to have disarmed him and tried to quieten him? I have often searched my conscience, and I do not blame myself. Anyone who wishes may cast the first stone at me.' But we cannot place complete reliance upon the account of a man who was a lifelong poseur, and who would lie or distort the truth to put himself in a favourable light. Nevertheless, for some time Vincent had been in a state of intense agitation, his constant disputes with Gauguin had increased the nervous excitement brought to a climax by overwork; he was eating very little (Gauguin's 'tasty dishes' were no solution) and drinking hard. For under Gauguin's influence he went back to the absinthe he had not touched since leaving Paris, and visits to the local brothels in the wake of Gauguin became more and more frequent. To all this must be added the collapse of Vincent's hopes and dreams, the imminence of the solitude he so much dreaded.

His sense of failure went hand in hand with his feelings of guilt. It was because of his impossible character, his rages, his lack of understanding, that Gauguin was leaving. Reversing their shares of responsibility, he reproached himself with not having been a true enough friend, and felt that once again he was being punished for his faults.

Theo was shortly to become engaged to Johanna Bonger, the sister of Vincent's one-time friend André. He was about to launch into 'the true life' that Vincent was denied.

On the morning after the incident with the razor Gauguin, who had spent a restless night at the hotel, went over to the yellow house.

'When I reached the square, I saw a large crowd. In front of our house there were some gendarmes and a little man in a bowler hat who was the police superintendent.

'This is what had happened.

'Van Gogh went home and immediately cut his ear off level with the skull. It must have taken him some time to stop the bleeding, for next day there were a lot of wet towels lying about the floor in the two downstairs rooms. There were bloodstains in both rooms, and on a little staircase that led up to our bedroom.

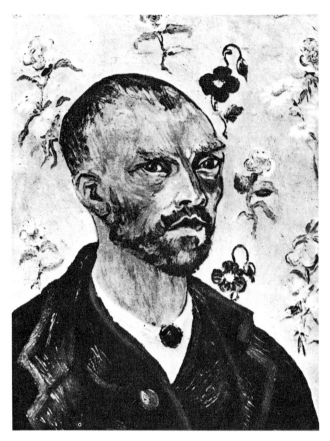

Self-portrait dedicated to Gauguin. Arles, September 1888.

'When he was fit to go out, with his head wrapped up and a Basque béret pulled right down over it, he went straight to one of the houses where those who lack friends can find acquaintances, and presented the 'doorkeeper' [128] with his ear, which he had carefully washed and put in an envelope. "Here is something to remember me by," he said. Then he hurried home, got into bed and fell asleep. He was careful, however, to close the shutters and put a lighted lamp on a table by the window.

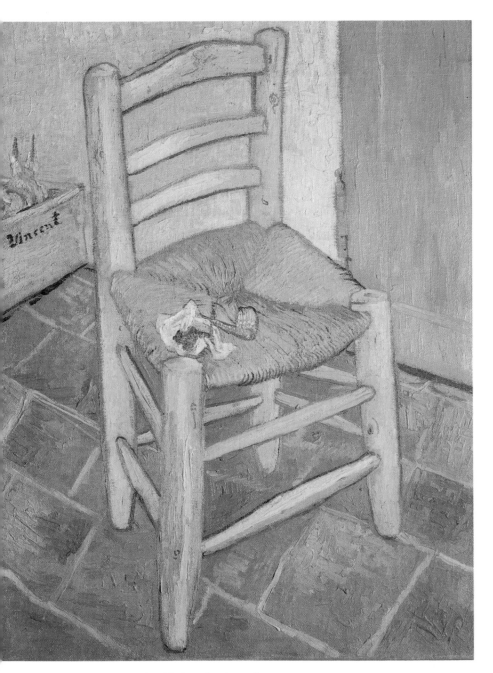

Van Gogh's Chair. Arles, December 1888–January 1889.

'I was far from suspecting any of this when I arrived at the door of our house and when the gentleman in the bowler asked me point-blank, in a tone that was more than severe:

'"What have you done with your friend?"

'"I don't know."

'"You know quite well . . . he's dead!"

'I would not wish anyone to live through such a moment, and it was several minutes before I could collect my thoughts and quiet the beating of my heart.'

Gauguin exaggerates Vincent's mutilation to heighten the drama; Vincent did not 'cut his ear off level with the skull,' but clipped off the lobe, which was enough to cause profuse bleeding.

The men went up to Vincent's room and Gauguin examined him 'gently, very gently' . . . fortunately he was alive. Gauguin advised the police superintendent: 'Be good enough to wake this man with great precautions, and if he asks for me, tell him I have left for Paris, the sight of me might be fatal to him.'

The superintendent sent for a carriage which took Vincent to the local hospital, while Gauguin despatched a telegram to Theo.

The story in the *Mercure* gives us only two reliable facts—that Vincent deliberately mutilated his ear, and that he was subsequently taken to hospital; both these pieces of information were published in the *Forum Républicain* of 30th December. Several explanations have been suggested: that Vincent heard some obscene language in a brothel and, after his return home, was overcome by a fit of religious despair and slashed at the ear that had been defiled; that one of the prostitutes he used to visit had jokingly asked him for one of his ears, as a parody of tauromachy. All this is mere guess-work, for Vincent himself never explained his action.

Whether we assume that he acted under the influence of something he thought he had heard; whether he was carrying out a sacrificial mutilation such as he had tried to commit in the flame of Kee's father's lamp; or whether it was a senseless impulse, the fact remains that when Vincent cut off the tip of his ear he was temporarily out of his mind.

Vincent knew that one of his mother's sisters was an epileptic and that there had been other similar cases in his family, that he himself

was morbidly irritable, and that certain aspects of his behaviour had so much upset his parents that at one time they had talked of placing him *en curatelle*. Even as a child he had had fits of aggressiveness, ill-temper and violence, both at home and at school. There were the fits of rage in Mauve's studio, and while he was living in Paris with Theo. Paul Signac, who often went out painting with him, refers frankly to the astonishment he used to feel at Vincent's inexplicable gesticulations; and Gustave Coquiot describes him in Guillaumin's studio, growing excited and throwing off his clothes and falling on his knees to make some point clear. All Vincent's acquaintances said the same thing—that he was unduly excitable, too easily carried away.

In October 1888 he wrote to Theo:

'I am not ill, but without the slightest doubt, I'd get ill if I did not eat plenty of food and if I did not stop painting for a few days. As a matter of fact, I am again pretty nearly reduced to the madness of Hugo van der Goes in Emile Wauters' picture. And if it were not that I have almost a double nature, that of a monk and that of a painter, as it were, I should have been reduced, and that long ago, completely and utterly, to the aforesaid condition.

'Yet even then I do not think that my madness could take the form of persecution mania, since when I am overwrought my feelings lead me rather to the contemplation of eternity, and eternal life.

'But in any case, I must beware of my nerves, etc.'

Vincent's instability is charted in a study entitled *La Folie de Vincent van Gogh* (Paris, 1928) by two doctors, Doiteau and Leroy [129] They outline his career up to the time when he shot himself at Auvers:

'After leaving home he spent four years at The Hague, working for Goupil; two years in London, in the same employment; ten months in Paris; then back to England, this time as assistant to a clergyman, for eight months; three months at Dordrecht as a bookseller's assistant; fourteen months at Amsterdam as a student of divinity; four months at the Mission School at Brussels; a year and ten months as a pastor in the Borinage; after which his life as an evangelist came to an abrupt and final conclusion. Henceforth he was to be a painter. He returned to Brussels and studied drawing for six months; spent eight months with his family at Etten, where his father was then pastor; went back

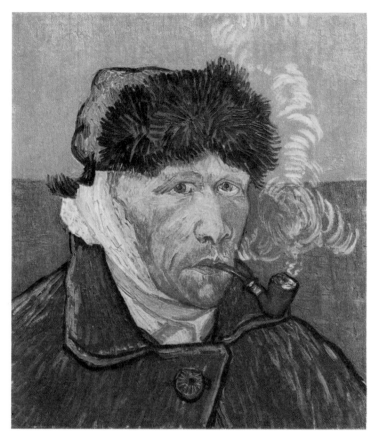

Self-portrait with Pipe. Arles, January–February 1889.

for two months; returned to his family at Nuenen, where his father had recently been appointed, and spent two years and one month there; lived at Antwerp for three months; arrived in Paris in March 1886 and remained for two years and one month; went to Arles in February 1888; was put into an asylum at Saint-Rémy in May 1889; disregarding Dr Peyron's objections he forced Theo's hand, left the asylum in May 1890, and died at Auvers-sur-Oise in July of that year.'

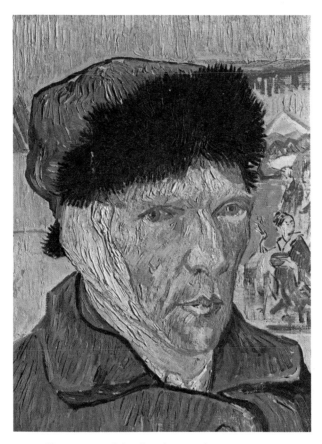

Self-portrait with bandaged Ear. Arles, January 1889.

For a variety of reasons—overwork, nervous strain, exacerbated sensibility, instability, guilt feelings, illness and 'a blind frenzy for work' —Vincent was a sick man, a fate it is safe to say he had foreseen for a long time. Theo too was threatened, Vincent believed.

In May 1888, Vincent wrote to Theo: 'I am inclined to think that he (Gruby) is slightly exaggerating the heart condition to the neglect of the need to give you a definite treatment for your nervous system.'

Upon receiving Gauguin's telegram of 24th December Theo took

the first train to Arles. He was not allowed to see Vincent, who was delirious a good deal of the time, and suffering from visual and auditory hallucinations. The best Theo could do was to ask the house physician, Félix Rey, to keep an eye on him. Dr Urpar, the doctor in charge of the *hospices civils* at Arles, diagnosed Vincent's case as 'acute mental derangement, accompanied by generalized delirium.' The ear was slowly healing, with no complications.

After three days Vincent's mind cleared; he was grieved to learn that his brother had been there and gone away again. Gauguin should not have sent for him. On 29th December he was transferred to the general ward, where M. Salles, a Protestant clergyman attached to the hospital, visited him. He was apparently rather vague as to what had occurred. 'My *dear boy,* I am so terribly distressed over your journey,' he wrote to Theo on 1st January; 'I wish you could have been spared that, for after all I came to no harm and there was no need for you to be so upset.'

On the back of this letter Vincent added a note for Gauguin, 'a few words of very deep and sincere friendship.' He does not refer directly to the tragedy, only expressing regret that Gauguin should have thought fit to alarm Theo: 'Look here, was my brother Theo's journey really necessary, my friend?'

And he asks with touching humility:

'I would like . . . you to refrain, until after more mature reflection on both our parts, from speaking ill of our poor little yellow house . . .'

Vincent had no reproaches, but on the contrary, told his brother that he would send Gauguin 'his pictures which were left in the house as soon as he wants me to.' His mind was still confused. Though he recognized his own defeat quite clearly, Gauguin's attitude surprised and upset him. 'Have I scared him?' he asked Theo,[130] 'In short, why doesn't he give me any sign of life? He must have left with you. Anyhow he felt the need to see Paris again, and he will perhaps feel more at home in Paris than here.' He added, 'Tell Gauguin to write to me, and that I am always thinking about him.'

One consolation was that 'M. Rey came to see the paintings with two of his friends, doctors, and they, at least, were uncommonly quick to understand what complementaries are.' [131]

On 1st January, wrapped in a military garment, with a fur cap on his bandaged head, Vincent had been allowed to visit his house, where he looked at his own pictures and Gauguin's. He was accompanied by the postman Roulin, who never wavered in his affection for him. On 17th January he left the hospital—though returning there daily to have his dressings changed—and settled down again at home, where he slowly recovered his interest in life.

He wrote to Theo,[132] 'I now intend to paint a portrait of M. Rey, and possibly other portraits, as soon as I am a little used to painting again.'

Looking at himself in the glass, he painted two of his finest self-portraits, *with Bandaged Ear*[133] (pages 162 and 163) and *with Pipe*. This is not the face of a madman, but of one who is ageing (Vincent was approaching his thirty-sixth birthday), with emaciated features, hollow cheeks, expressionless eyes and an air of absent-mindedness. A man who is resigned, who has 'seen life' and whose hopes are at an end. In the portrait with the bandage the asymmetry of the eyes is considerably more evident than in the self-portrait of September 1888, dedicated to Gauguin, where Vincent had 'slanted the eyes a *little* in the Japanese manner.' The right eye is staring hard at the spectator (that is, at the painter himself), piercing him, scrutinizing him, while the other remains apathetic, lifeless, as though a shadow already veiled its brilliance.

The hand was still firm, the drawing vigorous, the colours rich and harmonious. In *Self-portrait with Bandaged Ear*, the colour is iridescent, with a Japanese print touched in vividly behind the sitter's head. In *Self-portrait with Pipe*, on the contrary, everything is subdued, lustreless, unutterably sad. But there is no sign of mental derangement, or even of the slightest hesitation.

On 9th January Johanna Bonger wrote to Vincent announcing her engagement to Theo, and the attention touched him; he replied at once, sending his best wishes to both of them, and saying that as he was in better health, Theo could leave for Holland with an easy mind. 'Now if I recover,' he wrote to his brother, 'I must *begin again,* and I shall not again reach the heights to which sickness partially led me.'

Money matters were worrying him, but by 17th January he had

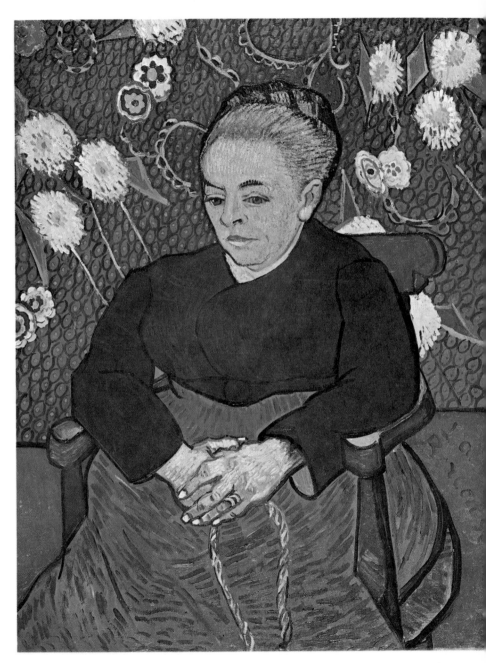

La Berceuse. Arles, January–March 1889.

'already three studies in the studio, plus the portrait of M. Rey,[134] which I gave him as a souvenir.'[135]

In the same letter Vincent wrote:

'I cannot commend you enough for paying Gauguin in such a way that he congratulates himself on any dealings he has had with us.

'Unfortunately, there again is another expenditure perhaps greater than it should have been, yet I catch a glimpse of hope in it.

'As for him, isn't he, or at least shouldn't he be, beginning to see a little that we were not exploiting him, but that on the contrary, we are anxious to secure him a living . . .?'

'If that does not attain the heights of grand projects for artists' associations that he proposed, and you know how he clings to it, if it does not attain the heights of his other castles in the air—then why not consider him as not responsible for the trouble and waste which his blindness has caused both you and me?'

More clear-sighted now, Vincent considered Gauguin's flight as a desertion.

'Gauguin has a fine, free and absolutely complete imaginary conception of the South, and with that imagination he is going to work in the North! My word, we may see some queer results yet.'

In his last letter Gauguin had gone so far as to 'call loudly'[136] for his masks and fencing gloves which he had left in the little room in the yellow house.

Vincent was working at a new version of *Woman rocking a Cradle*, for which Mme Roulin sat to him. 'Her hair is completely orange and plaited. The colour of the face is chrome yellow, naturally with some broken tints for the relief.'[137] In between times he had started two flower studies, 'nothing but sunflowers, in a yellow earthenware pot, painted with the three chrome yellows, yellow ochre and Veronese green. Nothing else.'

Vincent had also just finished 'a new canvas which is almost elegant, a wicker basket with lemons and oranges, a cypress branch and a pair of blue gloves.'[138] In addition he was working on several still-lifes: *Drawing-board and Onions,* a pair of clogs, some carnations in a vase, crabs lying on a table, etc. He was happy at having 'got back into the habit of painting.'

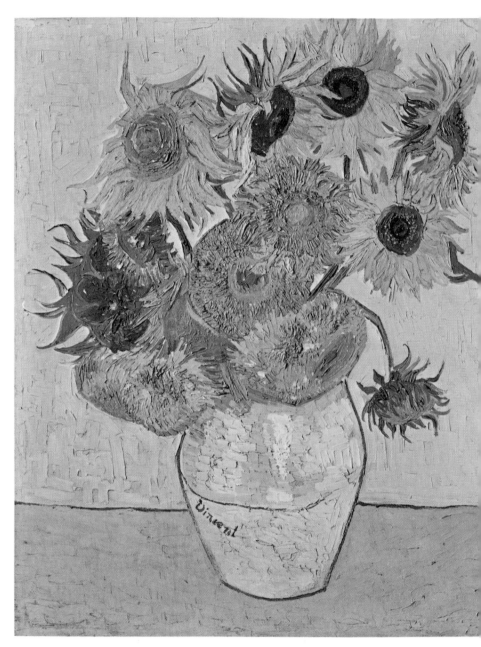

Sunflowers. Arles, August 1888.

Timidly, he confided to Theo:[139]

'Only you know how happy I shall be when your wedding has taken place. Look here now, if for your wife's sake it might be advisable to have a picture of mine at Goupil's from time to time . . .'

On the previous day, 22nd January, Roulin had left Arles, having been transferred to Marseilles. Vincent was grieved at the loss of a friend, especially as he had practically no others at Arles, except Félix Rey; but he was going through a comparatively optimistic phase and his mood showed itself in a variety of plans for the future. He was still planning to compensate Theo with pictures for the money he was giving him, and now reverted to calculations based on the hypothetical sale of his paintings, his brother's earnings, exchanges with other painters, and so on.

The hallucinations which for a time had continued to trouble his sleep had now ceased. 'I'm so eager to work that it amazes me,' he wrote to Theo; but the old frenzy had now made way for a moderated, more solemn ardour. Nevertheless, one can sense in his letters that his brain was overburdened, one can guess the questions he was asking himself, his anguish, his fears, his doubts, and the nagging anxiety that preyed on him.

'You will have gone on being poor all the time in order to support me,' he writes to Theo, 'but I will give you back the money or give up the ghost.'

He adds further on in the same letter:

'Perhaps someday everyone will have neurosis, St Vitus' dance, or something else.

'But doesn't the antidote exist? In Delacroix, in Berlioz, and Wagner? And really, as for the artist's madness of all the rest of us, I do not say that I especially am not infected through and through, but I say and will maintain that our antidotes and consolations may, with a little good will, be considered ample compensation.' [140]

Vincent was continually painting and repainting his *La Berceuse: Madame Roulin*. Rey advised him to take some relaxation, so he went to a performance of 'La Pastorale' at the Folies-Arlésiennes and found it delightful. He was happy, too, to see Roulin, who came home for the day, and to show him the two versions of his wife's portrait. In

fact everyone was being very kind to him, 'kind and attentive as if I were at home.' At the beginning of February he had the preposterous idea of paying a call on Gaby, the prostitute to whom he had presented the lobe of his ear; the poor creature must have been startled to receive her strange client. But after all, 'there will always be moments when one loses one's head,' he wrote to Theo, adding that in the South of France there was nothing really extraordinary about that.

One morning Vincent came to Rey's room in the hospital when he was shaving.[141] As Vincent approached he caught sight of the razor and his expression changed.

'What are you doing, Doctor?' he asked.

'Shaving, as you can see,' Rey answered.

Vincent held out a shaking hand:

'I'll shave you if you like . . .' Rey turned on him sharply.

'Go at once!' he ordered.

Vincent turned on his heel and left the room. This incident was followed by a fresh attack. Rey, who had been expecting it for several days, prevented a scandal by getting Vincent into the hospital for the second time.

On 13th February, anxious at not hearing from his brother, Theo sent a telegram to Rey, who telegraphed back: 'Vincent much better, hope getting better, keeping him here. Do not worry now.'

It was true that after a few days Vincent's balance returned. But he was forced to realize that he might relapse into insanity again at any moment. 'So often I feel quite normal,' he wrote to Theo,[142] 'and really I should think that if what I am suffering from is only a disease peculiar to this place, I must wait here quietly until it's over . . .' Supposing the whole of Arles were afflicted with madness? 'It seems to me that the people here have some superstition that makes them afraid of painting . . .' Perhaps Gauguin and he had been the victims of this species of curse? When Koning wrote to Vincent saying he would like to come to Arles and bring a friend, Vincent said, 'I do not dare persuade painters to come here after what has happened to me, they run the risk of losing their wits like me . . . Let them go to Antibes, Nice, or Menton, it is perhaps healthier.'

Vincent was thinking of going into an asylum—not, alas, in the hope

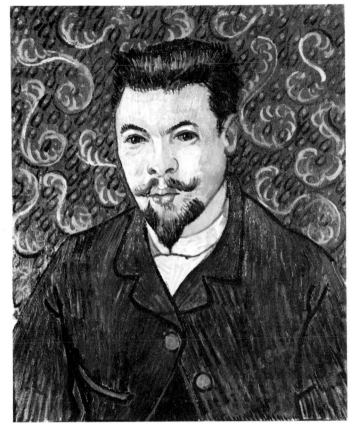

Portrait of Dr Rey. Arles, January 1889.

of being cured, but to be better looked after. He no longer had the heart to live alone in the little yellow house, and though he was hard at work, he who a few months before had been dashing off pictures in less than an hour was now patiently beginning a fourth version of *La Berceuse*. True, he had presented the best of the three earlier versions to his model. Mme Roulin, who had taken it away with her to her mother's house.

On 19th March 1889 Vincent wrote to Theo from hospital:

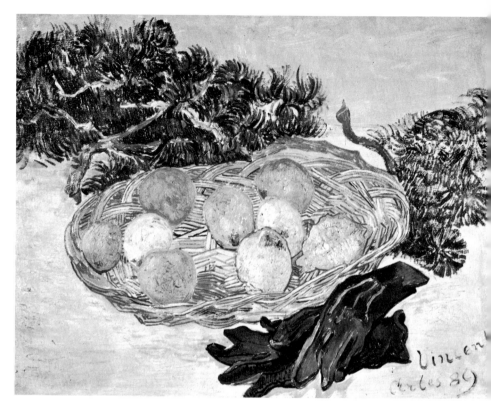

Still-life. Arles, January 1889.

'I seemed to see so much brotherly anxiety in your kind letter [143] that I think it my duty to break my silence. I write to you in full possession of my faculties and not as a madman, but as the brother you know. This is the truth. A certain number of the people here (there were more than 80 signatures [144]) addressed a petition to the Mayor (I think his name is M. Tardieu), describing me as a man not fit to be at liberty, or something like that.

'The Chief of Police or the Chief Constable then gave the order to shut me up again.

'Anyhow, here I am shut up in a cell all the livelong day, under lock and key and with keepers; without my guilt being proved or even open to proof.

'Needless to say, in the secret tribunal of my soul I have much to reply to all that. Needless to say, I cannot be angry, and it seems to me a case of *qui s'excuse s' accuse.*

'. . . If I did not restrain my indignation I should at once be thought a dangerous lunatic. Let us hope and have patience. Besides, strong emotions can only aggravate my case. That is why I beg you for the present to let things be without meddling.

'Take it as a warning from me that it might only complicate and confuse things.

'All the more because you will understand that while I am absolutely calm at the present moment, I may easily relapse into a state of overexcitement on account of fresh moral emotion.

'So you understand what a staggering blow between the eyes it was to find so many people here cowardly enough to join together against one man, and that man ill.'

Had Vincent had a fresh attack? The street-urchins, seeing him go by in his strange clothing, with his bandaged head, bent shoulders and fixed gaze, would call out 'Here comes the madman!' and throw stones at him. One day the unfortunate man lost his self-control and rushed at them, babbling threats. But the charges against Vincent were based on nothing more than gossip and guess-work; the fact was that some of the townspeople believed they were in danger from the 'red-haired madman' and thought of various pretexts to have him shut up.

Around him it was spring, just as when he had come to Arles exactly a year ago; but now he felt none of his former joy, for all his hopes had been disappointed. The studio of the South had come to nothing, Gauguin had betrayed and deserted him and the good people of Arles were doing their worst. He found himself alone in a cell, with no other furniture than an iron bedstead, and the yellow house had been locked up. His letter to his brother ends on a note of distressful resignation:

'They pester me because of my smoking and drinking, but what's the use? After all, with all their sobriety they only cause me fresh misery. My dear brother, the best we can do perhaps is to make fun of our petty griefs and, in a way, of the great griefs of human life too. Take it like a man, go straight to your goal. In present-day society we artists are only the broken pitchers. I so wish I could send you my

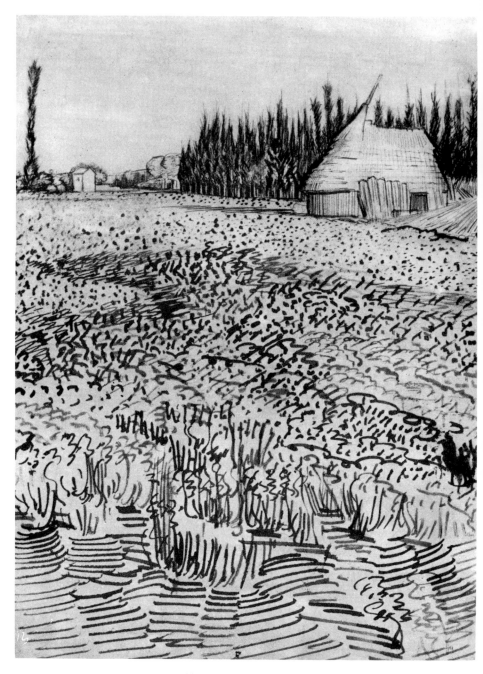

Field near Arles. Arles 1888–89.

paintings, but all of them are under lock and key, guarded by police and keepers. Don't try to release me, that will settle itself . . .'

Signac was to stop at Arles to see Vincent on his way to Cassis. Vincent wondered whether he would be allowed to leave the asylum and show him his pictures.

He was apprehensive about the future. He feared that he might never again be able to work as before, nor be capable of painting 'better in the orchards than I did last year.' [145]

'If sooner or later I should go really mad, I think I should not want to stay on here at the hospital, but just now I want to come and go freely.' [146]

Signac's visit did Vincent good. The doctor had decided that his condition was satisfactory and let him go out, and the two men were able to get into the yellow house. Signac, expecting a raving lunatic, was pleasantly surprised to find a man 'full of sense',[147] and even more so to discover the pictures that had accumulated during the past twelve months. They made a dazzling display. Signac was both bewildered and enraptured by them. 'I found your brother in perfect physical and mental health,' he wrote afterwards to Theo. 'He took me along to see his pictures, many of which are very good, and all of which are very curious.'

Why did Signac tone down his first impression? He was a man without warmth, it is true, and little given to enthusiasm. Perhaps, too, he may have felt a twinge of jealousy when faced with such magnificent accomplishment. Vincent summed him up as a man 'of balance and poise' and added, 'Rarely or never have I had a conversation with an Impressionist so free from discords or conflict on both sides.' [148] Signac was certainly not the man to clash with him or to change his views.

The two spent one afternoon and the whole of the following day together. Vincent warmed in his friend's presence, he grew excited; on the second evening he suddenly raised a bottle of turpentine to his lips. The gesture was probably automatic or unconscious, but it worried Signac, who thought it was time for Vincent to get back to the hospital.

The visit put fresh life into Vincent, who presented Signac with one of his latest canvases, *Still-life with Red Herrings,* as a souvenir. He

again felt 'the desire to work, the taste for work', and wished he could recover his former excitement and happiness, though he feared that this could never be. 'I shall never be able to found an upstanding building on a past so worm-eaten and tottering.' He must resign himself. He wrote gloomily to his brother:

'I am thinking of frankly accepting my role of madman, just as Degas took the part of a notary.' [149]

Theo was about to leave for Holland to get married. For the fifth time, Vincent returned to his portrait of Mme Roulin rocking the cradle. He used no other model so often, except himself. For in his eyes the postman's wife was motherhood personified, the symbol of 'the fruitful life' that Theo was about to experience in his stead. He had begun by painting her with her baby, but later he merely suggested the child's presence by showing the cord that Mme Roulin used to pull to rock the cradle.

Vincent was always haunted by symbols of motherhood and fertility. He began by depicting Sien suckling her baby; then, in Paris, he painted a young middle-class wife, seated beside a muslin-hung cradle in a comfortable room; and finally the seven portraits of Mme Roulin holding or rocking her baby. Like Sien, the sturdy, simple woman of Arles came from the common people; but unlike the prostitute she was the embodiment of health, security and quiet happiness, and despite her age she still had a youthful air, for 'no woman is old as long as she loves and is loved.' A mother, strong yet gentle, and with a good head on her shoulders, Mme Roulin symbolized life in Vincent's eyes; but his pictures of her were also a tribute to his own mother, whom he was not sure of ever seeing again.

To Theo and his fiancée he sincerely and bravely wished great happiness. He inevitably felt 'a certain underlying sadness, vague and hard to define', but his work distracted him, and his strength was returning. He had been to the yellow house again to fetch canvases and painting materials, and on 24th March asked his brother for ten or a dozen tubes of paint, 'in case . . . I should set to work shortly on the orchards again.'

And sure enough, he soon set up his easel before an orchard of peach-trees, beside a lane, with the Alpilles as a background. He had

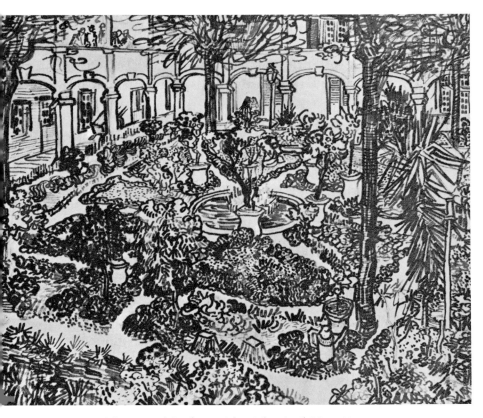

The Hospital Garden at Arles. Arles, April–May 1889.

got back his books too, and was re-reading *Uncle Tom's Cabin* and Dickens' *Christmas Carol*.

The work was going well. The weather was fine, and in the 'glorious sunshine' Vincent painted several canvases, including *The Crau at Arles, Peach-trees in Bloom,* and *A View of Arles,* which he describes in a letter to Paul Signac. In all, he did 'six studies of springtime, including two large orchards'. Moving out of the yellow house for good, he took two small rooms let by Dr Rey for six or eight francs a month. He stored his furniture in a room at the 'All-Night Café' and sent off two packing-cases full of pictures to Theo. He wrote affectionately to

him, telling him that he wished to enter the hospital at Saint-Rémy. He described his packing to leave his house:

'Do not be grieved at all this. Certainly these last days were sad, with all the moving, taking away all my furniture, packing up the canvases that are going to you, but the thing I felt saddest about was that you had given me all these things with such brotherly love, and that for so many years you were always the one who supported me, and then to be obliged to come back and tell you this sorry tale, but it is difficult to express it as I felt it. The goodness you have shown me is not lost, because you had it, and it remains for you; if the material results should be nil, it remains for you all the more, but I can't say it as I felt it.' [150]

Vincent, who had just asked Theo for forty-four large tubes of paint and thirty-nine small ones, now sent him, as a strange wedding-present, a carefully compiled list of his expenses. Regarding his decision to enter Saint-Rémy, he wrote: 'I am beginning to consider madness as a disease like any other and accept it as such.' Vincent wished to remain shut up for the time being as much for his own peace of mind as for other people's. But he did not want to discuss the matter.

'It will be enough, I hope, if I tell you that I feel quite unable to take a new studio and to stay there alone, here in Arles or elsewhere . . . I have tried to make up my mind to begin again, but at the moment it's not possible.' [151]

He was truly glad to think that Theo was married, the liaison he had contracted two years before had worried Vincent a great deal, and he had always been asking Theo for news of his health, which seemed not much better than his own. To Johanna, his sister-in-law, he could now entrust his much-loved brother, thanks to whom he was still alive and able to work. And to Theo he wrote: '. . . transfer this affection to your wife as much as possible. And if we correspond somewhat less, you will see that if she is what I think her, she will comfort you.'

Theo has been unjustly criticized, even very recently. While working for Boussod & Valadon he was always striving, though without success, to call attention to his brother's pictures and to sell them. Later on, and particularly during their months together in Paris, their relations were often strained because of Vincent's touchiness and quick

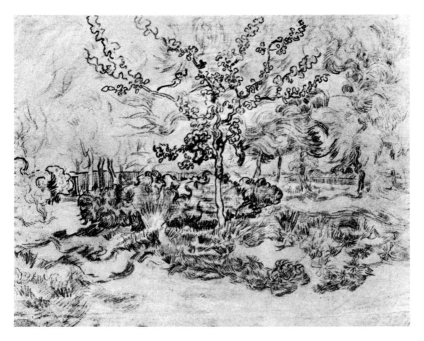

Garden in Provence. Arles, 1888–89.

temper. Even so, Theo never rebelled, never retorted, never blamed his brother; he realized that his role was not to criticize but to show understanding, and he tried with all his might to understand his exasperating, affectionate brother, his comrade and his cross—a heavy one to bear—his pathetic *alter ego,* and the radiance given off by their union. Should he have sacrificed everything to the brother he once described as 'his own enemy'? It would be unreasonable to regret that he married and blame him for it. And if he faltered now and again it was because the burden was too heavy and because Vincent so often seemed ungrateful, especially where the thorny problem of money was concerned.

By this time Vincent van Gogh had scarcely fifteen months to live, and those last months were to be spent in a relentless struggle. Despite the terrors of his malady and the dread of further attacks, he pushed

on, drawing fresh courage from his conviction that work was 'the best lightning-conductor for my disease'. It was not as an echo of the excitement or impetuosity of his early days at Arles that he went on painting, it was simply in order to keep alive. He had ceased to ask himself whether his fate was deserved, and to men's indifference or contempt he now paid little heed.

On 29th April, Pastor Salles, armed with a letter from Theo, went to visit the asylum at Saint-Rémy. This was housed in the ancient and partly dilapidated buildings of a former monastery, Saint-Paul-de-Mausole—the oldest portion of which dates from the 12th century and includes graceful Romanesque cloisters. Dr Peyron, the director, asked a hundred francs a month for Vincent's board and lodging, and would not agree that he might go out to paint. Discouraged, poor Vincent even contemplated joining the Foreign Legion—a plan against which Theo protested vigorously in a letter dated 2nd May. 'That idea,' he wrote, 'comes from an exaggerated fear of causing me expense and trouble, and you worry yourself quite unnecessarily. The last year has not been a bad one for me so far as money is concerned, so without hesitation, or fear of putting a strain on me, you can count on having what I used to send you.' And he added:

'Do you realize that in a way you're not to be pitied, although it seems otherwise? How many people would be glad to have done your work? What more do you want? Isn't that what you wanted, to have created something; since it has been given to you to do what you have, why should you despair of being able to do some more good work in due time? . . . I feel sure that if you want to, you'll soon be able to get back to work. But don't imagine that I don't understand how downcast you felt when you went back to your studio, for example, and found it mildewed. Hold on a bit longer, courage, the disasters will surely come to an end.'

This affectionate letter put fresh heart into Vincent, though he still persisted in his idea of joining the Foreign Legion if his health would allow it. Meanwhile he announced that he was sending Theo 'two cases of canvases . . . there are lots of daubs among them which you will have to destroy.'

Vincent had lately been out in the country round Arles, painting

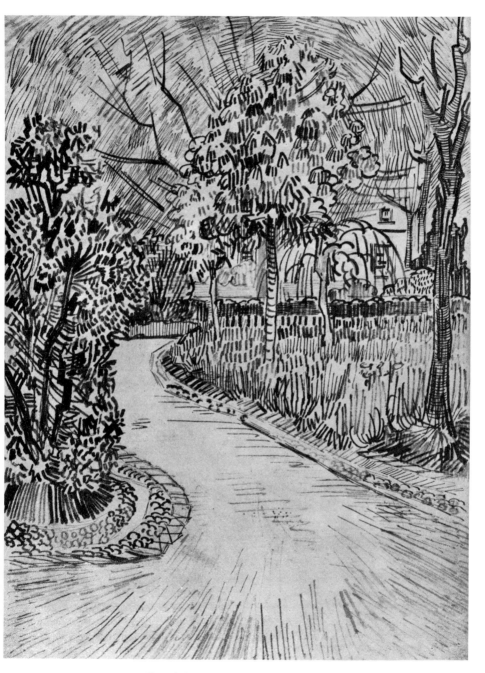

Alley of the Park at Arles. Arles, 1888–89.

orchards and olive trees 'with their dull silver and bright silver foliage turning to green against the blue.' He also painted a view of the courtyard at the hospital and of the men's ward, with the same energy as before, but in a more measured, meditative, reflective style.

'I am working... and have just done two pictures of the hospice, one of a ward, a very long room, with rows of white-curtained beds and a few patients moving about. The walls, the ceiling with its huge beams, everything is white, mauve-white or green-white. Here and there a window with pink or light green curtains. The floor paved with red bricks. At the far end, a door with a crucifix above it. It is very simple. And then, as a companion picture, the inner courtyard. That is an arcaded gallery, like the Arab buildings, whitewashed. These cloisters surround an ancient garden with a pool in the middle

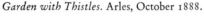

Garden with Thistles. Arles, October 1888.

and eight flowerbeds . . . So it's a picture full of flowers and springtime greenery.' [152]

Vincent wanted to give Rey the painting of the ward as a keepsake, but the doctor refused it for fear of his family's derision. The hospital's dispenser happened to be going past, and Rey called out to him:

'Would you like this picture Vincent has just offered me?'

The other man glanced at the painting and answered without even pausing on his way:

'What the devil should I do with that mess?'

Finally, the picture went to the almoner, who found it intriguing.

Its reception was a discouragement for Vincent, who had always hoped that his painting would appeal to ordinary, simple, unprejudiced people.

'As a painter I shall never really count, I can feel that absolutely,' he mourned.

On 2nd May he told Theo that he 'was doing an avenue of pink flowering chestnuts and a little cherry-tree in flower and a wisteria plant and a path in the garden splashed with light and shade.' Two or three days later he wrote to Willemien saying he had finished 'a landscape showing an olive-orchard, the green greyish, just about like that of willows, their shadows falling purple on the sunny sand' and 'a field of yellowing corn enclosed in brambles and green bushes.' Little attention was now paid to him, so he could settle down quietly to paint in the public gardens, with nothing to disturb him except the occasional curiosity of passers-by.

With Theo's agreement he made up his mind to move to the asylum at Saint-Paul-de-Mausole [153] despite the high charges, hoping that in the end he would get permission to paint. Now, at the beginning of May, the weather was fine and Vincent's morale was good, as can be gathered from his letters to his brother, in which he sets forth his ideas on art—something he had not done for a long time. We should note here one profession of faith—'If a painter paints what he sees, he always remains somebody', and one exclamation: 'Ah, to paint figures as Claude Monet paints landscapes!'

A postscript says:

'I must make the best of it, it is only too true that lots of painters go

mad, it's a life that makes you, to say the least, very absent-minded. If I throw myself fully into my work again, very good, but I shall always be cracked.'

'. . . I hope that there will be some canvases in the batch I have sent you that will give you some pleasure. If I remain a painter, then sooner or later I shall probably be in Paris again, and I promise myself in that case to give some old canvases a good overhaul.'

Vincent painted nearly two hundred canvases while he was at Arles —a hundred landscapes, about fifty portraits, and forty still-lifes or interiors, not counting the number which were destroyed or lost. He also did about a hundred drawings. This was his richest period, when the rhythm of his line and the force of his colour reached their climax, driving factors that kept pace with his momentum, his communion with the scene or object he was painting. All his colours are naked, pure, violent.

'The colour,' he notes, 'suggests the fiery atmosphere of harvest at full noon, with the heat at its most intense.' The country round Arles 'blossoms in yellow and mauve', it is 'a range of blues, brightened by a series of yellows that go as far as orange.' Or he tries, as he writes in a letter to Emile Bernard, 'the effect of a more intense blue in the sky'. His vineyards in autumn are 'green, purple, yellow with mauve bunches of grapes, with black and orange-tinted branches.' In the portrait of his friend Boch he wants to put 'orange tints as fiery as red-hot iron . . . tones of old gold, glowing in the darkness'; and in some of his paintings, where he has tried to give the full radiance of the light, there are 'effects like stained glass'.

Of his dazzling, explosive sunflowers he wrote: 'You know that the peony is Jeannin's,[154] the hollyhock belongs to Quost,[155] but the sunflower is mine in a way.' [156]

He was the sun's prey, its rays pierced him, and he followed its seasonal rhythm; in the winter he was depressed and gloomy, in spring he began to kindle, at midsummer he burst into flame, and then sank gradually back again into prostration and sadness. His whole life followed a similar pattern; it reached its zenith at Arles, but decline was inexorable. The dramatic incident of the slashed ear was the first sign.

184

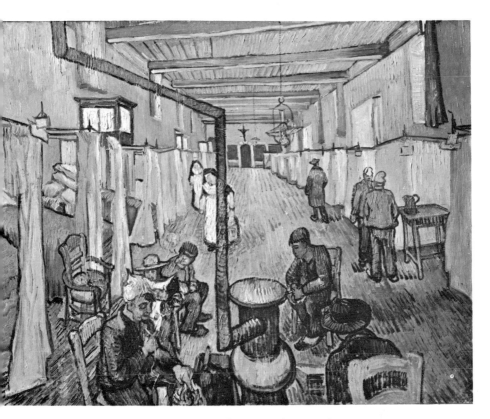

Room in the Hospital at Arles. Saint-Rémy, October 1889.

SAINT-RÉMY
3rd May 1889—16th May 1890

On 3rd May, Vincent moved into the asylum of Saint-Paul-de-Mausole. Is it possible, in the present state of knowledge, to say exactly what was wrong with him? And in the first place, was he 'mad'?

His letters have been closely studied; none of them (or at least, none of those that have survived, and there are nearly seven hundred and fifty) [157] shows the slightest sign of mental alienation; their clarity of expression and keenness of observation are undeniable. Moreover, he is

Hall in the Hospital of Saint-Paul. Saint-Rémy, 1889.

determined to recover his health, suggests the origin of his malady and tries to observe its course. After the February crisis he was taken into hospital at his own request—a request not made impulsively, but with full awareness of the implications. He was afraid of causing another scandal, of doing something he would regret, he wanted to protect himself and other people.

The 'madness' that brought him to Saint-Paul-de-Mausole was not simply the outcome of his breakdown at Christmas in 1888, when he mutilated his ear. This had been preceded by a long course of be-

haviour which was regarded in the town as proof that he was out of his mind. But we must remember that the term was often applied in those days to artists whose work disconcerted or repelled their contemporaries. When the *novateurs* first appeared in 1863, at the *Salon des Refusés,* and when the Impressionists held their earliest exhibitions, the critics made no bones about accusing Manet, Renoir, Monet and Cézanne of 'madness'—and indeed the painters were inclined to bandy the term among themselves. Madness was fashionable in the latter half of the 19th century.

Doctors Rey, Urpar and Peyron (the last being the director of Saint-Paul-de-Mausole) believed that Vincent's trouble was a form of epilepsy, and this opinion was supported by Leroy, Doiteau and Françoise Minkowska;[158] whereas Kraus (whose paper on *Vincent van Gogh en de Psychiatrie* [159] established him as an authority), Karl Jaspers [160] and Westerman-Holstijk [161] incline to the theory that he suffered from schizophrenia. Until he entered the asylum, Vincent's rare but violent attacks were followed by calm periods during which he would paint, write and behave quite normally, apart from an occasional unexpected gesture, such as his attempt to swallow turpentine during Signac's visit. And even that has been given too much importance, for it is not unusual for a heavy drinker, after a long period of temperance, to feel a sudden urge to drink whatever he finds at hand.

Professor Henri Gastaud, whose study of van Gogh is one of the most interesting,[162] shows that the symptoms of his 'madness' correspond to those of latent epilepsy, in the form known as *'petit mal'*, described in France by Morel, and now known to be due, in the majority of cases, to a cerebral lesion affecting the temporal lobe of the brain.

On the basis of this diagnosis, Dr C. Escoffier-Lambiotte [163] has traced the evidences of this malady displayed by Vincent.

In the first place, van Gogh was subject to psychomotory attacks of which he afterwards had no recollection and which resulted either from hallucinations (as when he kicked a hospital orderly), from a sudden outbreak of aggressiveness brought about by loss of conscious control (as when he threw the glass of absinthe in Gauguin's face just before the ear-cutting incident, or when he threatened Gauguin, and subsequently Dr Rey, with a razor), or from nocturnal fantasies ex-

pressed in uncontrolled movements resembling epileptic somnambulism.

Dr Escoffier-Lambiotte goes on to say that van Gogh showed unmistakable signs of the two types of permanent confusional state described by Falret in 1860 in a paper entitled *'De l'état mental des épileptiques'*—periods of slight mental disorder (*petit mal*), during which he would gesticulate, talk wildly and behave strangely (Emile Bernard, Signac, Coquiot and Gauguin give many detailed descriptions of such behaviour); and periods of great agitation or hallucinations during which he would fall into convulsions, scream, insult and threaten people, followed by prostration, calm, and a gradual return to normal.

Between attacks he was visited by fits of terror or anguish, for which he usually tried to prepare himself; or he went through brief periods of absent-mindedness, with sudden violent fits of rage provoked by trifles.

Intellectually Vincent appeared completely normal; his intuitive powers were well developed, his judgment acute and lucid, he read a great deal, invariably the more difficult authors, and he was fluent in four languages, which he wrote and spoke with equal ease. His intellectual excitability was constantly on the boil; always on a leash, it increased the natural impulsiveness of his character. Even the most ordinary conversations soon became violent.

Vincent went out of his way to provoke quarrels, assailing his opponent and harassing him so effectively that the latter tired and gave in. In his altercations and debates with Gauguin, stoked with absinthe, it was never long before tempers flared. For instance, their discussions in front of the pictures in the museum at Montpellier were charged, in Vincent's own words, with 'an excessive electricity'. And if one wishes to explain his lack of mental stability, one must not lose sight of the crises of morbid hyper-religiosity during his stay in the Borinage, which was later replaced by a kind of no less incoherent agnostic socialism that led him from excess to excess.

Dr Escoffier-Lambiotte tells us that 'Vincent's cerebral lesion probably dated from his birth, when labour was prolonged (his mother was small and delicate, and was then thirty-five years old). A craniofacial assymmetry (evident in some of his portraits, particularly the one painted in October 1888 and now in the Munich art gallery) which was

188

most probably connected with a cerebral lesion dating from a very early stage supports this hypothesis.

'In addition, there was certainly a family history of nervous instability. His brother suffered neuro-psychic disturbance shortly before he died, and schizophrenia confined one of his sisters to an asylum for thirty-eight years.'

At Saint-Paul, Vincent's behaviour continued to swing from one extreme to the other, fits of violence alternating with periods of calm. When he seemed quiet, lucid and reasonable he was allowed to go about, either with a male nurse or alone, and was thus able to paint.

When he first arrived, Vincent was entered in the Register of voluntary patients:

Monsieur Vincent van Gogh, aged thirty-six, painter, born in Holland at Groot-Zandeel (sic), *now resident at Arles (B.d.R.).*

In the second column, headed 'person entering the patient', we read:

M. van Gogh Théodore, aged thirty-two, born in Holland, resident in Paris (Seine), patient's brother.

In the third column, 'Copy of medical certificate accompanying the application', comes a transcription of a certificate issued by Dr Urpar, of the hospital at Arles:

I the undersigned, doctor in charge of the hospital, certify that Van Gogh (Vincent), aged thirty-six, suffered six months ago from acute mania with general delirium. At that time he cut off his ear. At present his condition has greatly improved, but he none the less considers it advisable to enter an asylum for treatment.

Arles, 7th May 1889
Signed: Dr Urpar. Copy certified by the Director: Dr Peyron.

The certificate is undated, gives no details of the nature of the illness, and the statement that Vincent 'cut off his ear' shows that the doctor had not looked very closely into the matter.

'I wanted to tell you,' wrote Vincent to Theo on 8th or 9th May 1889, 'that I have done well to come here; first of all by seeing the *reality* of the life of the various madmen and lunatics in this menage-

View of Saint-Rémy. Saint-Rémy, 1889–90.

rie, I am losing the vague dread, the fear of the thing. And little by little can come to look upon madness as a disease like any other. Then the change of surroundings does me good, I think.'

In this environment he came to feel an immense pity for the poor, demented creatures with whom he was in continual contact; some seemed utterly dazed as though withdrawn from the world, others suffered terrible attacks of frenzy. One man used to beat his breast with shrieks of 'My mistress! My mistress!' Another believed the tragedian Mounet-Sully hated and was victimizing him; another could make only inarticulate sounds.

Vincent came near to believing that here he was as it were atoning for his own irritability, his errors. If it had to be, he would submit to this new trial; he felt subdued, resigned.

'It is those who love nature to the extent of becoming mad or ill who are painters ... Although there are some very grave cases here,

the fear, the horror I used to have of going mad has already greatly diminished', Vincent wrote to Theo's wife, Johanna, in a letter enclosed with the one quoted above.

'But quite seriously', he wrote to his brother on 25th May, 'My *fear* of madness has considerably lessened.'

He had a smallish room with green-grey wallpaper, sea-green curtains, 'with a design of very pale roses, brightened by thin blood-red lines.' There was a very shabby armchair, upholstered with tapestry 'splashed over, like a Diaz or a Monticelli, with brown, red, pink, white, cream, black, forget-me-not blue and bottle green. Through the iron-barred window I can see a fenced patch of wheat, a perspective like van Goyen, above which I see the morning sun rising in all its glory. Besides this one—as there are more than thirty empty rooms—I have another to work in.

Park. Saint-Rémy, 1889–90.

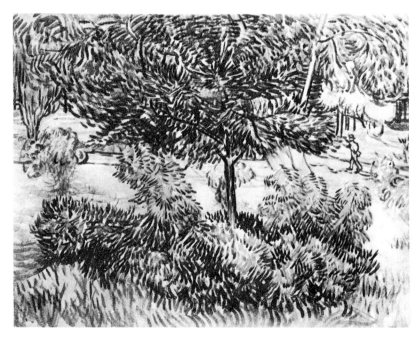

'The food is so-so. It naturally tastes a bit musty, like a cockroach-infested restaurant in Paris or a boarding-house.' [164]

Being allowed to work, he promptly set up his easel in the garden and painted four pictures of a clump of iris and a lilac-bush, and then some ivy-covered tree-trunks. He also drew a stone seat in a deserted corner of the grounds, the fountain and its basin, and a big 'death's head' moth.

He needed colours, and asked his brother to send eight large tubes: emerald green, cobalt, ultramarine and orange lead, plus six tubes of zinc white, five yards of canvas, and some brushes, the size of which he indicated by sketching them. In mid-May Theo had received the consignment of paintings sent off by Vincent before he left for Saint-Rémy; he wrote to him on the 21st, saying they had arrived 'in good order and undamaged'.

'... The cradle, the portrait of Roulin, the little Sower with the tree, the baby, the starry night, the sunflowers and the chair with the pipe and tobacco are the ones I like best so far.

'The first two are particularly unusual. True, they do not have what we are taught to regard as beauty, but there is something so striking and so close to reality. How can we tell that we know better than simple people who buy crudely-coloured reproductions? Or rather, isn't their seeing charm in them just as genuine a response as that of pretentious people who see the pictures in a gallery? Now there is an energy in your pictures that certainly is not to be found in colour-lithography; in course of time the texture will become very fine, and certainly one day they will be appreciated.'

Vincent seems to echo Theo's dissatisfaction:

'I am always filled with remorse, terribly so, when I think of my work that is so little in harmony with what I should have liked to do. I hope that in the long run this will make me do better things, but we have not got that far yet.' [165]

He was working on two landscapes (size 30 canvases) 'views taken in the hills, one is the country that I see from the window of my bedroom.

'In the foreground, a field of wheat ruined and hurled to the ground by a storm. A boundary wall, and beyond the grey foliage of a few

192

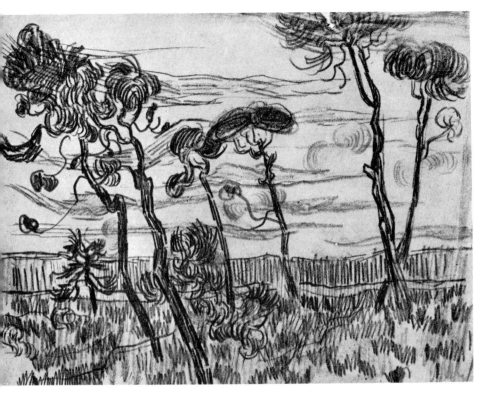

Six Pines in an Enclosure. Saint-Rémy, 1889–90.

olive trees, some huts, and the hills. Then at the top of the canvas, a great white and grey cloud, floating in the azure.

'It is queer that every time I try to reason with myself to get a clear idea of things, why I came here, and that after all it is only an accident like any other, a terrible dismay and horror seizes me and prevents me from thinking. It is true that this is tending to diminish slightly, but it also seems to me to prove that there is quite definitely something or other deranged in my brain, it is astounding to be afraid of nothing like this, and to be unable to remember things. Only you may be sure I shall do all I can to become active again and perhaps useful, at least in the sense that I want to do better pictures than before.' [166]

Theo's health was not good. 'I should have written to you long ago, but I couldn't formulate my ideas,' he wrote to Vincent on 16th June. 'I'm not sure if I can write to you as I would like, as I would like to today, but my letter shall go off all the same, if only to tell you that we often think of you and that your latest pictures make me think a lot about your state of mind when you were doing them. They all have a force of colour you have not reached until now, which is a rare quality in itself, but you go even further, and while there are some that try to find the symbol by torturing the form, I find it in many of your pictures through the expression of the epitome of your thoughts about nature and living beings, which you feel to be so closely linked with it.

Peasant Women in the Fields. Saint-Rémy, 1889–90.

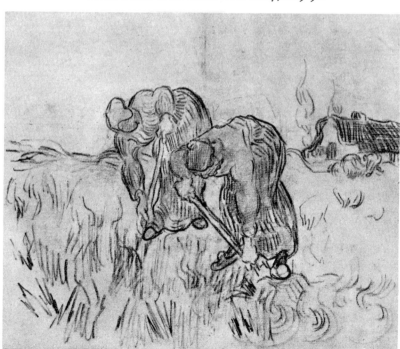

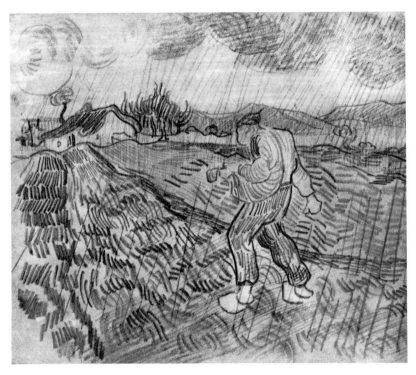

The Sower. Saint-Rémy, 1889–90.

But how your head must have laboured, and how boldly you ventured to the furthest point, where dizziness is inevitable.

'For this reason, my dear brother, when you tell me you are working again, though I am delighted in one way, since this gives you a means of avoiding the condition into which so many of the unfortunate people fall who are having treatment where you are, nevertheless I feel a little uneasy when I think of it, because before you are completely cured you must not venture into those mysterious regions which it seems one can skirt past, but not enter with impunity. Don't take more trouble than you need, for if you do no more than a simple description of what you see, there are enough qualities to ensure that your pictures will survive. Think of the still-lifes and flower pictures

Delacroix did when he went to stay with G. Sand in the country. It's true that afterwards he had a reaction and painted *The Education of the Virgin,* and it's quite possible that in doing as I say you may produce a masterpiece.'

An admirable letter, full of affection and respect for the brother Theo had so often failed to understand, who had seemed stubborn, headstrong, vindictive and unjust and whom at one time he had been anxious to get rid of. Now Theo in his turn was threatened by disease, the advance of which was gradually to become evident, and this may have helped him to appreciate Vincent's character and the meaning of his life and work. The dialogue between the two brothers had reached a new pitch of intensity.

Vincent replied on 19th June:

'Do not fear that I shall ever of my own will rush to dizzy heights. Unfortunately we are subject to the circumstances and the maladies of our own time, whether we like it or not. But with the number of precautions I am now taking, I am not likely to relapse, and I hope the attacks will not begin again.'

His own health was satisfactory. He was working without excesses, calmly, and with perfect lucidity. Having nothing to read, he asked his brother to send him the works of Shakespeare. Sœur Epiphane, the Mother Superior of the nuns attached to the asylum, was one of the few people there who took an interest in Vincent's painting; she even thought of asking him for a picture to put in the nuns' parlour, but they dissuaded her. Later she said that what she found most surprising in van Gogh's pictures was the impasto, 'like swallow droppings'. Drs Doiteau and Leroy, in the book already quoted, say that according to Dr Peyron's son, the painter worked 'like a steam engine'.

At the beginning of June the Director gave Vincent permission to go out into the country and paint under the supervision of an orderly. Vincent chose a spot not far from the asylum, to paint the fenced-in wheatfield he could see from his window; and there was a sudden change in his style. The cross-hatching of his Arles period gave way to sinuous, twirling lines, like surging waves; outlines sagged and curved inwards, forms stretched and swelled as though the wheat were heaving. On 25th June he had twelve size 30 canvases under way; the

colour had been toned down, the brilliant symphonies and contrasts had vanished; ochres, browns, Veronese green, burnt and raw Sienna and ultramarine were now dominant. 'The latest one I have started,' he wrote to Theo [167], 'is the *Wheatfield* in which there is a little reaper and a big sun. The canvas is all yellow except for the wall and the background of violet-tinted hills. The canvas that has almost the same subject is different in colouring, being greyish-green with a white and blue sky.'

Vincent painted the wheatfield three times during June; on other occasions he set up his easel in front of the cypresses. 'It is a splash of *black* in a sunny landscape, but is one of the most interesting black notes, and the most difficult to hit off exactly, that I can imagine.' The cypress was for him the symbol of the countryside in Provence, he saw it as 'the equivalent—and the antithesis of the sunflowers'. The first series of pictures, showing the trees either alone or with the cornfield, was followed a year later by a second series, painted in May 1890, shortly before Vincent left Saint-Rémy.

He now returned to a theme that had occupied him considerably while he was at Arles, the *Starry Night* (page 222). It is, of course, easy to seek for traces of his mental disorder in this picture, painted right at the end of June, as well as in the cypresses of the same month, with their whirling curves, or in the *Ripening Corn*. Those convolutions and spirals, twisting and untwisting, those prancing flames, those stars like groups of dancers in a sky where suns are revolving, those streaks of glaucous light along the hills that close the horizon, all seem to be part of a kind of cosmic upheaval. The colour no longer shines or glows, it has become like fire rising out of the ground and devouring it; the trees writhe, shoot upwards like waterspouts, or seem to be struggling with the soil that engendered them, in which their roots are growing.

Yet with what mastery, amidst his hallucinations, the painter controls the sinuous rhythm of his lines, gauges proportions and spatial relationships, restrains the whirling of his fiery spheres and composes his canvas. Vincent is entering the fantastic, visionary world he will henceforth make his own, but despite its hallucinatory appearance, its twists and undulations, its intertwining lines, his work retains an ad-

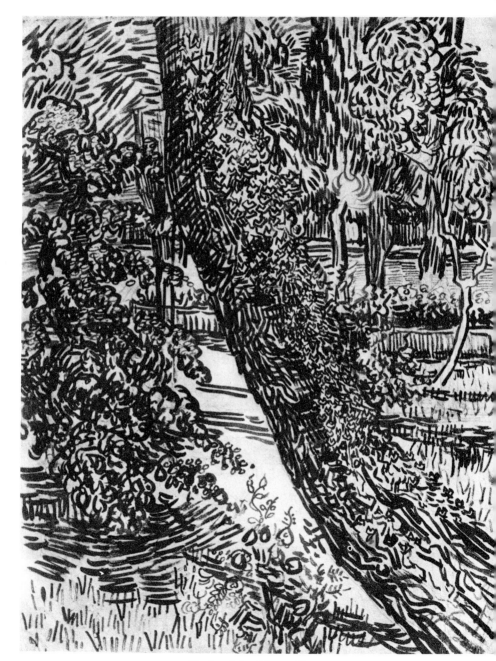

Garden. Saint-Rémy, 1889–90.

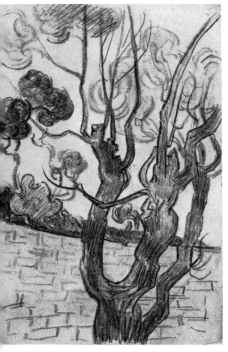

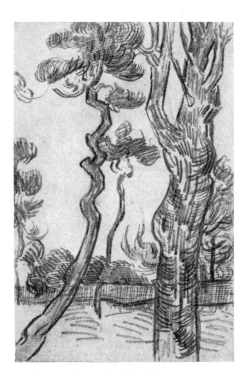

The Tree. Saint-Rémy, 1889–90. *Corner of a Park*. Saint-Rémy, 1889–90.

mirable balance, disregarding the man's frenzy and obedient to the painter's logic.

It is not, in Vincent, his exaltation which transforms and transfigures shapes, but shapes which exacerbate his passion. The danger which threatens him is in a kind of baroque style which ruins his dream of calm and serenity; it is not long since he declared that 'the sight of a picture should rest one's head, or rather one's imagination' and yet . . .

But there was another danger: the strokes grew longer, weaker, the rhythms no longer had the power of the triumphant Arles period and the colour was drained of its brilliance. A certain tendency towards symbolism added to the confusion. Concerning the *Champ de blé au faucheur*, the artist wrote: 'I see in this reaper—a vague figure fighting

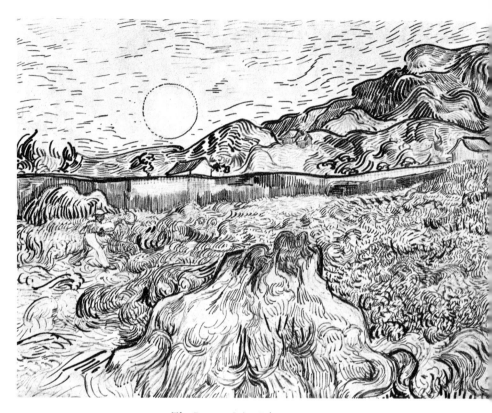

The Reaper. Saint-Rémy, 1889–90.

like a devil in the midst of the heat to get to the end of his task—I see in him the image of death, in the sense that humanity might be the wheat he is reaping . . . But there is nothing sad in this death, it goes its way in broad daylight with the sun inundating everything with a light of pure gold.' It is easy to see here the influence of his reading: Edouard Rod's *Le Sens de la Vie* which he greatly admired and which preoccupied him; but above all Shakespeare, where death is constantly on the prowl. When he read the tragedies he was so upset—so he wrote to his sister Willemien—that he had 'to go and look at a blade of grass, a branch of pine, an ear of corn to calm my self'.

After the cypress, the olive is the most characteristic tree of Provence, and Vincent often painted its black gnarled trunks, its silvery leaves: the first series in June-July 1889, a second series in September-October and a final one in November at the time of the olive harvest.

On 5th July he received a letter from Johanna, his sister-in-law, telling him that she and Theo were expecting a baby, and that if it was a boy they would name it after him. Despite her happiness Johanna had fears for it, since neither she nor Theo were in good health.

Vincent answered at once, encouraging Theo and Jo to take a bright view, telling them that the Roulins' child came to them smiling and

Mountain Landscape. Saint-Rémy, 1889–90.

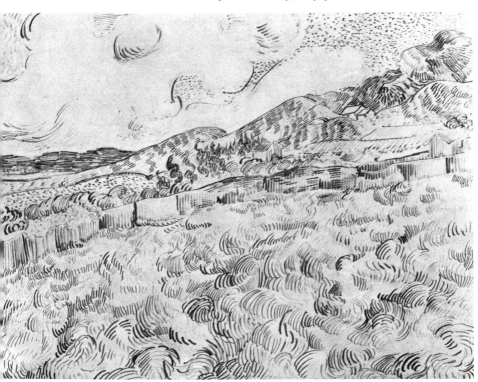

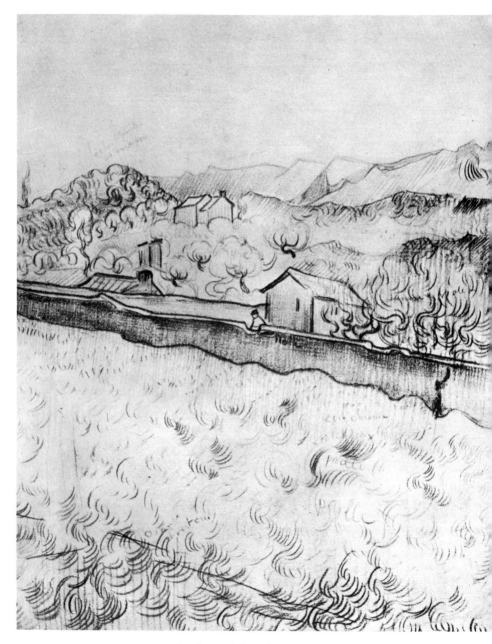

Landscape. Saint-Rémy, 1889–90.

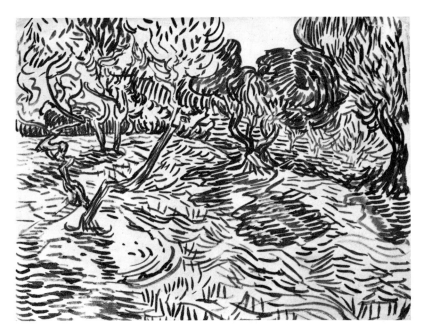

Olive Trees. Saint-Rémy, 1889–90.

very healthy when the parents were in straits. But he refused to be the baby's godfather. 'Honestly, in the circumstances, I would rather wait until I am away from here.' He suggested that, to please their mother, the child should be named after their father.

With Dr Peyron's permission Vincent returned to Arles to fetch the furniture and pictures he had left in the yellow house, which he could now store in the asylum. He was accompanied by the chief orderly, Trabu, 'a very interesting face' in the style of an 'old Spanish grandee', whose portrait he painted a few months later. Vincent called on several of his old neighbours, but M. Salles, the pastor, was away on holiday and Dr Rey was out, but he spent hours with the Ginouxs, who were delighted to see him. That evening he visited Gaby.

Next day, back at Saint-Paul, he despatched four canvases and seven studies for pictures to Theo.

Two days later he was settling down to paint in the Glanum quarry, with an orderly beside him, when suddenly his eyes became wild, his

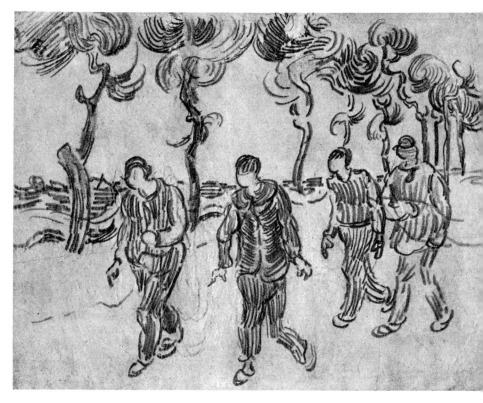

On the Road. Saint-Rémy, 1889–90.

hand began to move convulsively, his body arched backwards. Not without a struggle the orderly got him back to his room.

For the next three weeks, until the end of July, terrible attacks of dementia alternated with periods of prostration, and Vincent never left his room. Theo, who knew nothing of this, wrote to congratulate him on his latest pictures, which he had shown to Pissarro, Père Tanguy and a young Norwegian painter, Verenskiold, who had been awarded the Medal of Honour at the International Exhibition at Maus. Verenskiold was the Secretary of the Society of XX at Brussels, and had called on Theo to ask whether Vincent would be willing to exhibit with them.

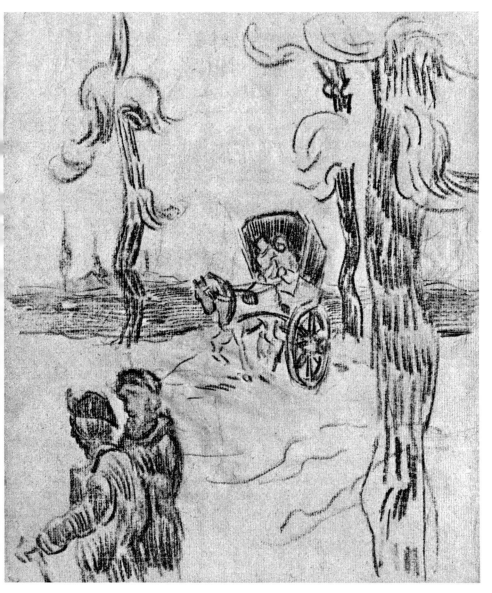

The Cabriolet. Saint-Rémy, 1889–90.

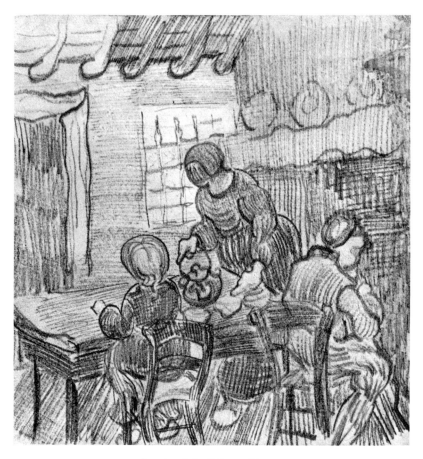

Interior. Saint-Rémy, 1889–90.

Theo grew worried at receiving no answer to his letter and wrote again on 29th July. The pictures Vincent had sent off at the beginning of the month had now arrived; he thought them 'very fine' and urged Vincent to keep on working, for he found in 'most of these paintings, greater clarity of expression and such a fine general effect.'

On 14th August Dr Peyron at last told Theo that his brother had had another attack, but that his condition had now improved. Theo at

once wrote to Vincent—in Dutch, no doubt so that other people should not be able to read the letter. Two days later Jo wrote as well, but the poor man was in such a state of exhaustion that he could not reply until the end of the month. From then onwards, his health improved rapidly.

'I no longer see any possibility of having courage and hope,' he wrote, 'but after all, it wasn't just yesterday we found this job of ours was not a cheerful one.' Where his art was concerned, he remained as clear-sighted as ever, describing the picture on which he had been working in the Glanum quarry when his attack came on as 'a sober attempt, matt in colour without showiness, in broken greens and reds and rusty yellow ochres.' Vincent was well aware that he would never recover the brilliant palette of his Arles period, and indeed, there were

A Peasant and his Wife at Table. Saint-Rémy, 1889–90.

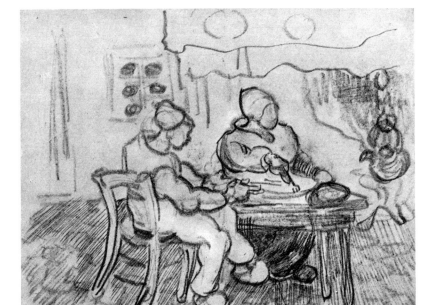

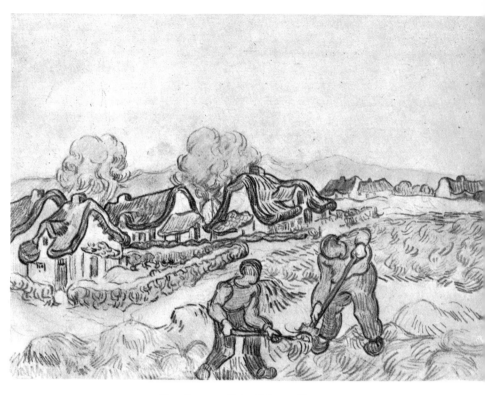

Two Peasants. Saint-Rémy, 1889–90.

moments when he would have liked 'to begin again with the same palette as in the North.'

During this latest illness Vincent had been haunted by his past, by memories that left him with a feeling of remorse and melancholy. The South had brought him nothing but failure, disappointment and his illness, which might never have become so violent but for the 'most glorious heat'.

'If it were possible for me to start again with the experience I have now, I should not go to see the South,' he wrote to Theo. He thought of going to Brittany, where Gauguin was, or of returning to Paris. His letters show that he was inexpressibly downhearted. Where should he

go? What could he do, in future? 'I feel like a fool going and asking doctors permission to paint.'

Little by little, however, as he took up his work, he began to recover his strength and interest in life. 'Ah! I would almost believe that I have a new period of lucidity before me.'

September. Vincent had noticed that his attacks came on at intervals of about three months; this meant he would be left in peace until Christmas, at any rate, and the passion for work gripped him again—for as he once wrote:

'I can get along all right in life, and in painting too, without religion, but I cannot get along without something bigger than myself, which is my life—the power to create.'

Working from memory, he twice repeated his painting of *Bedroom at Arles,* first painted in October 1888, one of the pictures that seemed best to him in that period. Then he began a copy of Delacroix's *Pietà,* from a lithograph by Nanteuil, taking Sœur Epiphane as his inspiration for the Virgin's face; this was followed by an *Angel's Head* after Rembrandt. He also made many paintings in the garden of the asylum.

'I am struggling with all my energy to master my work,' he wrote to Theo in September, 'thinking that if I succeed, that will be the best lightning conductor for my illness.' He asked for paints—ten large and ten small tubes—and ten yards of canvas, as he intended 'to go and paint a few pictures for Holland, for Mother and my sister.'

From September to November Vincent was painting with his former verve, without going to such exaggerated lengths. Though he could not go out and had scarcely any models to sit for him, the pictures were piling up—landscapes, copies from Millet [168], portraits—first two of himself, then those of Trabu—splendid achievements showing extraordinary mastery.

The first self-portrait, 'dark violet-blue and the head whitish with yellow hair' where Vincent was holding his palette in check, dates from September; the second, a three-quarter length in a harmony of red and green, from November. This latter was preceded, like the *Portrait with Bandaged Ear,* by a small study, heart-rending in its candour. It shows a man on the brink of old age, dazed, with blank eyes. In the actual portrait painted in November he looks quite well. 'The

tranquil harmony of greens and related blues, scarcely broken by the almost flaxen hair and beard, transfigures and spiritualizes the tragedy he had been through,' writes Philippe Huisman.[169] 'This is still Vincent, yet it is already a dream and a legend; amid curls of blue smoke, "the colour of blue sky at dusk", as Vincent wrote.'

In September the painter wrote to his brother: 'I am sending you my own portrait today; you must look at it for some time; you will see, I hope, that my face is much calmer, though it seems to me that my look is vaguer than before. I have another one which is an attempt made

Street bordered on the right by Huts. Saint-Rémy, 1889–90.

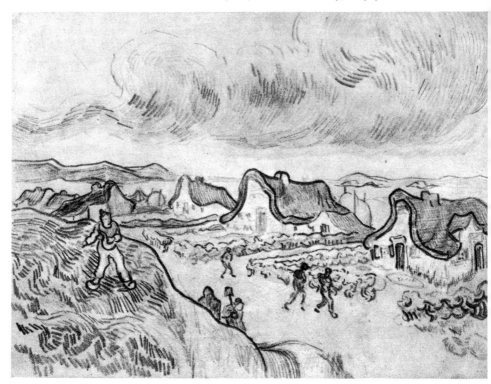

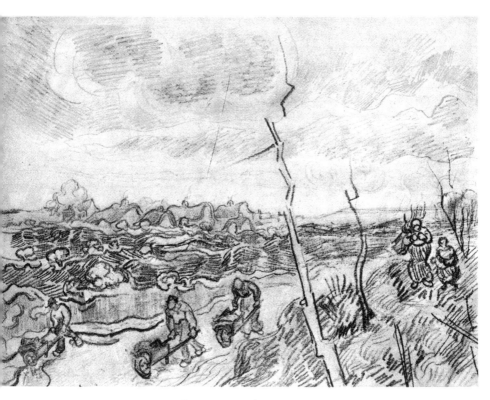

Landscape. Saint-Rémy, 1889–90.

when I was ill, but I think this will please you more, and I have tried to make it simple. Show it to old Pissarro when you see him. You will be surprised at the effect *Les Travaux des Champs* takes on in colour. It is a very profound series of his. I am going to try to tell you what I am seeking in it and why it seems good to me to copy them. We painters are always asked to *compose* and *be nothing but* composers.'

Dr Peyron, on a short visit to Paris, had reassured Theo about his brother's condition. 'For the moment he says you are absolutely sane and that if it weren't that you had an attack such a short time ago, he would encourage you to go outside the place more often. He told me that as your visit to Arles had brought on an attack, we ought to see,

before you go to live anywhere else, if you can stand changes now. If you come through these trials satisfactorily, he sees no reason why you shouldn't leave him.'

For a short time Theo had thought of entrusting his brother to Pissarro, but this plan was impracticable, for Pissarro 'hasn't much of a say in his own home, it's his wife who wears the breeches.' However, 'Pissarro knows a doctor at Auvers who paints in his spare time. He tells me,' Theo goes on to say, 'that this man has been friendly with all the Impressionists. He thinks you could probably stay there permanently. He has to go and see him, and will talk to him about it.'

Theo advised his brother against Brittany because of its 'monastic atmosphere, and even in the latest Gauguins there are great signs of this, I find . . . If your change of residence brought you to Paris first of all, I should be delighted.'

Vincent was taking advantage of the fine autumn weather to paint studies, 'among others a mulberry tree all yellow on stony ground, outlined against the blue of the sky, in which study I hope you will see,' he wrote to Theo [170], 'that I am on Monticelli's track.' The plan of going from Arles to Auvers seemed to him 'a pleasant prospect', though 'there's absolutely no hurry'. But life in the asylum was oppressive and he was in dread of winter and its loneliness.

However, these sad days brought two pieces of good news—the Society XX, in Brussels, wanted Vincent to exhibit with them at the beginning of the following year; and the Dutch painter and art critic, Isaäcson, had just published in several Dutch papers some 'Paris Letters' in which he mentioned Vincent. Vincent wished Isaäcson had waited at least another year, for then he would have 'before his eyes some more characteristic things with firmer drawing and a better understanding of the provençal South.' All the same he was pleased with the article, though he thought it overpraised him.

On 22nd October Theo told him that he had shown his paintings to Israëls, to the Dutch painter and writer Veth, and, still more important, to van Rysselberghe, one of the Brussels Vingtistes, who 'also saw everything there is at Tanguy's' and showed a great interest in Vincent's work. The Salon des Indépendants was over and Theo had got back the two pictures shown there, one of which was the *Irises,*

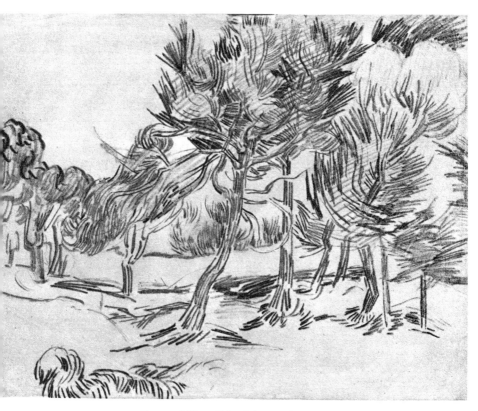

Group of Pines. Saint-Rémy, 1889–90.

'one of your good things'. He added: 'I find you are at your best when you do things true to life, like that. It seems to me that you are stronger when you paint true things like that, or like the stagecoach at Tarascon, or the head of a child, or the underbrush with the ivy, seen from above. The form is so well defined, and the whole is full of colour. I understand quite well what it is that preoccupies you in your new canvases, like the village in the moonlight, or the mountains, but I think that the search for some style is prejudicial to the true sentiment of things.'

As for Vincent's return to the neighbourhood of Paris, Theo explains that 'Pissarro is to see about the good fellow at Auvers (Dr

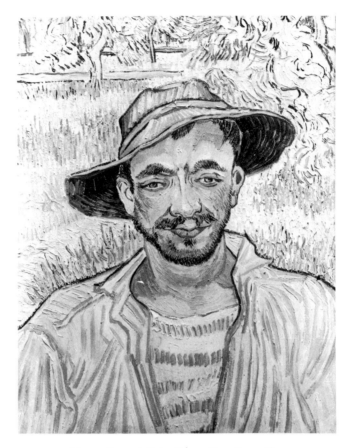

Young Peasant. Saint-Rémy, May-June 1889.

Gachet).' He hopes 'that he will be successful and that next spring, if not before, you'll be coming to see us.' Nevertheless, in spite of the affection and admiration he felt for his brother, he showed no excessive enthusiasm. He still had painful memories of the period when they were living together in the rue Lepic.

At the beginning of November Vincent was allowed to make another trip to Arles. He spent two days there, visiting the Ginouxs, Pastor Salles, and also, no doubt, his customary brothel. Most of his

latest pictures were of the garden at the asylum, which he painted from many angles, including 'a view of the house with a tall pine-tree.' He also painted *The Poplars on the Hill, The Pinewood at Dusk,* and *The Roadmenders,* showing the broken pavements beneath the huge plane-trees that line the Cours de Saint-Rémy. At the end of the year he was working on *Le Ravin des Péroulets,* a copy of a picture he had painted on the spot in October, and *Fenced Field with Setting*

The Harvest. Saint-Rémy, October 1889.

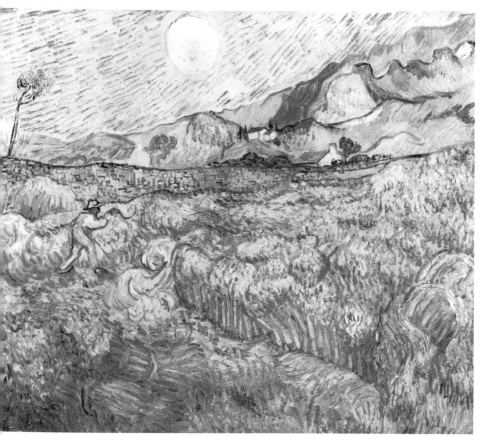

Sun, the view he could see from his barred window. He was also copying a whole series of engravings from Millet: *Siesta, Return from the Fields, The Evening Vigil, The Diggers, The Sower,* etc., which had been sent to him by his brother and had brought back to his mind the peasant themes he had once been so fond of.

He also painted a strange figure he called *Portrait of an Actor,* which no doubt represents one of the inmates of the asylum, though whether he had really been an actor or merely took himself for one we do not know. Vincent's exaggerated expressionism shows that he was trying to penetrate to the essence of another's nature. Several portraits belonging to this period have been lost, among them one of Trabu with his wife (the one of Trabu alone is now in the Dübi collection at Soleure) and one of a manservant at the asylum.

Vincent was living in dread of the new attack he anticipated at the end of the year, and he suffered from feelings of remorse and guilt. 'I doubt,' he wrote to his mother, 'that I can make up for faults in any way ... You and father have been, if possible, even more to me than the others, so much, so very much, and I do not seem to have had a happy character.' The attack he feared did come at the end of December, but fortunately it was shorter and less violent than the previous one. A week later he was up and about. 'Above all I must not waste time,' he wrote to Theo.

On the 22nd Theo wrote: 'Your wheatfield and two bedrooms have reached me safely. Most of all I like the last, the colour is like a bunch of flowers. It has a tremendous intensity of colour. The wheatfield has more poetry, perhaps; it's like the memory of something one has seen. Tangui (*sic*) is showing it at present, and on 3rd January everything goes off to Brussels.' [171]

On 3rd January 1890: 'Your latest consignment arrived yesterday evening, and is really remarkable. Do you know, one of the things I like best is "the evening" after Millet? Copied like that, it is no longer a copy ... It is really most successful. Among the other pictures, I very much like the women climbing the rocks and the highroad with the labourers. In your latest pictures there is more atmosphere and depth than in the previous ones, I find. It may perhaps be because you don't lay the paint on so thickly everywhere.'

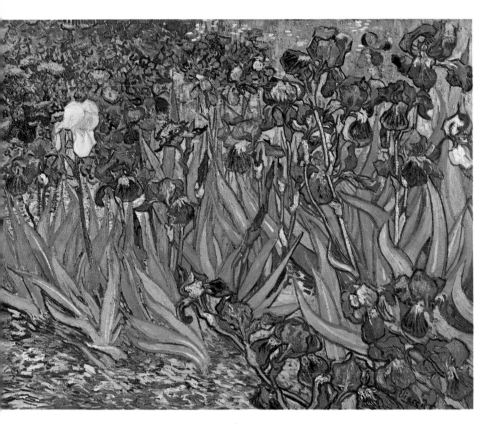

Irises. Saint-Rémy, May 1889.

Theo was glad Vincent's fresh attack had been so short. 'I think that at those times,' he says, 'you'll do better not to try to work with colour.' He reassures Vincent about the pictures he had sent to the Salon des Indépendants, and tells him that their sister Willemien has arrived in Paris.

Vincent had taken up his brushes again with a calm mind, even with optimism and confidence in the future. 'Let's go on working then as much as possible as though nothing had happened,' he wrote to his brother at the beginning of January 1890. He had only seven months to live.

Pastor Salles came to see him and Vincent, greatly touched by this evidence of sympathy, gave him a small picture, pink and red geraniums against a completely black ground. He wrote to his friends the Ginouxs, assuring them of his friendship and sending good wishes for the recovery of Mme Ginoux, who had fallen ill. Dr Peyron now seemed better disposed towards him, and allowed him 'complete liberty to distract myself.'

'What the Impressionists have found in colour will develop even more,' he wrote to Theo [172], 'but many forget the tie which binds them to the past, and I will strive to show that I have little belief in a vigorous division between Impressionists and others.'

Vincent was waiting in some fearfulness for news of the confinement of his sister-in-law. All went well, and on 1st February his brother wrote to tell Vincent that Jo had given birth to a son.

Vincent expressed his happiness in a painting of 'big branches of almond-trees in blossom against a blue sky.'

Also at the beginning of February Vincent was astonished to receive from Theo an article by a young critic, Albert Aurier, then twenty-five years old. (Aurier's career was unfortunately very short, for he died two years later, in 1892.) This article—the only one to be written entirely about van Gogh during his lifetime [173]—appeared in the January number of the *Mercure de France*.

In the pompous and rather esoteric style of the day, Aurier expresses his enthusiastic admiration for Vincent's pictures—those Tanguy was showing and others that Theo had in his care:

'... Beneath skies sometimes cut from dazzling sapphire or turquoise, sometimes kneaded from I know not what infernal sulphur, hot, baleful and blinding; beneath skies like molten metals and dissolving crystals; with, sometimes, the torrid, incandescent sun-disks; beneath the incessant and formidable stream of every kind of light; in an atmosphere which is heavy, flaming, scorching, as if thrown off from fantastic furnaces which are vapourizing gold and diamond and strange gems—we see displayed a disturbing, troubling, strange nature, both truly real and half supernatural, a nature of excesses in which all

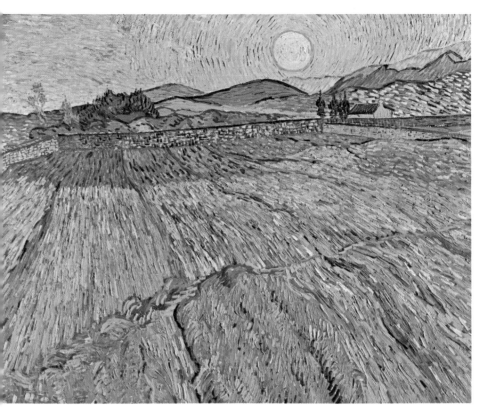

Landscape with setting Sun. Saint-Rémy, May 1889.

beings and objects, shadows and lights, forms and colours, rear themselves in a savage determination to throw out their essential, individual song, at the fiercest, shrillest pitch; there are trees twisted like giants in battle, there are cypresses thrusting up their nightmarish forms, like black flames.

'... This is the whole of nature twisted in frenzy, in a paroxysm carried to the climax of exacerbation; this is form becoming nightmare, colour becoming flames, lava and precious stones, light becoming a blaze, life a high fever.

'Such is . . . the impression left on the eye at first sight of the strange, intense, feverish works of Vincent van Gogh, the compatriot and not unworthy descendant of the old masters of Holland.

'. . . All his work is characterized by its excess, an excessive force, an excessive nervous tension, a violence in expression. In his categorical affirmation of the nature of things, in the boldness with which his forms are often simplified, in the insolence with which he stares into the face of the sun, in the fiery vehemence of his drawing and colour, even in the smallest details of his technique, he reveals himself as powerful, masculine, daring, very often brutal and sometimes in-genuously delicate . . .

'Lastly, and above all, he is a hyper-aesthete, perceiving with ab-normal, perhaps even painful intensity the scarcely perceptible, secret characteristics of line and form, and still more of colour . . . That is why his realism, the realism of this neurotic, and his sincerity and his truth are different from the realism, the sincerity, and truth of those great *petits bourgeois* of Holland, so sound of body and well-balanced in mind, who were his fathers and his masters.

'Will this robust, true artist, very much of his race, with the rough hands of a giant, the sensibility of a woman and the soul of a mystic, so original and so much apart from the pitiful art of the present-day, one day experience the repentant wooing of fashionable society? Per-haps. But in any event, even if his canvases came to command the same prices as *'des petits infamies'* of M. Meissonier—which is improb-able—I think there can never be a great deal of sincerity in such belated admiration by the general public. Vincent van Gogh is both too simple and too subtle for the modern bourgeois mind. He will never be fully understood except by his brothers, artists who are very much artists . . . and by such of the humble people as are fortunate enough to escape the benefits of a State education.'

To this effusion Vincent replied calmly and humbly:
Dear M. Aurier,
Many thanks for your article in the *Mercure de France,* which greatly surprised me. I like it very much as a work of art in itself, in my

opinion your words produce colour, in short, I rediscover my canvases in your article, but better than they are, richer, more full of meaning. However, I feel uneasy in my mind when I reflect that what you say is due to others rather than to myself. For example, Monticelli in particular. Saying as you do: 'As far as I know, he is the only painter to perceive the chromatism of things with such intensity, with such a metallic, gemlike lustre,' be so kind as to go and see a certain bouquet by Monticelli at my brother's—a bouquet in white, forget-me-not blue and orange—then you will feel what I want to say.

... And further, I owe much to Paul Gauguin, with whom I worked in Arles for some months, and whom I already knew in Paris, for that matter.

Gauguin, that curious artist, that alien whose mien and the look in whose eyes vaguely remind one of Rembrandt's *Portrait of a Man* in the Galerie Lacaze—this friend of mine likes to make one feel that a good picture is equivalent to a good deed; not that he says so, but it is difficult to be on intimate terms with him without being aware of a certain moral responsibility. A few days before parting company, when my disease forced me to go into a lunatic asylum, I tried to paint 'his empty seat'.

... Then you will perceive that your article would have been fairer, and consequently more powerful, I think, if, when discussing the question of the future of 'tropical painting' and of colours, you had done justice to Gauguin and Monticelli before speaking of me. *For the part which is allotted to me, or will be allotted to me, will remain, I assure you, very secondary.* And then there is another question I want to ask you. Suppose that the two pictures of sunflowers, which are now at the Vingtistes' exhibition, have certain qualities of colour, and that they also express an idea symbolizing 'gratitude'. Is this different from so many flower pieces, more skilfully painted, and which are not yet sufficiently appreciated, such as *Hollyhocks* and *Yellow Irises* by Father Quost? The magnificent bouquets of peonies which Jeannin produces so abundantly? You see, it seems so difficult to me to make a distinction between Impressionism and other things; I do not see the use of so much sectarian spirit as we have seen these last years, but *I am afraid of the preposterousness of it.*

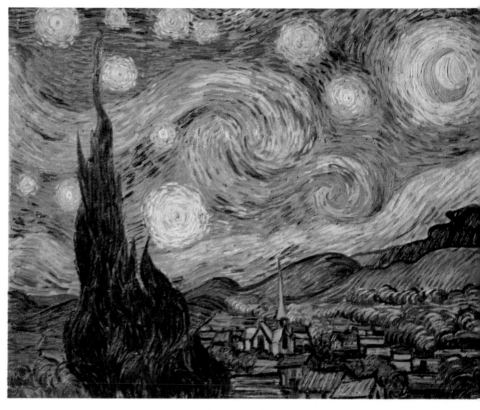

Starry Night. Saint-Rémy, June 1889.

And in conclusion I declare that I do not understand why *you* should speak of Meissonier's 'infamies'. It is possible that I have inherited from the excellent Mauve an absolutely unlimited admiration for Meissonier; Mauve's eulogies on Troyon and Meissonier used to be inexhaustible—a strange pair.

I say this to draw your attention to the extent to which people in foreign countries admire the artists of France, without making the least fuss about what divides them. What Mauve repeated so often was something like this: 'If one wants to paint colours, one should also be able to draw a chimney corner or an interior as Meissonier does.'

In the next batch that I send my brother I shall include a study of cypresses for you, if you will do me the favour of accepting it in remembrance of your article. I am still working on it at the moment, as I want to put in a little figure. The cypress is so characteristic of the scenery of Provence; you will feel it and say 'Even the colour is black.' Until now I have not been able to do them as I feel them; the emotions that grip me in front of nature can cause me to lose consciousness, and then follows a fortnight during which I cannot work. Nevertheless, before leaving here I feel sure I shall return to the charge and attack

Olive Trees. Saint-Rémy, September–October 1889.

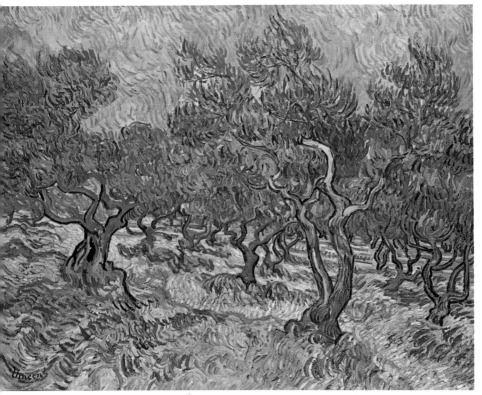

the cypresses. The study I have set aside for you represents a group of them in the corner of a wheatfield during a summer mistral. So it is a note of a certain nameless black in the restless, gusty blue of the wide sky and the vermilion of the poppies contrasting with this dark note.

You will see that this constitutes something like the combination of tones in those pretty Scottish tartans of green, blue, red, yellow, black, which at the time seemed so charming to you as well as to me, and which, alas, one hardly sees anymore nowadays.

Meanwhile, dear Sir, accept my gratitude for your article. When I go to Paris in the spring, I shall certainly not fail to call on you to thank you in person.

Vincent van Gogh.

Vincent sent this letter to his brother to be forwarded, adding that he was going to copy his reply for Gauguin, '. . . for really I think they ought to say things like that about him, and of me only very secondarily.'

He further disclaimed the praise: 'I needn't tell you that I hope to go on thinking that I do not paint like that, but I do see in it how I ought to paint.'

And again: 'Aurier's article would encourage me if I dared to let myself go, and venture even further, dropping reality and making a kind of music of tones with colours, like some Monticellis. But it is so dear to me, this truth, *trying to make it true*, after all I think, I think I would still rather be a shoemaker than a musician in colours.

'In any case, trying to remain true is perhaps a remedy in fighting the disease which still continues to disquiet me.'

On 29th April, recovering from a fresh attack, he wrote to Theo: 'Please ask M. Aurier not to write any more articles on my painting, insist upon this, that to begin with he is mistaken about me, since I am too overwhelmed with grief to be able to face publicity. Making pictures distracts me, but if I hear them spoken of it pains me more than he knows.'

Vincent's unexpected attitude did not disturb Aurier's opinions, and he joyfully accepted the offer of the study of cypresses, and later

bought several pictures from the Dutch period, showing that he could also appreciate works quite unlike those which had revealed van Gogh's genius to him.

Vincent thought of leaving Saint-Rémy and going to live at Antwerp with Gauguin, founding a 'studio of the North' as a successor to the studio of the South. Theo put forward several more prudent suggestions—Vincent might share a studio in Paris with Lauzet, the lithographer, who was a great admirer of his; he might go into an asylum in Belgium or Holland, or settle at Auvers-sur-Oise with Dr Gachet to keep an eye on him. Vincent was not enthusiastic about Belgium, particularly as the asylum there would be the one at Gheel, where his parents had wanted to place him *'en curatelle'* in the old days.

On 14th February came a piece of news even more unexpected than Aurier's article: Anna Boch, a member of the Vingtistes—the sister of Boch the painter whom he had known at Saint-Rémy—had bought his *Red Vineyard* from the Brussels exhibition, for the sum of four hundred francs.

Next day, 15th February, he wrote in a letter to his mother: '. . .Now I am strongly inclined to take advantage of my good luck in selling this picture by going to Paris and seeing Theo. Thanks to the physician here, I shall leave feeling calmer and healthier than when I came. Trying how it goes outside a hospital is perhaps only natural.'

During this spring of 1890, Vincent's third springtime in Provence, he had worked quite as hard as in the two previous years. Through his barred window he was yet again painting the view before his eyes—*The Enclosed Field*, the first version of which was on exhibition in Brussels. The theme is the same, but transformed, stirred up by some unrecorded earthquake.

Was this the approach of another periodical crisis, heralded as always by terrors and hallucinations? In the *Cornfield in the Alpilles* the ground undulates and breaks up, a sort of furious delirium transforms the fields into tumbling waves as they cling to slopes, which are convulsed in their turn. In the *Field of Poppies* (page 238) the perspective lines rush away and burst violently apart; in *Winter Landscape (Memory of the North)* the twisted lines of the trees and houses become entangled with the contortions of the clouds and plants, while

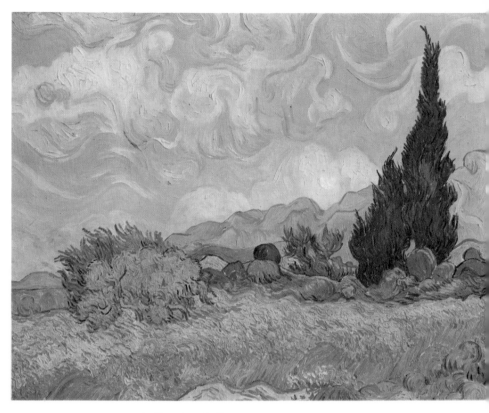

Yellow Cornfield. Saint-Rémy, October 1889.

the tree in *Road with Cypresses* (page 235) moulded and kneaded straight from the tube, contributes its upward surge to the universal commotion.

On this canvas the contrasted movement of the hatching and the curves, of short strokes and spirals, and the way they are balanced against each other, adds to the agitation of all the elements present. 'The burnt incendiary has not painted cypresses like green flames', writes D. Verbanesco, 'but, rather green flames like cypresses.' Vincent gained release from his obsessions, his impulses and his conflicts by projecting them onto his canvases; his anguish and dread at the possi-

bility of another crisis are expressed in a bewilderment which embraces and dislocates simultaneously his self and the organic life of the earth to which he is so intimately tied with all the fibres of his being. The upward spiralling of the cypress, the spinning stars boring into the sky, the sinuous, fleeing road in which vague phantasmal human beings—a cart and two passers-by—remind man that he is inseparable from Creation, the misshapen plumes of the cypresses framing the cottage to the right of the picture—everything is included and dissolves in a gigantic baroque paroxysm in which the haunted expressionist, with his deep blacks, his contorted and moving forms—that is, Vincent at the time of Nuenen, before the revelation of Impressionism and of Japanese prints—unites lyricism with the agony of his painful vigils.

Cornfield with Cypress and Tree in blossom. Saint-Rémy, June 1889.

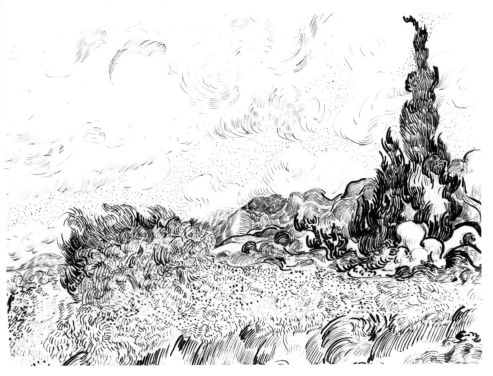

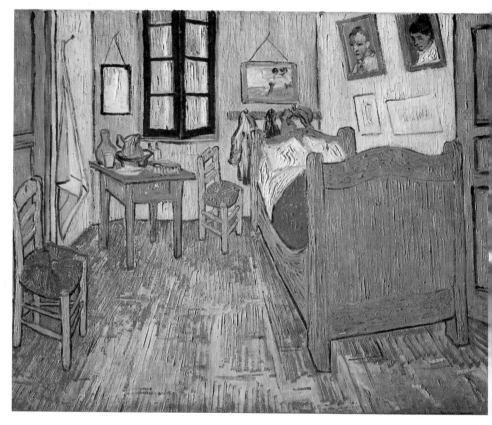

Vincent's Bedroom at Arles. Saint-Rémy. September 1889.

'He had gone too far,' writes Gustave Coquiot,[174] 'he was consuming himself beyond human endurance. He could no longer go near the lunatics. It was essential for him to move out. And it was then that he sent out a cry of help to his brother. Auvers awaited him. Would this be, at last, the refuge of silence and repose? . . . To leave, first of all to leave.'

'My pictures are almost a cry of anguish,' wrote Vincent.

About 20th February he again obtained permission to go to Arles; he wanted to return to M. and Mme Ginoux the boxes in which they had sent him olives at Christmas, and as usual on these visits he went

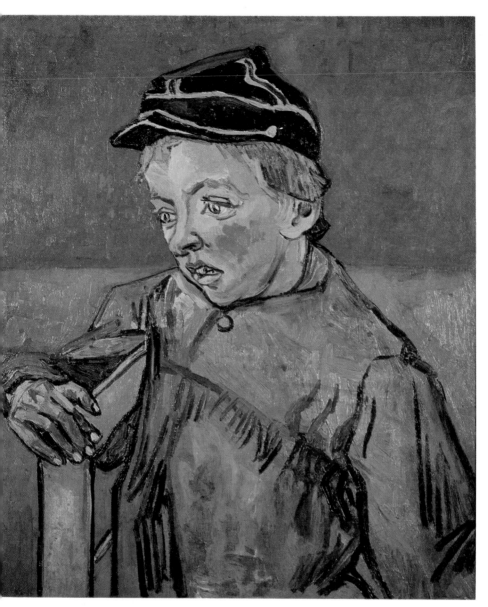

Schoolboy. Saint-Rémy, January 1890.

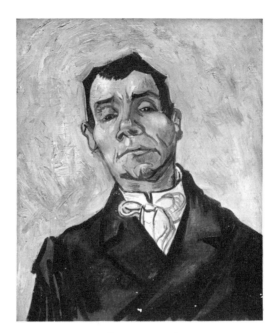

Portrait of an Actor. Arles, 1888.

to the brothel. But on the 24th, Dr Peyron wrote to tell Theo that his brother, smitten by a terrible attack, had been rushed by carriage back to the asylum. Vincent had no recollection of where he had spent the night, nor of what he had done with the picture he had been carrying.

This was a long and particularly distressing attack, during which Vincent suffered from appalling terrors and hallucinations. Once he escaped from his cell and went to sprawl on a heap of coal; on another occasion he tried to snatch the lamp oil and drink it. Then, as usual, he sank into a dazed torpor, from which he only began to emerge, slowly, in the first half of April. He sat down to write to Theo:

'Today I wanted to read the letters which had come for me, but I was not clear-headed enough yet to be able to understand them.

'However, I am trying to answer you at once, and I hope that this will clear away in a few days. Above all I hope you are well, and your wife and child too. Don't worry about me, even if this should last a bit

230

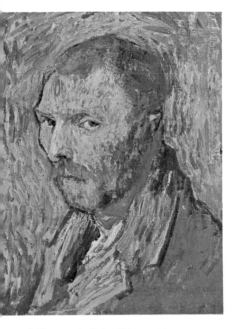

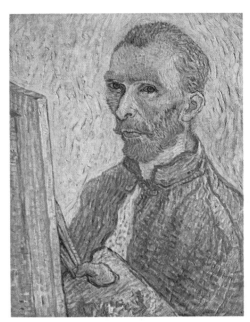

Self-portrait. Saint-Rémy, 1889.

Portrait of the Artist in front of his Easel.
Saint-Rémy, September 1889.

longer, and write the same things to those at home and give them kindest regards from me . . . Perhaps, perhaps I might really recover if I were in the country for a time.'

Painfully, he sat down again at his easel. He painted those *Memories of the North* which are both a return to the past and an appeal to the land of his childhood. He thought of repainting *The Potato-eaters* from memory, but his mind was still confused and his fingers hesitant; the return to normal life was much slower than after the first attacks.

His convalescence was not without setbacks. One day he suddenly turned on a hospital orderly and gave him a terrible kick in the stomach. Then 'Forgive me', he said humbly, 'I'm not very clear what I've done. I thought I was at Arles being hunted by the police!'

On another occasion he was found in his cell with paint in his mouth. He was immediately given a poison antidote, and the rumour circulated that he was tired of life and had tried to kill himself. A few

days afterwards, on 29th April, he began a new letter to Theo:

'I haven't been able to write to you until now, but being a little better just now, I did not wish to delay wishing you a happy year, since it's your birthday, and your wife and child. At the same time I beg you to accept the various pictures I am sending you with my thanks for all the kindness you have shown me, for without you I should be very unhappy.'

Gradually his strength seemed to return. He went out into the grounds of the asylum and began to paint, as before, and sent to his brother for colours, but he had little energy. He had just finished 'a corner of a sunny meadow' which he thought 'fairly vigorous', but as he could not go out and about freely, he advised Theo to choose some figures from among his drawings and send them back to him, to be used instead of living models.

He would also like 'to do the picture of the peasants at dinner, with the lamplight effect again.' *(The Potato-eaters)*

He was now eager to leave Saint-Paul-de-Mausole as soon as possible. He told Dr Peyron that it was almost impossible for him to endure his lot there and, 'not knowing with any clearness what line to take, I thought it preferable to return to the North.' He would be accompanied to Tarascon or to Lyons, and would spend a few days in Paris before going to Auvers, for it seemed practically decided that when he left the asylum he was to settle in that little village, under Dr Gachet's supervision.

His work was going better now; he had regained all his 'lucidity for work', and 'the brush-strokes come like clock-work. So, relying on that, I dare think that I shall find my balance in the north, once delivered from surroundings and circumstances which I do not understand or wish to understand.' He made a copy of etchings sent to him by Theo: Rembrandt's *Resurrection of Lazarus*—'the dead man and his two sisters. The cave and the corpse are white-yellow-violet. The woman who takes the kerchief from the face of the resurrected man has a green dress and orange hair, the other has black hair and a gown of striped green and pink. In the background a countryside of blue hills, a yellow sunrise.

'Thus the combination of colours would itself suggest the same thing

232

which the chiaroscuro of the etching expresses.'

Dr Peyron, returning from a short absence, gave Vincent letters which had arrived while he was ill. One from Theo, written on 19th March, told Vincent he was having a success at the Salon des Indépendants, where ten paintings and several drawings by him had been hung. 'Your pictures are well placed and make a very good show. A lot of people have come asking me to send you their congratulations. Gauguin was saying that your pictures are the *clou* of the exhibition.'

On 3rd May 1890, Theo wrote: 'The copies of Millet are perhaps the finest things you've done, and make me feel convinced that if you ever turn to figure composition we shall have some more big surprises.'

Vincent had started a picture which has sometimes been regarded as a kind of spiritual testament to mark the end of his stay at Saint-Rémy. He took the model from a drawing he had done at The Hague in November 1882. It shows an old man sitting on a chair in front of a fireplace; he is obviously distressed and his clenched fists are pressed to his eyes as though he were weeping or in fear.

'An old labourer like that', he had written eight years previously to Theo, 'in a well-darned cotton suit, bald-headed, how beautiful!' This picture, named—by whom?—*Au Seuil de l'Eternité*, does not have the meaning which over-imaginative exegetes have tried to give it. As is often the case with Vincent van Gogh, his intentions have been deliberately misrepresented.

The artist had no models (he deplored this fact in a letter he wrote to Theo in May) so, to paint the face, he used either etchings, reproductions of paintings, or his own drawings as a guide. That is why he used the drawing of the old man which Theo had no doubt sent him shortly before.

Vincent used the drawing of the old man because of his lack of models. He also painted versions of pictures by Delacroix, Daumier, Millet and Gustave Doré (*The Prison-yard*) of which he had reproductions, and in January and February 1890 he did four variations of a drawing, *The Arlésienne*, made by Gauguin at Arles two years before. In this picture he included two of his favourite books, *Uncle Tom's Cabin* and Dickens' *A Christmas Carol*.

Vincent's departure from Saint-Rémy was at hand. He wrote to

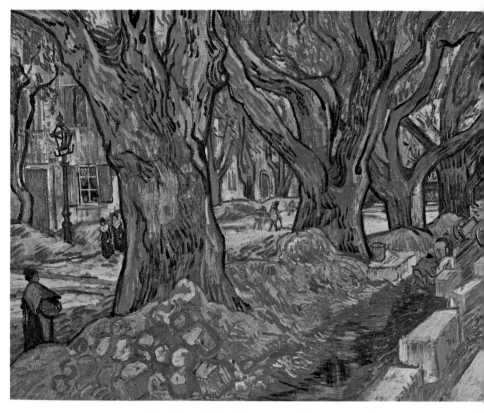

The Pavers. Saint-Rémy, November 1889.

ask M. Ginoux to send to Paris his bed, which he had left at Arles; 'I do not intend to stay in Paris longer than a fortnight at the most, after that I am going to work in the country.'

'The most horrible attack has disappeared like a thunderstorm,' he wrote to Theo, 'and I am working to give the last stroke of the brush here with calm and steady enthusiasm.' Until the last moment, indeed, he was painting 'a canvas of roses with a light green background and two canvases representing big bunches of violet irises, one lot against a pink background in which the effect is soft and harmonious because of the combination of greens, pinks and mauves.'

234 *Road with Cypresses.* Saint-Rémy, May 1890. ▶

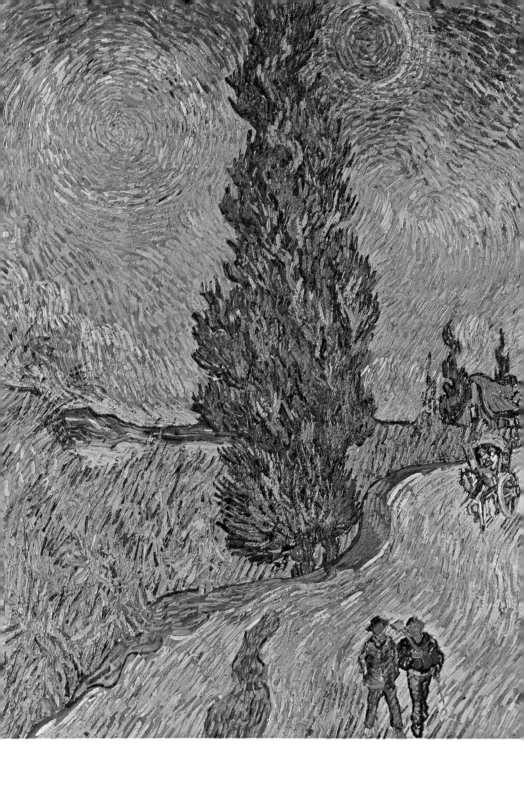

Another, a violet bunch, ranging from carmine to Prussian blue, stood out against a startling lemon-yellow background, with yellow tones in the vase and stand, the juxtaposition strengthening the colours.

Vincent was working 'with such enthusiasm that my packing seems more difficult than painting.' It is clear at a glance that the work he produced during his last month at Saint-Paul-de-Mausole was far inferior to the work he had done at Arles, and there is little sign of the brilliance of colour he mentions so enthusiastically. But we have to remember that each of these pictures is a victory over madness and death.

The one hundred and fifty paintings [175] he did at Saint-Rémy are more limited in their inspiration and less striking in their final result, they reveal his haste to use his powers of expression to the utmost during the intervals of calm, since from one moment to the next he might again be stricken. The fact that in such conditions, and even in his most impassioned canvases, he was able to keep control over himself, dismisses finally the myth which has been spread by so many bad biographies, shortsighted interpretations, and 'passionate lives'—even a Hollywood super-production 'filmed on the spot'. But even when his stay at the Saint-Rémy asylum came to an end, he was overcome by sadness; in the universe where he used to feel that he was a kind of inspired demiurge, he was now only a pathetic wreck threatened with a new crisis, a renewed failure of all his faculties, with all-enveloping night. It was only his painting which bound him to life—to a life of which all he asked was pictures—landscapes which looked like him, tortured like him, trees in convulsions like his soul, troubled skies crossed with lightning, spinning stars, where the sun—his own reason—reeled in its battle with the shadows of darkness.

'Why', he wrote to Theo, 'continue to paint pictures which cost us money and bring us no return?' This 'seems like madness to me'. And this, in fact, was his only real madness, the madness which helped him to put up with the other 'madness', that of the doctors who understood nothing of the torments he suffered, the 'madness' of the men who cast him out of society, tricked him, despised and betrayed him. Vincent van Gogh—man of fire—was not cut out to soothe the conscience of society, which wanted to be reassured and flattered by the bastardized

forms of beauty in which fashionable artists and men of taste, united in sordid complicity, took pleasure. The inevitable breach which exists between genius and society existed in the case of van Gogh in its most dramatic but also its most impassioned form. People often fail to realize at what cost in suffering a work of art is born. By admiring it, praising it merits (having during his lifetime despised, insulted and cast out its creator), by granting him a place of honour in their museums, they think they are 'rehabilitating' their victim, whereas all they are doing is condemning his executioners all the more. Society was responsible for van Gogh's 'madness' just as society was responsible for the fall of Rembrandt, discredited and abandoned by all, for the morbid obsessions of Goya, for Delacroix's deliria, for Lautrec's moral decay, for the cursed life of Pascin, for the martyrdom of Utrillo, for the 'mysterious' death of Nicolas de Staël. The cry from the Cross—'Why hast thou forsaken me?'—echoes through the ages, finding its most tragic expression in the spiritual night of the man who tried to impose his private universe on the society which gave him birth.

Thus the problem of van Gogh cannot be discussed from the pathological point of view—although it will no doubt be discussed as such for years to come—but, as is seen from the study of his life and his work, the problem is a sociological one. That a certain clear-cut form of mental alienation can be discerned in a few rare canvases does not prove at all that they were dictated by this alienation; more real and more moving is the battle which van Gogh waged against the evil forces to which he was a prey. 'His story', wrote Wilhelm Uhde, 'is not that of an eye, a palette, a paint-brush, but it is the story of a lonely heart beating in the breast of a dark prison.' Vincent was to find his only kinship in colours—'sisters of suffering' says Hofmannsthal, who has written some admirable pages on van Gogh—for nothing in the world belonged to him besides them, their richness and their brilliance. Through them he would exercise his demons, but he was not to convince other men and so he died, becoming thus a victim offered in a sacrifice to his own dreams.

On 14th May he wrote to Theo:

'In Paris—if I feel strong enough—I should very much like to do at

once a picture of a yellow bookshop (gas effect) which I have had in mind so long. You will see that I'll be fit for it the day after my arrival. I tell you, I feel my head is absolutely calm for my work, and the brushstrokes come to me and follow each other logically.'

He left Saint-Rémy by train on 16th May, and on the following day he was in Paris.

Field of Poppies. Saint-Rémy, April 1890.

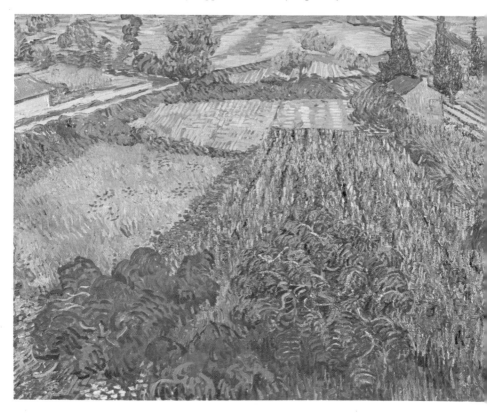

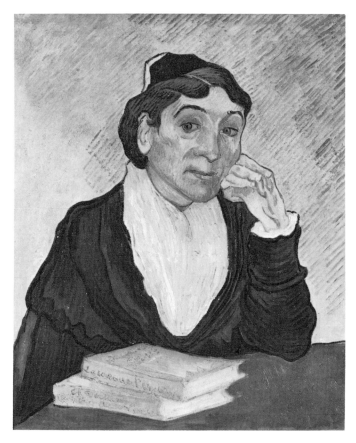

The Arlésienne. Saint-Rémy, January-February 1890.

PARIS
17th—20th May 1890

The two brothers met at the Gare de Lyon with mutual delight. Theo, who had been afraid Vincent would seem ill, was delighted with his appearance; but Jo was even more astonished to meet 'a sturdy, broad-shouldered man with a healthy colour, a smile on his face, and a very resolute appearance.' [176]

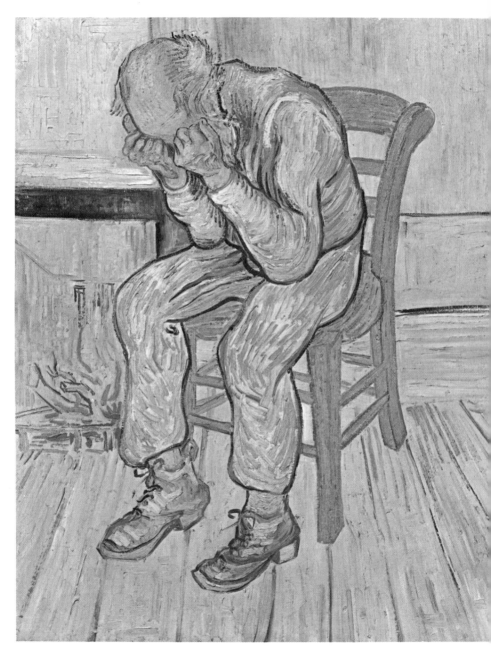

On the Threshold of Eternity. Saint-Rémy, May 1890.

Jo and Theo had a small flat on the fourth floor at 8, Cité Pigalle. Once the greetings were over, Theo took his brother to the room where the baby's cradle stood. They stood beside it silently—both had tears in their eyes. Despite Vincent's protests the child had been named after him, Vincent-Wilhelm. Vincent found his sister-in-law 'intelligent, warmhearted and unaffected.'

The morning after his arrival Vincent rose very early, and when Jo and Theo got up he was looking at his own paintings, of which the flat was full. Everything about Vincent's brief stay in Paris was simple, informal, happy. He had got into the habit of eating olives in Provence, so he went out to buy some and insisted that his 'little sister' should taste them. No mention was made of his illness or his recent attacks.

Many of Vincent's canvases had been stored in an attic belonging to Père Tanguy. Vincent went to look at them and came back angry that anyone should have stacked his pictures, and not only his, but paintings that Gauguin, Bernard, Guillaumin and Russell had given him, in such a damp place. Theo was greatly concerned and promised to find somewhere better. His face and trembling hands revealed his anxiety lest Vincent's anger should bring on an attack.

'We had many visitors,' Johanna relates, 'but Vincent soon perceived that the bustle of Paris did him no good.' He left Paris after three days. The brothers assured each other they would meet often; either Vincent would come up to Paris to paint Theo's and Jo's portraits [177] or they would visit him at Auvers.

During his time in Paris, Vincent read some articles Isaäcson had written on Impressionism in the Dutch press. He wrote in reply: 'As it is possible that in your next article you will put in a few words about me, I will repeat my scruples so that you will not go beyond *few* words, because it is *absolutely certain* that I shall never do important things.'

This letter [179] gives a very interesting glimpse of Vincent's beliefs and feelings only two months before his death.

He believes that 'a later generation will be, and will go on being, concerned with the interesting research on the subject of colours initiated by the Impressionists,' but he expects their research to parallel

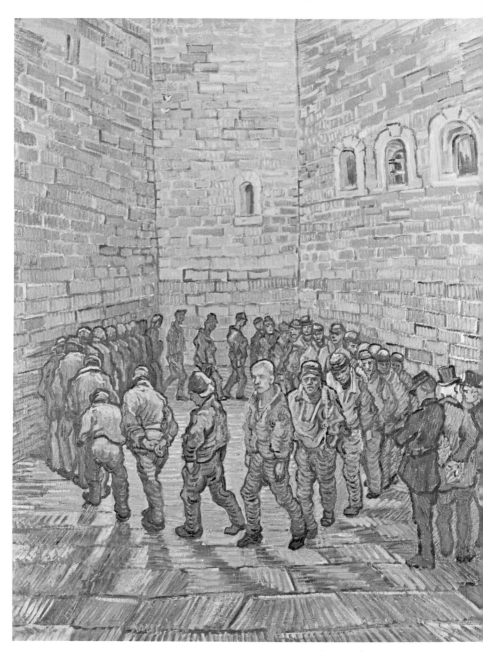

Prisoners at Exercise. Saint-Rémy, February 1890.

that of Delacroix and Puvis de Chavannes—the latter of whom he considers to be as important as the former. '(Puvis de Chavannes') canvas now at the Champ de Mars, among other pictures,' he writes, 'seems to contain an allusion to an equivalence, a strange and providential meeting between *very* far off antiquities and *crude* modernity. His canvases of the last few years are vaguer, more prophetic if possible than even Delacroix, before them one feels an emotion as if one were present at the continuation of all kinds of things, a benevolent renaissance ordained by fate ... Ah, he knows how to do the olive-trees of the South—he the *Seer*!

'... Therefore I assure you I cannot think of Puvis de Chavannes without a presentiment that one day he or someone else will explain the olive-trees to us.'

Vincent asks whether Isaäcson knows that he has painted a great many olives in Provence. Renoir and Monet, he says, must have done some as well.

'Well,' he declares, 'probably the day is not far off when they will paint olive-trees in all kinds of way, just as they have painted the Norman apple-tree ever since Daubigny and César de Cocq.' [178]

He felt that his painting in the South should be seen as devoted to these typical trees of Mediterranean Provence. But it was not only their form, colour and symbolic meaning that intrigued him, he also wonders 'Who are the human beings that actually live among the olives, the orange, the lemon orchards?'

He explains: 'Until now no-one has painted the real Southern Frenchman for us,' he is 'different from the inhabitant of Millet's wide wheatfields ... But when Chavannes or someone else shows us that human being, we shall be reminded of those words, ancient but with a blissfully new meaning: blessed are the poor in spirit, blessed are the pure of heart, words that have such a wide purport that we, educated in the confused and battered cities of the North, are compelled to stop at a great distance from the threshold of those dwellings.'

So he considers that his efforts in Provence were unfinished or incomplete, did not go as far or as deep as he would have wished. Perhaps he was not the right man for it? And perhaps he had remained too much of a Dutchman?

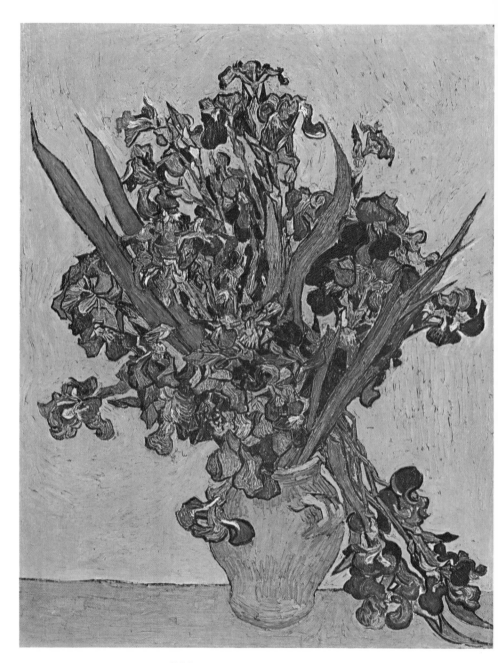

Still-life with Iris. Saint-Rémy, May 1890.

The end of this strange letter is missing.

On 20th May Vincent left Paris for Auvers-sur-Oise, where Dr Gachet was expecting him.

AUVERS-SUR-OISE
20th May—29th July 1890

Auvers, a little village built in terraces on a hillside between Pontoise and Valmondois, was a pleasant, peaceful spot which had been discovered, some years before Vincent's arrival, by painters looking for a place on the banks of the Oise where they could live and work. Daubigny settled at Auvers in 1860, and his guests included Corot and Daumier, his neighbour at Valmondois. Then came Jules Dupré, followed by Pissarro and Cézanne—who painted *The House of the Hanged Man* and many other pictures there—Guillaumin, Monet and Renoir. They were all on friendly terms with Dr Gachet, who had been living since 1872 at 'Le Castel', a large house in the Rue des Vessenots, at the top of the village.

Paul-Ferdinand Gachet was now sixty-two years old. Of Flemish origin, he was born and brought up at Lille and then came to Paris to study medicine. In the Quartier Latin he had become friendly with writers and artists, including Schanne, Murger, Champfleury, Courbet, Proudhon, Duranty, Daumier and Chintreuil. Later he came to know Monticelli and Bazille. He became a general practitioner in Paris, living first in the Rue Montholon and later in the Faubourg Saint-Denis.

Being also medical consultant to the Northern Railway Company and municipal Medical Inspector for Paris, he spent only three days a week at Auvers. His wife had died of tuberculosis three years after they had come there, and he now lived with his son, Paul, his daughter, Marguerite, and a housekeeper. He was a member of the Society for the Protection of Animals and owned several cats and dogs, a pea-hen and a goat called Henriette, which he calmly took for strolls round the village. He was regarded locally as eccentric, if not a little mad. He was a nonconformist in social and medical matters alike. His views on art, while not exactly revolutionary, were quite advanced for that period; he admired the Impressionists as he did all novelties, whether

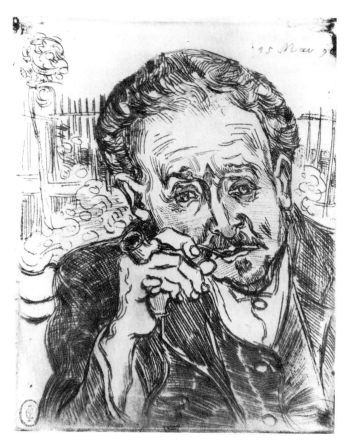

Portrait of Dr Gachet. Auvers, 15 May 1890.

in art or medicine. Dr Gachet was himself a painter, but preferred etching; he signed his work with a pseudonym, 'P. van Ryssel'. His house was hung from floor to ceiling with pictures, not only those of his friends—Sisley, Pissarro, Cézanne, Manet, Daumier, Courbet, Renoir—but a number of old canvases as well, 'black antiques, black, black, black', as Vincent described them. Such was the man Pissarro had recommended to Theo van Gogh to watch over his brother's health.

'Auvers is very beautiful,' wrote Vincent to Theo and Jo as soon as he arrived [179], 'among other things a lot of old thatched roofs, which are getting rare . . . I have seen Dr Gachet, who gives me the impression of being rather eccentric, but his experience as a doctor must keep him balanced enough to combat the nervous trouble from which he certainly seems to me to be suffering at least as seriously as I.'

Dr Gachet, in the officer's cape he had worn since the Siege of Paris, when he had served in the Medical Corps, and equally shabby white peaked cap, was utterly unlike the doctors to whom Vincent was accustomed. Curiously enough he somewhat resembled Vincent in physical appearance. He won Vincent's confidence by talking to him about his illness in simple, straightforward terms, advising him 'to work boldly on, and not think at all of what went wrong with me,' as Vincent wrote to Theo. On the whole Vincent's first impression of him was not unfavourable, and he wrote: 'I really think I shall go on being friends with him and that I shall do his portrait.'

Dr Gachet was not at all perturbed by his new 'case'. He thought Vincent's nervous system, already very shaky, had been attacked by the violence of the southern sunlight, too strong for his northern constitution, and considered that one of Vincent's most serious troubles was turpentine poisoning, which he thought had not received proper treatment; a very different diagnosis from that of Drs Rey, Urpar and Peyron, all of whom believed he was an epileptic.

Vincent was eager to settle down and start painting. Dr Gachet took him to the Auberge Saint Aubin, not far from his own house, but the daily charge there was six francs, which Vincent thought too high, so he chose a small café in the Place de la Mairie, in the centre of the village, whose proprietor, Gustave Ravoux, asked only three francs fifty centimes. He was given a little whitewashed attic room, just big enough to hold a bed and a table.

He liked Auvers, where there was a great deal of colour, and at once began 'a study of old thatched roofs with a field of peas in the foreground and some wheat, background of hills . . .' He asked his brother to send him ten yards of canvas and twenty sheets of drawing paper; he felt that the country suited him, and that 'it was a good thing to have gone South, the better to see the North.' He also asked

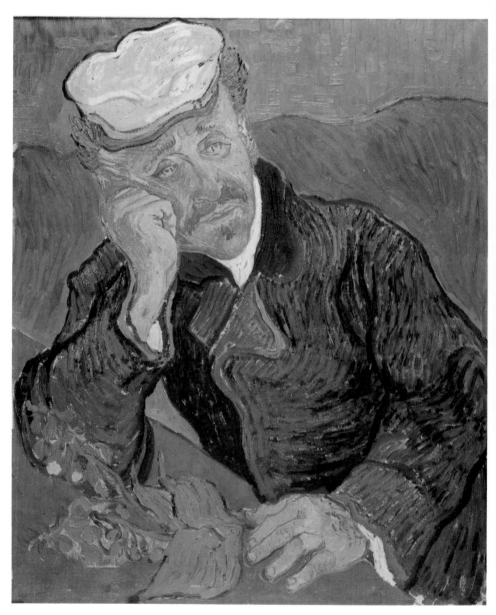

Portrait of Dr Gachet. Auvers, June 1890.

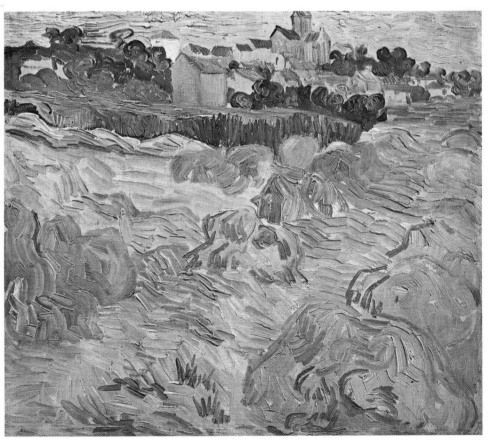

View of the Village. Auvers, June 1890.

Theo to send Bargue's *Exercises au fusain*, which had been his first textbook.

Once or twice each week, on Sundays or Mondays, he was invited to take his meals at Dr Gachet's house, occasions which he did not particularly enjoy because Dr Gachet went to the trouble of arranging four- or five-course dinners, 'which is as dreadful for him as for me— for he has not a strong digestion.'

The canvas and paper were sent at once, and Vincent had soon finished a drawing of an old vine from which he intended to make a size 30 canvas, and studies of pink and white chestnuts; but he hoped 'to work on the figure a little.' Gachet was to be his first sitter, 'the head with a white cap, very fair, very light, the hands also a light flesh tint, a blue frock-coat and a cobalt blue background, leaning on a red table, on which are a yellow book and a foxglove plant with purple flowers.'

The doctor was 'absolutely fanatical' as Vincent put it, about the portrait. At the first glance he had realized Vincent's quality as a painter; none of those he had known until then, not even Monticelli or Cézanne, had given him such an impression of power, of passionate genius. 'How hard it is to be simple,' he murmured as he examined Vincent's paintings. Later he said of his guest: 'Not a day passes that I do not look at his pictures. I always find there a new idea, something different each day ... I think again of the painter and I find him a colossus. Besides, he was a philosopher ...' 'Love of art is not exact, one must call it faith, a faith that maketh martyrs!' And he often repeated, 'The more I think of it, the more I think Vincent was a giant.'

The two men got on well together. On his visits to Le Castel, Vincent would paint in the garden; the doctor asked him to make a second version of his portrait and of the copy of Delacroix's Pietà. Dr Gachet thought Vincent's condition satisfactory, and did not believe that there would be any more attacks.

Theo had scarcely found a moment to write, as he had been fully occupied by the Raffaëlli exhibition. But Gachet had been to see him. 'He told me,' Theo wrote to Vincent, 'that he thinks you are cured and sees no reason why the trouble should recur.' The doctor had invited Theo, Jo and the baby to come down on a Sunday, 8th June, to see Vincent at his home.

Aurier's article on Vincent had been a surprise to many painters, but no other critics followed his lead, and no dealers troubled to look at the pictures of which Aurier spoke so enthusiastically. But several artists wanted to exchange pictures with Vincent, and Theo wrote to him that 'Guillaumin is offering you a magnificent picture that was at Tanguy's: Sunset. It will look well in your studio. Gausson [180] would

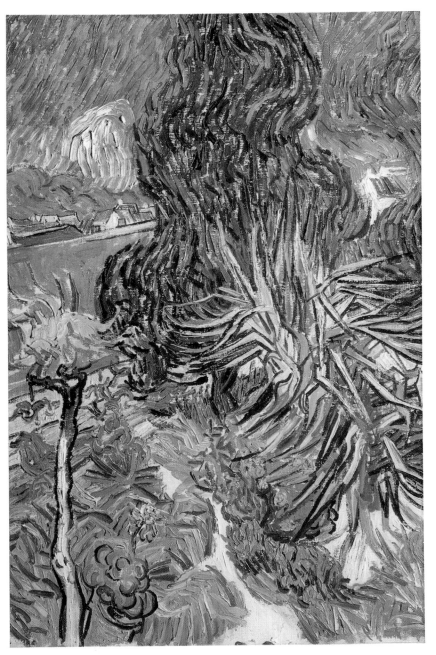

Dr Gachet's Garden. Auvers, May 1890.

like to make an exchange with you, whatever you feel like giving him ... Aurier will come one day, too. He's very pleased with your picture and will come with me one Sunday to see you.'

On the appointed Sunday Theo, Johanna and the baby came to Auvers. Vincent was radiant. The family atmosphere of this reunion at Gachet's house comforted him and gave him fresh heart. He was in excellent health, but unfortunately the same could not be said of Theo. Of the two brothers, it was he who seemed more like an invalid; he was thin, bent and feverish, while Vincent gave an impression of strength and health. Vincent had not failed to notice his brother's condition during his few days in Paris, and in a letter written soon after the move to Auvers, he expressed uneasiness about Theo's lack of appetite.

The Sunday went by quickly. After lunch in the open air Vincent showed his latest pictures to Theo and Jo, and they went for a long walk. Little Vincent-Wilhelm was not very strong, and country air would suit him better than Paris. Vincent suggested that Jo and the baby should spend the summer at Auvers rather than make the tiring journey to Holland. Theo knew he must not gainsay him.

Here was the modest cell, of which no warder held the key, and the fanlight opening to the sky—not the hard blue sky of Provence, but the delicate, changing blue of the sky of the Ile-de-France. Here was our good café proprietor Ravoux, his wife and their two daughters: Adeline, the elder, aged sixteen and Germaine, whom 'Monsieur Vincent' kissed good-night in her bed so that she could sleep. Pascalini, the retired gendarme; Old Penel who kept the bar at Chaponval, where he used to serve Corot, Jules Dupré, and Daumier; the artists Martinez and Walpole Brooke with whom he dined at the inn, and others. None of them knew that this good and affable man had just come out of the asylum and that the doctors considered him mad. Here was his new kingdom. But also the stage and the actors for his Passion.

If Theo and Jo accepted his plan, thought Vincent, then perhaps he would be able to live something like the 'real life' which he hardly hoped to experience, yet which he continually strived after all the same. When he met them at the station Vincent brought his nephew a nest—a symbol of the hearth, of the 'fertile life'.

The day with his family stimulated Vincent tremendously and filled him with happiness, as he wrote to his mother and to his sister. On 15th June, Theo wrote to say he would be receiving a visit from a Dutch painter, Hirschig, who brought news of Gauguin. Gauguin 'very much likes the portrait of a woman you did at Arles,' [181] says Theo, 'and is going to Martinique.' A note from Gauguin was enclosed with this letter.

Vincent was working 'a good deal and quickly', as he wrote to his sister, adding: 'by this I am seeking to find an expression for the desperately swift passing away of things in modern life.'

'Yesterday in the square I painted a large landscape, showing fields as far as one can see, looked at from a height, different kinds of green growth, a potato field of a sombre green colour between the regular beds of rich violet earth—on one side a field of peas in white bloom, then a field of clover with pink flowers and the little figure of a mower, a field of long, ripe grass somewhat reddish in tone, then various kinds of wheat, poplars, on the horizon a last line of blue hills along the foot of which a train is passing, leaving behind an immense trail of white smoke all over the green vegetation. A white road lies across the canvas. On the road a little cart, and white houses with harshly red roofs by the side of this road.

'A fine drizzle streaks the whole with blue and grey lines.

'There is another landscape with vines and meadows in the foreground, and behind them the roofs of the village.

'And another one, with nothing but a green field of wheat, stretching away to a white country house, surrounded by a white wall with a single tree.' [182]

Hirschig arrived. 'He looks much too nice to paint under the present conditions,' [183] said Vincent. In the same letter he mentions that he meant to make etchings from some of the pictures he had painted in the south. Dr Gachet had a press and would be pleased to print them.

'At the moment I am working on two studies,' Vincent added, 'one a bunch of wild plants—thistles, ears of wheat, sprays of different kinds of leaves—the one almost red, the other bright green, the third turning yellow.

'The second study, a white house among trees, with a night sky and

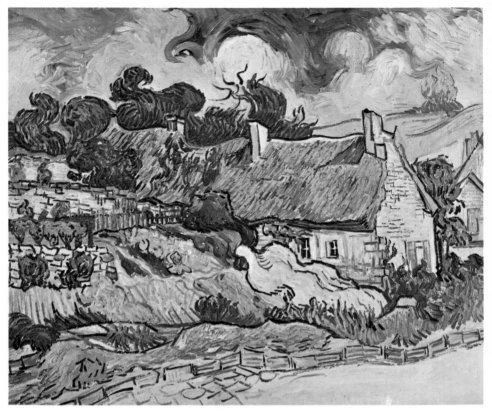

Cottages at Cordeville. Auvers, June 1890.

an orange light in the window and dark green foliage and a note of deep pink.'

Vincent was again gripped by restlessness. He even thought of following Gauguin to Madagascar if he went there, as was now his intention. 'Certainly the future of painting is in the Tropics, either in Java or Martinique, Brazil or Australia, and not here', he wrote, 'but you know that I am not convinced that you, Gauguin or I are the men of that future.' [184] He wrote to Gauguin on about 20th June, telling him about his own pictures and plans, including the idea of joining him in

a short time at Pont-Aven, 'to do one or two seascapes, but more especially to see you again and make de Haan's [185] acquaintance.' But this letter was never sent.

On 23rd June, Theo described his visit to the Salon with their friend Boch. 'And now,' he added, 'I must tell you something about your etching.[186] It is actually an etching done by a painter. There is no refinement of process, but it is a drawing on metal. I like that drawing very much—de Bock liked it too.' With his letter he sent a fifty franc note.

In the second fortnight of June, Vincent painted a portrait of Adeline Ravoux 'in blue against a blue background', and made a smaller replica of it for his brother. He also had in hand a picture of some wheatfields, and 'one which is a pendant to it, of undergrowth with lilac poplar trunks at their foot, grass with flowers, pink, yellow, white and various greens.

'Lastly, an evening effect—two pear-trees quite black against a yellowish sky, with some wheat and, in the purple distance, the château, set among dark green trees.' [187]

At about this time Vincent made the acquaintance of two youths, Gaston and René Secrétan, whose father, a wealthy chemist in the Rue de la Pompe in Paris, had a country house at Champagne, on the Oise, some six miles from Auvers. The two brothers and some of their friends—among whom was André Tardieu, the future politician—were a cheerful crowd, further enlivened by a number of women brought down from Montmartre. Gaston liked painting and made it his hobby. He had had some conversations with Vincent, and though he is never mentioned in the painter's letters to Theo, a friendship quickly developed between the nineteen-year-old boy from the Lycée Condorcet in Paris and the unsociable Dutchman.

Gaston was astounded by his first sight of Vincent's pictures, but soon grew very fond of them and called the painter 'an unrecognized trump'.

Dr Doiteau [188] relates some particulars gathered from the Secrétan brothers. René described van Gogh as 'a bit of a scarecrow', saying that 'his battered felt hat had no back or front to it. I never saw him in workman's overalls, he used to wear a sort of labourer's jacket. He

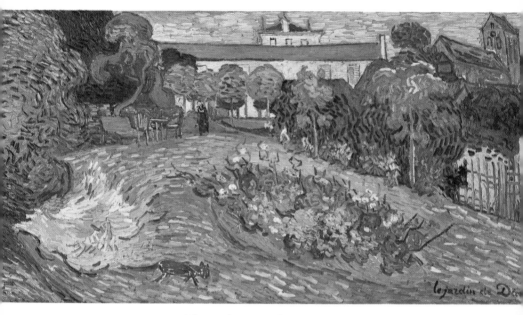

The Daubigny Garden. Auvers, July 1890.

went about with a kind of shopping basket to carry all his odds and ends.' And he added, 'The word I would choose to describe our friend van Gogh would be *touched*. He was erratic, moody, cheerful one day and glum the next, talkative when he'd had a drop of drink, or silent for hours in dream or thought, but . . . what made him likeable was the expression of his eyes . . . extremely deep and bright . . . Eyes which looked at nothing, but seemed to take in everything and gaze away into the distance.'

It is clear from this sketch that Vincent had begun to drink again: these friends were heavy drinkers, and he often let them buy him drinks.

One day he flew into a violent rage and threatened to kill them all because someone had put salt in his coffee, which seemed a strange reaction coming from a man of thirty-seven towards a bunch of boys, particularly as they had often played practical jokes and Vincent usually just laughed.

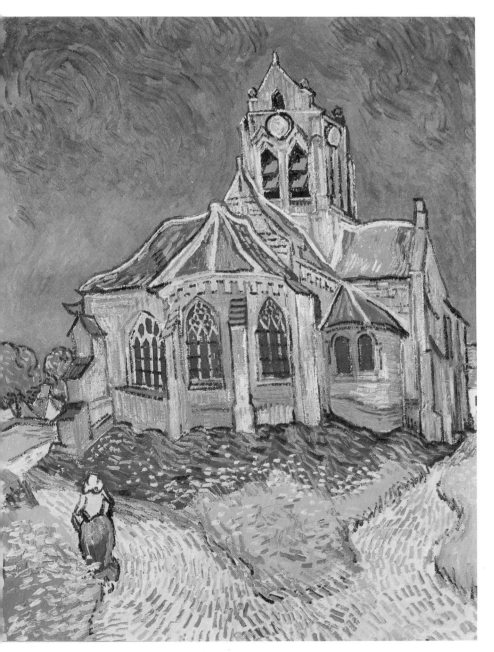

The Church at Auvers. Auvers, 4–8 June 1890.

Vincent gave the Secrétans a number of sketches, but they took very little interest in them and must soon have got rid of them, for they could not be found after the artist's death, when he began to attract general interest.

Towards the end of the month Vincent painted the portrait of Mlle Gachet. 'The dress is red, the wall in the background green with a touch of orange, the carpet red with a touch of green, the piano dark violet; it is 40 inches high by 20 inches wide.' He enjoyed painting it, though he ran into a number of difficulties he would doubtless have ignored a year earlier, and which resulted in some weak or clumsy passages, also to be found in other pictures, such as the *Portrait of Adeline Ravoux*, the strange *Man with the Cornflower*, and some of the landscapes.

In many cases the drawing is weak and the composition lacks balance; the unsteadiness, the whirling, sinuous or dizzy forms are no longer a matter of style, they have become tricks or eccentricities. The thatched cottages, gardens and fields, and the plain with its expanse of cornfields and its little villages that remind one of Brabant, look as though they were being jolted; they are emphasized by convulsive blobs of colour, spattered with meaningless dabs. Subjects as quiet and restful as *Street at Auvers, Landscape near Auvers, The Town Hall at Auvers, Thatched Cottages at Cordeville, Les Vessenots, Auvers, The Road near Auvers, Stairway at Auvers, Wooded Landscape* and *Daubigny's Garden* prompted him to untidy, distorted pictures with quivering lines, contorted curves and flabby, unsubstantial volumes.

The little church is dislocated by the strange thrust of the soil, the branches of the trees writhe in convulsions like the cypresses and olives of Saint-Rémy. Even the plain, so serene beneath its boundless sky, as balanced and 'classical' as a scene by Poussin, looks as though it were shaken by an earthquake. This exaggeration is the more surprising because while painting these pictures Vincent wrote to his mother, 'I am in a mood of almost too much calmness, in the mood to paint this.'

The colour is less rich, less brilliant than during the Arles period; but sometimes it seems glossier, fuller, as though drawing fresh sustenance from the soil. The dominant colours are milky white, subdued

green, faded yellow and mauve. With the exception of the self-portrait, probably painted in May[189] (page 260), the figures, some fifteen in all, are insipid compared with those of the previous period; Vincent's powers seem to be declining, though he was working with extraordinary speed.

Many of the paintings show signs of haste; the drawings—some thirty-five of them—are firmer, sturdier; they reflect van Gogh's love of the land to which he has returned, and the affectionate attention with which he studies the peasants, as in the old days. Everything reminded him of the past, the village life, work in the fields, rubbing shoulders with humble people; by coincidence even the little town hall at Auvers looked like the one at Zundert. After making a drawing of it, he did a painting which showed it decked with flags, fairy-lamps and paper garlands for the 14th July.

In this painting the short brush-strokes and coloured commas which once served to define volume and line play a purely decorative role; they have become almost a convention. This technique reappears in *The Church at Auvers*, which Vincent nicknamed 'the Cathedral'; but here the restrained beauty of the colours and the feeling that emanates from the rough, dark mass with the stormy sky behind it create a kind of touching dignity.

'You have found the right word for it', René Secrétan told Dr. Doiteau while relating his memories and judgment of van Gogh: *'depressed,* perhaps *obsessed* and certainly *anguished.'*

On 30th June, Vincent heard from Theo that the baby had been ill; this had put a terrible strain on Jo and himself, and in addition they were worried about money. He wrote affectionately and encouragingly, but for all his act, Vincent shared his anxiety.

Theo tried to joke: 'We shall draw the plough until our strength forsakes us, and we shall still look with admiration at the sun or the moon, according to the hour. We like this better than being put into an armchair and rubbing our shins like the old merchant at Auvers. Listen, old chap, watch your health as much as you can, and I shall do the same, for we have much too much in our noodles to forget the daisies and the lumps of earth freshly turned by the plough ... the limpid blue of the calm skies, the big autumn clouds, the uniformly

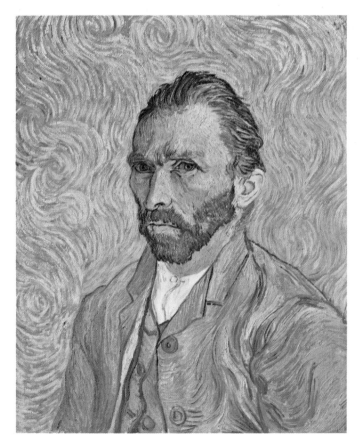

Self-portrait. Auvers, May-June 1890.

grey sky in winter, or the sun rising over our aunts' garden, or the red sun going down into the sea at Scheveningen, or the moon and stars of a fine night in summer or winter—no, come what may, this is our profession.

'. . . As for you, you have found your way, old fellow, your carriage is steadily on its wheels and strong, and I am seeing my way, thanks to my dear wife. Take it easy, and hold your horse a little, so that there may be no accident, and as for me, an occasional lash of the whip does me no harm.'

Vincent replied: 'I should greatly like to come and see you, and what holds me back is the thought that I should be even more powerless than you in the present state of anxiety.'

He regretted that Dr Gachet's house was 'so encumbered with all sorts of things,' for otherwise Jo and the baby could come and stay with him for a month or so.

Then he returned to his work, to the canvases he had painted, to Gauguin's plans to go to Madagascar... 'What can I say about a future perhaps, perhaps, without the Boussods? That will be as it may, you have not spared yourself trouble for them, you have served them with exemplary loyalty at all times.

'... I myself am trying to do as well as I can, but I will not conceal from you that I hardly dare to count on always being in good health.'

In a letter dated 5th July, Theo told his brother the baby was better; he and Jo were expecting Vincent to visit them on the next Sunday, 6th July.

Sheaves. Auvers, July 1890.

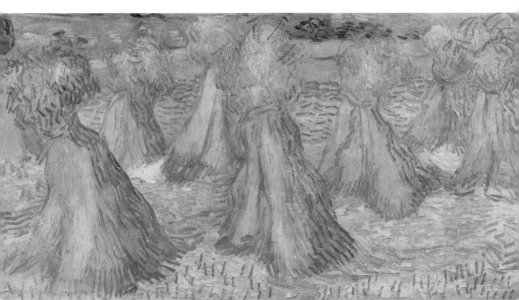

At their flat Vincent would meet Walpole Brooke, who was at Auvers when he first arrived and with whom he had become friendly; afterwards they would go together to look at a Japanese Buddha Theo had noticed in a curio-shop, and 'then we are going to lunch at home, in order to see your studies. You will stay with us as long as you like, and you are going to advise us with regard to the arrangement of our new flat.'

The first part of that July Sunday was spent in the friendliest manner possible. Bernard came to see them first, and then Albert Aurier, whom Vincent had never met and with whom he had a long talk about painting. Then they had lunch, at which Toulouse-Lautrec was also present, and he and Vincent joked about an undertaker they had met on the stairs. But once the guests had gone, the atmosphere quickly changed. Relations between Theo and his employers were very strained, and in expressing his disgust at the way they were treating him, he touched, perhaps too emphatically, on money matters. He told Vincent that he had decided to take his family to Holland for the summer holidays, not to Auvers. It was difficult for Theo to go on supporting his brother; Vincent was a heavy drain on his lean purse, as Jo must often have pointed out to him.

It was not only the disappointment at not being able to spend a summer month with them in Auvers, but this unexpected move, plus Theo's financial embarrassment, which made the situation infinitely more complicated. The latter could no longer, under the present circumstances, provide for the needs of his brother; Vincent placed too heavy a burden on his meagre budget and Jo, undoubtedly, had often pointed this out to him. On top of this, in Holland, his family and the Bongers, with the exception of his mother and faithful Wil, would not fail to insist on this point. Waste several hundreds of francs each quarter for that . . .

The words were burning Jo's tongue, but even if they were not uttered, Vincent sensed them, heard them: failure, weakling, good-for-nothing, madman, madman, madman . . .

Vincent was to have spent two or three days in Paris, but he returned to Auvers that evening. Whether there had been a quarrel we shall never know. 'My impression,' he wrote next day to his 'brother and

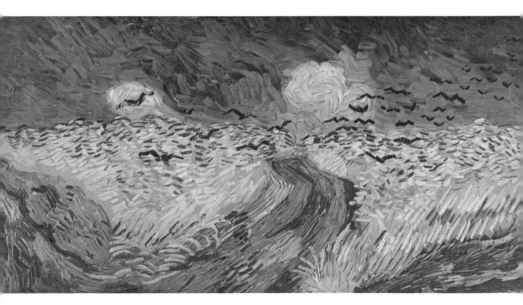

Wheatfield with Crows. Auvers, July 1890.

sister', 'is that since we are all rather distressed and a little over-wrought, it matters comparatively little to insist on having any very clear definition of the position in which we are. You rather surprise me by seeming to wish to force the situation. Can I do anything about it, at least can I do anything that you would like me to do?'

Vincent was assailed by complex feelings. When Theo had married he had a vague feeling of frustration. Hadn't he himself for years vainly sought the woman together with whom he could realize 'the fertile life'? And hadn't he had to give up this idea after renewed failures or humiliations which had not failed to leave their mark on him? He was not far from the thought that Theo, the only person on earth whom he loved, had stolen his life from him.

Besides this, knowing the heavy burden of their heredity, he was continually tormented by fear on behalf of his nephew. What if the unfortunate child, inheriting his name, were also to inherit the sickness which gnawed at him. Although his health was good at the moment,

263

Vincent was haunted by the idea that his attacks were likely to recur; and he could not forget what had happened at Theo's flat. Some of his biographers have assumed that the dispute which took place on 6th July was followed by an exchange of conciliatory letters, and have lamented their disappearance. But Theo and his wife did not answer Vincent's note: 'Under ordinary circumstances,' he wrote shortly afterwards, probably on the 9th or 10th, 'I should certainly have hoped for a line from you these first few days.

'But considering how things have happened— honestly—I think that Theo, Jo and the little one are a little on edge and are worn out.' One sentence seems to imply that it was the question of money which was most important in their discussion. 'I very much fear that I was distressed and I think it strange that I do not in the least know under what conditions I left—if it is 150 francs a month paid in three instalments, as before. Theo has fixed nothing and so to begin with I left in confusion. Would there be a way of seeing each other again more calmly? I hope so . . .'

On the 7th, the day after he got back from Paris, Vincent had gone to call on Gachet, but the doctor was not at home. 'I think we must not count on Dr Gachet at *all*,' he wrote. 'First of all he is sicker than I am, I think, or shall we say just as much, so that's that.'

There is still little known concerning Vincent's relationship with his doctor. Had something come between them, and if so, what? Or was it one of the artist's frequent changes of mood? Perhaps also the nonconformist and sometimes rather original Dr Gachet seemed to him irresponsible compared to his previous doctors. It does seem strange that the doctor failed to supervise closely this man whom he knew to be subject to terrible fits of madness. When he put his brother in his care, did Theo know that Dr Gachet was absent from Auvers five days out of seven? Who would look after Vincent if he had a relapse? Had they forgotten that Vincent had just spent a year in an asylum for lunatics whom doctors did not hesitate to class as dangerous epileptics?

At last Vincent received a letter from Jo; it came as an immense comfort, 'a deliverance from the agony which had been caused by the hours I had spent with you, which were a bit too difficult and trying for us all.'

264

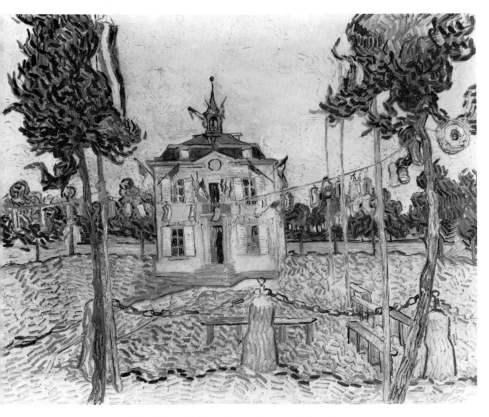

The Town Hall at Auvers. Auvers, July 1890.

'Back here, I still felt very sad and continued to feel the storm which threatens you weighing on me too. What's to be done—you see, I generally try to be fairly cheerful, but my life is also threatened at the very root, and my steps are also wavering. I feared, not altogether but yet a little, that being a burden to you, you felt me rather a thing to be dreaded, but Jo's letter proves to me clearly that you understand that for my part I am as much in toil and trouble as you are.'

This letter, which Vincent says 'was like a Gospel to me,' has disappeared.

The journey to Holland preoccupied him; he persisted in advising Theo and Jo against this move and returned several times in the same

265

letter to this question, which was important for him. 'I fear that it will be the last straw for us', he wrote. He tried as hard as he could to prevent their departure.

Vincent still wished to dissuade Theo and Jo from their visit to Holland. Some writers have suggested that Vincent feared a fresh attack which might end in final madness and even death, and wanted to have his brother beside him. Another theory is that he feared that Jo's family, the Bongers, would take advantage of the visit to Holland to urge upon Theo and Jo that the bond between the brothers was unnatural now that Theo was a husband and father.

Slowly he began to paint again. But he realized how much he had changed since the previous year. Vincent was worn out. All the same, he painted three large canvases, two of 'vast fields of wheat under troubled skies' and the third, Daubigny's garden. On 14th July came a letter from Theo:

'We are very glad to learn that you are feeling less dispirited on account of the unsettled business than when you were here. The danger is really not as serious as you thought. If we can continue in good health, which will permit us to undertake what is growing little by little into a necessity in our minds, all will go well. Disappointments, —certainly, but we are no tyros and we are like waggoners who by the utmost efforts of their horses, have *nearly* reached the top of the hill.'

This was vague, though of course affectionate and intended to soothe Vincent. Theo, his wife and the baby were to leave for Leyden next day; then Theo would go on to Antwerp by himself and come back to Paris in a week's time, so the separation would not last too long. And he enclosed a fifty franc note.

On the 14th July Vincent painted the town hall at Auvers and the decorations, but the little square with its garlands and fairy-lights was empty of figures.

He went to call on Dr Gachet, his head down and face gloomy, and noticed in the drawing-room a picture by Guillaumin, *Nude with Japanese Screen*, which Dr Gachet had not had framed in spite of Vincent's urging. Vincent lost his temper and suddenly thrust his hand into his pocket. Dr Gachet's stern look stopped him short, and he left with bowed head.

266

One's first reaction to this is to find it strange that the doctor did not examine Vincent's pocket, where he might have found the revolver which, according to some accounts, he had been lent by Ravoux to shoot the crows that bothered him while he was painting. Another explanation of Vincent's possession of a revolver is that it was bought at Lebœuf's, the gunsmith at Pontoise; while René Secrétan says that it was borrowed from one of the group of lads, who had been using it to shoot squirrels, though it was Ravoux who had lent it in the first place.

Between 20th and 23rd July, Vincent wrote to his mother and sister. On this letter his mother has written: 'Very last letter from Auvers.'

'I myself,' wrote Vincent, 'am quite absorbed in the immense plain with wheatfields against the hills, boundless as a sea, delicate yellow, delicate soft green, the delicate violet of a dug up and weeded piece of soil checkered at intervals with the green of flowering potato plants, everything under a sky of delicate blue, white, pink and violet tones.'

To Theo, just back from Holland, Vincent wrote on 23rd July: 'I'd rather write to you about a list of things, but to begin with, the desire to do so has completely left me, and then I feel it is useless.

'. . . As far as I am concerned, I apply myself to my canvases with all my mind, I am trying to do as well as certain painters whom I have loved and admired.

'Now I'm back, what I think is that the painters themselves are fighting more and more with their backs to the wall.'

On the hill overlooking the village he set up his easel at the edge of the golden wheat to paint *Wheatfield with Crows*. Everything is about to be crushed, wiped out, in a cataclysm which will sweep earth and sky into one torrent shot with gold. Here, art and psychosis are inseparable, the movement of the corn and that of the crows oppose and contradict each other, rising in one direction, sinking in the other, creating the dual rhythm of the painter's psychopathic manifestation.

There was nothing in Vincent's manner to suggest that he meant to kill himself and none of those around him during the last weeks of July felt any foreboding.

It seems that Vincent was driven to self-punishment whenever some setback awoke murderous feelings in him. And he realized that his

ability to paint was declining, and knew he might at any moment suffer another attack. He may also have feared that his aggressiveness might turn against the two people to whom he owed much of his happiness and his misery—Theo and Jo.

The concurrence of Vincent's attacks and the events of Theo's marriage have been traced by Pierre Marois[190] and more recently by Mlle Gilberte Aigrisse[191].

Mlle Aigrisse suggests the tragic psychological process which may have led to the painter's suicide. By achieving with Jo the 'true life' Vincent had dreamt of, Theo had betrayed his brother; but the betrayal was as 'natural' as the 'lawful union' of the two brothers had been unnatural. Vincent's was the guilt, and punishment had to follow.

Vincent usually spent the morning painting out of doors and the afternoon working in the back room of the café, but on Sunday 27th July he went out in the heat of the day, immediately after lunch. The village was deserted, except for a peasant who heard him mutter, 'It's impossible! Impossible!' as he went by. Vincent apparently took the Chaponval direction on the way to Pontoise; he went into a farmyard in the Rue Boucher, and it was no doubt there that he shot himself in the chest.

He may have wandered about injured for some time—he did not reappear at Ravoux's until early in the evening. The proprietor, knowing he was always punctual, was surprised not to see him at about seven o'clock. And when he appeared at last, holding his side, he went straight up to his room without replying to questions. Ravoux followed him a few moments later and found him curled up on his bed. His face was drawn and he pointed to a small wound on his chest near his heart.

Dr Gachet lived at some distance and up a steep hill, so Ravoux sent Hirschig for Dr Mazery instead. The news reached Gachet about nine o'clock that evening, whereupon he hurried to the café, examined the wound, reassured Vincent about his condition and asked him for Theo's private address. Vincent refused to give it, and the doctor did not insist. He left his son Paul to watch over him. Downstairs in the café he wrote a note for Hirschig to give to Theo first thing in the morning, when the gallery opened.

Theo came to Auvers immediately. 'Do not grieve, I did it because it was best for us all,' Vincent told him.

On the same day Theo wrote to Jo in Holland:

'Poor fellow, very little happiness fell to his share, and no illusions are left him; the burden grows too heavy at times, he feels so alone . . . he said you could not imagine there was so much sorrow in life. Oh! if we could only give him some new courage to live!'

At that date it was not practicable to extract the bullet, which had been directed towards the heart but had been deflected by the fifth rib; the only prescription was rest.

Throughout the following day Vincent sat propped up in bed, smoking his pipe and staring silently into space. He seemed to be in no pain. Theo, Gachet, his son Paul, Hirschig and Ravoux took turns at his bedside. The police came to investigate and questioned him rather bluntly. 'It is nobody's business,' he replied.

In the evening he grew weaker. About eleven o'clock he took a turn for the worse, at one in the morning of the 29th he died. He was then thirty-seven years old.[192]

Dr Gachet made a drawing of Vincent, from which he later did an etching. It was signed, like all his work, 'Van Ryssel'.

The funeral took place on 30th July at three in the afternoon, and Vincent's friends came down from Paris. Père Tanguy was the first to arrive, followed by Emile Bernard and Laval, and then by André Bonger, Jo's brother, Lucien Pissarro and Lauzet. 'On the walls of the room [193] where he lay,' Bernard wrote to Albert Aurier [194], 'all his latest pictures were nailed up, forming a kind of halo for him, so that the radiance of the genius that shone from them made his death seem even more grievous to the artists. On the bier there was a plain white sheet and quantities of flowers, the sunflowers he loved so much, and yellow dahlias, yellow flowers everywhere . . . Nearby, too, his easel, his camp stool and his brushes had been laid on the ground in front of the coffin.'

The local priest would not allow the church hearse to be used for a man who had committed suicide, so one was lent by the 'progressive' town of Méry, delighted to score a point. It was a day of blazing sunshine; the procession of about a dozen mourners set out on foot for

DR GACHET: *Van Gogh on his Deathbed*. Auvers, 29 July 1890.

the graveyard, led by André Bonger and Theo, who 'sobbed painfully the whole time.' [195]

After Bonger and Theo had each put a spadeful of earth in the grave, Dr Gachet said a few words. 'Gentlemen,' replied Theo, broken with grief, 'I cannot make you a speech, but I thank you from the bottom of my heart.' Then they went their ways.

In the pocket of Vincent's jacket, Theo had found a letter:

'My dear brother,

Thanks for your kind letter and for the 50-fr. note it contained. There are many things I should like to write you about, but I feel it is useless. I hope you have found those worthy gentlemen favourably disposed towards you.

'Your reassuring me as to the peacefulness of your household was hardly worth the trouble, I think, having seen the weal and woe of it for myself. And I quite agree with you that rearing a boy on a fourth floor is a hell of a job for you as well as for Jo.

'Since the thing that matters most is going well, why should I say more about things of less importance? My word, before we have a chance to talk business more collectedly, we shall probably have a long way to go.

'The other painters, whatever they think, instinctively keep themselves at a distance from discussions about the actual trade.

'Well, the truth is, we can only make our pictures speak. But yet, my dear brother, there is this that I have always told you, and I repeat it once more with all the earnestness that can be expressed by the effort of a mind diligently fixed on trying to do as well as possible—I tell you again that I shall always consider you to be something more than a simple dealer in Corots, that through my mediation you have your part in the actual production of some canvases, which will retain their calm even in the catastrophe.

'For this is what we have got to, and this is all or at least the main thing that I can have to tell you at a moment of comparative crisis. At a moment when things are very strained between dealers in pictures of dead artists, and living artists.

'Well, my own work, I am risking my life for it and my reason has half foundered because of it—that's all right—but you are not among the dealers in men as far as I know, and you can still choose your side, I think, acting with humanity, but *que veux-tu?'*

When Vincent's friends got back to Ravoux's café, Theo thanked them and asked them to choose canvases from among those left by his brother in his room; Dr Gachet carried away several, which his son bequeathed sixty years later to the Louvre, together with those that Vincent himself had given to the Gachet family.

Vincent's death was a crippling blow to his younger brother, whose already failing health was gravely affected by it. He asked Paul Durand-Ruel to hold an exhibition of Vincent's work, but the dealer refused. Theo then wrote, on 18th September, to Emile Bernard, asking for help in 'getting justice done to Vincent's work'. The first necessity was to sort out and list the pictures in Theo's possession, which meant almost all those painted in Paris, at Arles and at Saint-Rémy, and a great number of those done at Auvers—more than five hundred and eighty paintings in all, not to mention drawings.[196]

But at the beginning of October, only two months after Vincent's death, Theo's nephritis developed into uremia with delirium. He had a violent dispute with his employers, and resigned from his job. He then reverted to Vincent's early projects and planned to take a lease of 'Le Tambourin' and found a society of painters there. But his attacks grew more acute, he threatened his wife and son, and on 12th October it became necessary for him to go into the Maison de Santé Dubois, where Dr Gachet, to whom Jo sent word, came to see him. On 14th October he went from there to a similar nursing home run by Dr Blanche. His condition improved and Jo took him to Holland, but soon afterwards he had to enter an asylum at Utrecht, where he died of a paralytic stroke on 21st January 1891, having survived his brother by only five months and twenty-three days.

Twenty-three years later, Theo's body was brought back from Holland, thanks to his wife's efforts[197], and the two brothers now lie under twin tombstones in the little graveyard at Auvers.

NOTES

1 Elisabeth Duquesne-van Gogh, *Vincent van Gogh. Persoonlijke herinneringen aangaande een Kunstenaar* (Baarn, 1910). Unfortunately these recollections are romanticized.

2 June–July, 1882.

3 Saint-Rémy, 1889.

4 *VvG. Persoonlijke,* op. cit.

5 To Theo, July 1880.

6 Introduction to *Lettres de van Gogh à son frère Théo* (Paris 1956).

7 10th August, 1874.

8 30th March, 1874.

9 6th October, 1875.

10 Etten, 4th April, 1876.

11 6th May, 1876.

12 Isleworth, 10th November, 1876.

13 Isleworth, 3rd October, 1876.

14 Late January or early February, 1877.

15 22nd March, 1877.

16 16th April, 1877.

17 Poet and painter of rustic scenes, b. Courrières (Pas-de-Calais), 1827, d. 1905.

18 Painter specializing in scenes of the poultry yard and agricultural work (1813–1894).

19 Painter and engraver specializing in 'chiaroscuro'. Born and died at The Hague (1817–1891).

20 To Theo, 30th April, 1877.

21 To Theo, 30th May, 1877.

22 19th November, 1877.

23 12th June, 1877.

24 One of Vincent's sermons at Isleworth, the manuscript of which has been found, was based on his comments on a picture by the English painter G. H. Boughton.

25 3rd April, 1878.

26 Charles de Groux, a Belgian painter of scenes of daily life (1825–1870).

27 Painter of genre and historical scenes, frequently set in Alsace (1824–1877).

28 Flemish writer on rustic life (1812–1883).

29 French landscape painter (1811–1889).

30 Painter of Paris suburban scenes (1763–1843).

31 Petit-Wasmes, 26th December, 1878.

32 Louis Piérard, 'Van Gogh au pays noir' (*Mercure de France,* 1913), based on the particulars given to the writer by the pastor of Warquignies.

33 Painters of The Hague school, the brothers Jacob, Matthys and Willem.

34 Landscape painter, scenes of work in the fields (1838–1888).

35 Painter of portraits, landscapes, seascapes and still-lifes (1824–1911).

36 Wasmes, June 1879.

37 Louis Piérard, 'Van Gogh au pays noir', op. cit.

38 15th August, 1882.

39 To Theo, Cuesmes, 7th September, 1880.

40 Cuesmes, 24th September, 1880.

41 15th October, 1880.

42 From van Rappart to Mme Theodore van Gogh. Letter written after Vincent's death.

43 The picture-dealers, Goupil.

44 Mr Tersteeg, manager of Goupil's branch at The Hague.

45 Vincent's Uncle Cornelius-Marinus (known as Cor).

46 Brussels, 2nd April, 1881.

47 3rd September, 1881.

48 7th September, 1881.

49 Etten, 12th October, 1881.

50 Painter and engraver of scenes of everyday life. His facile pictures were much in fashion at the time (1826–1888).

51 French painter of daily life (1838–1883).

52 Genre painter, b. The Hague, 1837, d. 1890.

53 October–November, 1881.

54 To Theo, Etten, December, 1881.

55 Jean Leymarie, *Van Gogh* (Paris, 1951).

56 January or February, 1882.

57 To Theo, May, 1882.

58 Louis Roetland, *Vincent van Gogh et son frère Théo* (Paris, 1957).

59 To Theo, March, 1884.

60 6th July, 1882.

61 To Theo, May or June, 1882.

62 To Theo.

63 To Theo, May or June, 1882.

64 May or June, 1882.

65 French painter, illustrator and engraver (1845–1924).

66 Gustave Morin, French painter of daily life (1829–1886).

67 Charles-Auguste Loye, alias Montbard (1841–1906).

68 October–December, 1882.

69 September, 1883.

70 October or November, 1883.

71 15th December, 1883.

72 Gustave Coquiot, *Vincent van Gogh* (Paris, 1923).

73 Recorded by Kerssemakers in *De Amsterdamer, 12th and 14th April,* 1912.

74 Summer of 1884.

75 'The lessons were soon abandoned, because during them Vincent continually compared the notes of the piano to colours, such as Prussian blue or cadmium. The good man decided his pupil must be a lunatic, and was so alarmed that he stopped the lessons.' (Kerssemakers, op. cit.).

76 March–April, 1885.

77 October–November, 1885.

78 October–November, 1885.

79 The municipal authorities of Arles described him, on the plate which bears the name of the street called after him, as '*Vincent van Gogh, célèbre peintre hollandais*'.

80 November or December, 1885.

81 November, 1885.

82 28th December, 1885.

83 January, 1886.

84 January, 1886.

85 February, 1886.

86 To Theo, 28th December, 1886.

87 To Theo, February, 1886.

88 February, 1886.

89 To Theo, summer, 1886.

90 February, 1886.

91 F. Gauzi, *Lautrec et son temps* (Paris, 1954).

92 Perhaps the *Female Nude* in Mme Pierre Goujon's collection.

93 E. Bernard, *Lettres de Vincent van Gogh* (Paris, 1911), Introduction.

94 M. Osborn, *Der bunte Spiegel* (1890–1933, New York 1945).

95 E. Bernard, *Mercure de France,* April, 1933.

96 Mme J. van Gogh-Bonger, *Verzamelde Brieven van Vincent van Gogh* (I).

97 Théodore Duret, *Van Gogh Vincent* (Paris, 1910).

98 Jean Leymarie, *Van Gogh*, op. cit.

99 'Vincent was living in a good-sized, well-lighted room which also served as a studio. He was just finishing a still-life, which he showed me. In the Flea-market he had bought a pair of old, heavy, thick-soled boots, carter's boots, but clean and freshly polished. They were rich croquenots, with no originality. One wet afternoon he put them on and set out for a walk along the fortifications. Splashed with mud, they became interesting. A study is not necessarily a picture; a pair of clodhoppers or a bunch of roses may both serve their turn.

'Vincent faithfully copied his pair of boots. There was nothing revolutionary about the idea, but it seemed peculiar to some of our fellow-students, who could not imagine a pair of clodhoppers in a dining-room as the companion picture to a plate of apples.' (François Gauzi, *Lautrec et son temps*, op. cit.)

100 Among two-hundred-odd pictures painted by Vincent while in Paris are no less than fifty bunches of flowers.

101 To Theo, summer, 1886.

102 *Verzamelde Brieven* (I).

103 A. Artaud, *Van Gogh, le suicidé de la société* (Paris, 1947).

104 E. Bernard.

105 Summer, 1887.

106 See T. J. Honeyman, 'Van Gogh, a Link with Glasgow,' in *Scottish Art Review*, 1948, vol. II.

107 To Theo. Arles, 21st February, 1888.

108 Of the firm of Boussod & Valadon.

109 Three paintings by Vincent were shown in the Salon of 1888, *Parisian Romances, The Butte Montmartre* and *Behind the Moulin de la Galette,* and several drawings.

110 To Theo, March, 1888.

111 It took that name from one of its keepers, but the people of Arles called it the 'Pont de l'Anglois', and Vincent followed them.

112 'What has become of the "Souvenir of Mauve"?' Vincent asks in a letter to Theo in August 1888. Everything suggests that Theo, surprised by the omission of his name, had not sent the picture on.

113 10th May, 1888.

114 May, 1888.

115 To Theo, June, 1888.

116 To Theo, Les Saintes-Maries, 16th June, 1888.

117 Van Gogh's pictures have lost a great deal of their colour, chiefly because he used chromes, crimson, Prussian blue and Veronese green, which darken or absorb the colours with which they are mixed. In addition, the colours mixed by Tanguy and supplied to Vincent through Theo were not of very good quality.

118 To Theo, 8th August, 1888.

119 To Willemien. Arles, about 8th September, 1888.

120 To Theo, August, 1888.

121 8th September, 1888.

122 To Theo, September, 1888.

123 To Theo, September, 1888.

124 To Theo, September, 1888.

125 Despite the difficulty of the undertaking Theo van Gogh tried to sell pictures by Vincent and Gauguin at Boussod & Valadon's. Marc-Edo Tralbaut, Director of the *Archives*

internationales de van Gogh, has pointed out that the register for the years 1888–9 mentions, under 8th June 1888, a *Pont de Clichy* painted by Vincent while in Paris, and a Gauguin (spelt 'Goguin'): *Seascape: Dieppe.* The former is priced at 250 francs (about 500 New Francs, 1960) and the latter at 500 francs, or double. Both painters were equally unknown, but Theo probably regarded Gauguin as more 'saleable' than his brother, an opinion which events at first justified.

126 'Don't worry,' wrote Gauguin on 16th October, 1888, to his friend the painter Schuffenecker, 'however in love with me Theo van Gogh may be, he would never go so far as to feed me in the South just for my *beaux yeux*. He has studied the terrain like a cold-blooded Dutchman.' Gauguin thought that 'the object of this visit is to help me to work without money worries until he (Theo) has managed to launch me.' That Vincent had waited with eager impatience for the arrival of one he regarded as a friend, Gauguin either pretended not to know or thought of no importance.

127 Gauguin's own account of his stay at Arles was published by Charles Morice in the *Mercure de France* (October–December, 1903).

128 According to the *Forum Républicain*, the woman at the door at No. 1, Rue du Bout d'Arles, was called Rachel. But it was to a girl called Gaby that Vincent brought the bit of his ear.

129 Doiteau and Leroy, *La folie de Vincent van Gogh* (Paris, 1928).

130 2nd January, 1889.

131/2 7th January, 1889.

133 This portrait, now in the Courtauld collection, London, is regarded without conclusive evidence as of doubtful authenticity.

134 Rey was not particularly pleased with his portrait. His family derided it, and it was relegated to the loft until one day it was found useful to stop a hole in the chicken-run. In 1900 Rey made the acquaintance of Charles Camoin, a young painter then doing his National Service, and learnt from him that the painting was valuable. Unconvinced, but wishing to be on the safe side, Rey removed the picture from the chicken-run, cleaned it and put it back in the loft. Camoin told Vollard, who offered to buy it for fifty francs (about £8 of today's money). Rey's father was indignant at the suggestion of taking so much money for a 'daub'. Rey, annoyed at being thus accused of cupidity, exclaimed: 'If that's how it is, I want a hundred and fifty francs for it.' Before the eyes of the dumbfounded family, Vollard paid unhesitatingly. (Doiteau and Leroy, 'Van Gogh et le portrait du Dr Rey,' in *Esculape*, February–March, 1939). It should be added that to the day of his death, in 1952, Dr Rey continued to look upon Vincent as a 'fraud' and his high reputation as the result of a passing craze.

135 To Theo, 17th January, 1889.

136 The expression was Gauguin's own, placed between quotation-marks by Vincent.

137 To the painter A. Koning, January, 1889.

138 To Theo, 23rd January, 1889.

139 To Theo, 23rd January, 1889.

140 To Theo, 23rd January, 1889.

141 This story was told by Rey to Drs Doiteau and Leroy ('Vincent van Gogh et le drame de l'oreille coupée,' in Esculape, July, 1936).

142 22nd February, 1889.

143 After replying by telegram on 13th February, Dr Peyron wrote to inform Theo of his brother's state of health. On 27th February Theo wrote to his fiancée to warn her that Vincent had had another attack.

144 In fact there were about thirty signatures.

145/6 To Theo, about 20th–23rd March, 1889.

147 Signac to Coquiot, in Coquiot's Vincent van Gogh, op. cit.

148/9 To Theo, 24th March, 1889.

150/1 To Theo, 21st April, 1889.

152 To Willemien, April, 1889.

153 A booklet on the 'Maison de Santé de Saint-Rémy de Provence' was brought out in 1866 by the publisher Victor Masson, in Paris. Coquiot, reprinting it in his book on van Gogh (op. cit.), remarks that 'It reads almost like an invitation for the holidays, intended for people who usually spend them in the country.'

154 French flower-painter (1841–1925).

155 French flower-painter (1844–1931).

156 To Theo, Arles, 23rd January, 1889.

157 After the publication of van Gogh's letters in a French edition in 1960, V. W. van Gogh, Theo's son, wrote to the editor of that publication, Georges Charensol, saying that 'in principle, all Vincent's letters have been published.'

158 F. Minkowska, 'Van Gogh, sa vie, sa maladie et son œuvre,' in L'Evolution psychiatrique (Paris, 1932, No. 1).

159 G. Kraus, 'Vincent van Gogh en de Psychiatrie,' in Psychiatrische en Neurologische Bladen uitgegeven door de Nederlandsche Vereeniging voor Psychiatrie en Neurologie (Amsterdam, September–October 1941).

160 Karl Jaspers, 'Strindberg und van Gogh, Versuch einer pathographischen Analyse unter vergleichender Heranziehung von Swedenborg und Hölderlin, III,' Arbeiten zur angewandten Psychiatrie, No. 5, 1922.

161 A. J. Westerman-Holstijk, 'Die psychologische Entwicklung V. v. G.,' in Image, X (April, 1924).

162 H. Gastaud, 'La maladie de V. v. G. envisagée à la lumière des conceptions nouvelles sur l'épilepsie psychomotrice.' Annales Médicales Psychiatriques, 1956, Vol II, p. 196.

163 Dr Escoffier-Lambiotte, 'La Folie de Vincent van Gogh,' in Médecine de France, March, 1961.

164 To Theo, 25th May, 1889.

165 To Theo, late May or early June, 1889.

166 To Theo, 9th June, 1889.

167 Late June, 1889.

168 'I now have copies of seven of Millet's ten Travaux des champs ... I would like also to copy The Sower and The Diggers ... Then The Four Hours of the Day ... I am going to copy Delacroix's Good Samaritan as well.' (To Theo, September, 1888).

169 Ph. Huisman, *Van Gogh-Portraits* (Paris-Lausanne, 1960).

170 October, 1889.

171 To the Exhibition of the Society XX, to which Vincent, through Theo, sent two studies of sunflowers, *The Ivy, Orchards in Blossom* (Arles), *Cornfield at Sunrise* (Saint-Rémy) and *The Red Vineyard (Mont-Major)*.

172 January, 1890.

173 Van Gogh's name and work were also mentioned in the series of articles published by Isaäcson; and in a letter written by Vincent to M. and Mme Ginoux in June 1890, referring to the exhibition of the XX, he says: 'Two articles have been written about my pictures. Once in a magazine in Paris [this was Aurier's article] and the other time in Brussels, where I had exhibited, and now in a paper in my own country [Isaäcson's articles] as a result of which a lot of people have been to look at my pictures.'

174 Coquiot, *V. v. G.*, op. cit.

175 Some of these, left behind at the asylum, were used by Peyron's son as targets for rifle-practice; others were destroyed by their various owners, who thought them worthless.

176 J. van Gogh-Bonger, *Brieven van zijn Broeder*. Letters from Vincent to Theo (Amsterdam, 1914–25), Introduction.

177 Vincent never painted a portrait of Theo.

178 A painter from Normandy, then exhibiting in the Salon.

179 This letter seems to have been begun in Paris and continued in Auvers.

180 Léo Gausson, a neo-Impressionist painter and engraver, who gave up art and entered the Colonial service.

181 No doubt *The Arlésienne,* painted by Vincent from a drawing by Gauguin.

182 To Willemien, middle of June, 1890.

183 To Theo, 17th June, 1890.

184 To Theo, 17th June, 1890.

185 Isaac Meyer de Haan, a Dutch painter, pupil and friend of Gauguin (1852–1893).

186 This etching—the only one Vincent ever made, based on his portrait of Dr Gachet, *The Man with the Pipe* — has been called in question because Vincent made a mistake in dating it, putting '15 mai 1890' instead of '15 juin'.

187 To Theo, 24th June, 1890.

188 Vincent Doiteau, *'Deux "copains" de van Gogh inconnus, les frères Gaston et René Secrétan, Vincent, tel qu'ils l'ont vu,'* in *Esculape*, March, 1957.

189 There is some doubt as to the date of this picture, believed to be Vincent's last self-portrait and said by those who knew him to be the best likeness. La Faille's *Catalogue* (1939 edition) puts it at the end of May, but W. Scherjon and J. de Gruyter (*Vincent van Gogh's great period: Arles, Saint-Rémy, Auvers-sur-Oise*, Amsterdam, 1939) declare it to be one of the last works painted at Saint-Rémy. Michel Florisoone (*'Deux grands chefs-d'œuvre de van Gogh entrent au Louvre'* in *Museés de France*, July–August, 1949) suggests September 1889, in

relation to the portrait of Trabu. The most likely date would seem, however, to be the end of May, for in inspiration and style the work shows similarities with the portrait of Dr Gachet. M. Paul Gachet is also of this opinion.

190 Pierre Marois, *Le secret de van Gogh* (Paris, 1957).

191 Gilberte Aigrisse, Thesis for the Faculty of Medicine, Brussels (unpublished).

192 Mairie of Auvers-sur-Oise, 'No. 60 of 1890, Vincent Wilhelm (or Willem) van Gogh. This twenty-ninth day of July, one thousand eight hundred and ninety, at ten a.m., certificate of death of Vincent Wilhelm van Gogh, painter, unmarried, aged thirty-seven, born on the thirtieth of March, one thousand eight hundred and fifty-three, at Groot-Zundert, Holland, deceased this day at one-thirty a.m. on the premises of Monsieur Ravoux, Hotel-keeper, in this municipality of Auvers-sur-Oise, where he was temporarily resident, of no fixed address, son of Theodore van Gogh, deceased, and of Anna Cornelia Carbentus, resident at Leyden, Holland. This certificate is drawn up in accordance with the declaration made by Messrs Theodore van Gogh, employee, picture-dealer, aged thirty-three, brother of the deceased, resident in Paris, Cité Pigalle, number eight, and Arthur Gustave Ravoux, hotel and restaurant keeper, aged forty-one, resident in this municipality, who have signed the same together with us, Alexandre Caffin, Mayor and Registrar, after it had been read and the death certified by us, the undersigned.'

193 The back room of Ravoux's café. In 1893, before leaving France for Italy and Egypt, Emile Bernard painted a symbolical picture of van Gogh's funeral. The real ceremony was much simpler than Bernard's pompous, solemn burial scene. Bernard places a yellow wreath beside the coffin as a tribute, and in the foreground a large patch of lemon-yellow seems to be whirling like the stars in the sky above Saint-Rémy.

194 Paris, 1st August, 1890.

195 E. Bernard to Albert Aurier, op. cit.

196 The *Catalogue raisonné* by J. B. de La Faille, published in 1928, gives the following list of van Gogh's works:

I. Paintings—Catalogue: 824 items described, not including replicas and 'versos'.

II. Paintings—Plates: 857 works reproduced.

III. Drawings, water-colours, lithographs, etchings. Catalogue: 86 items described, not including replicas and 'versos'.

IV. Drawings—Plates: 869 works reproduced.

A revised edition was published in 1939, with an introduction by Charles Terrasse: Catalogue: 833 pictures reproduced. In fact, between 1884 and 1890, Vincent must have produced over a thousand paintings and as many drawings.

197 Johanna had remarried, and was now a widow for the second time.

LIST OF ILLUSTRATIONS

Figures in italics refer to colour plates

282

BIBLIOGRAPHY

Seventy-seven studies of van Gogh were published between 1890 and 1940, and for the last twenty-one years they have appeared at a steadily increasing rate. Vincent's letters to Theo were arranged by Mme J. van Gogh-Bonger, Theo's widow, who wrote an introduction to them, and published in three volumes in Dutch (1914–1925), German (1914) and English (1927). The four-volume 'Century' edition, comprising all known letters from van Gogh to Theo and his other correspondents, was issued at Amsterdam and Antwerp in 1932. It was reprinted in two volumes in 1955, with the addition of two unpublished letters. In 1958 *The Complete Letters of Vincent van Gogh* were published in America and England. In 1960 another French edition, edited by M. Georges Charensol, comprised all the known letters, including seven not included in the Centenary edition. Among recent books on van Gogh remarkable for their scholarship and abstention from romantic embellishment are: Jean Leymarie: *Van Gogh*, Paris, 1951; Marc-Edo Tralbaut: *Van Gogh*, Paris, 1960; Philippe Huisman: *Van Gogh-Portraits*, Paris-Lausanne, 1960; Meyer Schapiro: *Vincent van Gogh*, New York, 1950; Jacques Combe: *Van Gogh*, Paris, 1951, and Henri Perruchot, *Van Gogh*, Paris, 1955.

INDEX